A COWMAN'S
WIFE

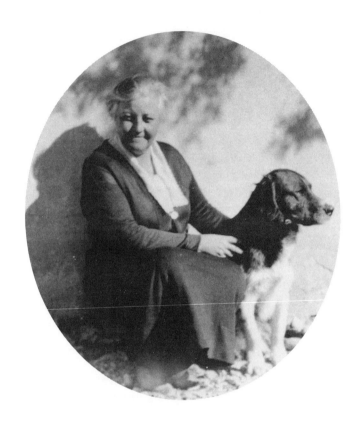

A COWMAN'S WIFE

BY MARY
KIDDER RAK

WITH AN INTRODUCTION BY
SANDRA L. MYRES

TEXAS STATE HISTORICAL ASSOCIATION
AUSTIN

Copyright © 1993 The Texas State Historical Association
Austin, Texas. All rights reserved. Printed in the United States of America.

Library of Congress Cataloging-in-Publication Data

Rak, Mary Kidder, 1879–1958
 A cowman's wife / by Mary Kidder Rak : with an introduction by
Sandra L. Myres.
 p. cm. —(DeGolyer Library cowboy and ranch life series ;
no. 2)
 Originally published: Houghton Mifflin, 1934.
 Includes bibliographical references and index.
 ISBN 0-87611-126-6 : $29.95. —ISBN 0-87611-127-4 (pbk.) : $19.95
 1. Ranch life—Arizona—Douglas Region. 2. Old Camp Rucker Ranch
(Ariz.) 3. Rak, Mary Kidder, 1879–1958. 4. Ranchers' wives—Arizona—
Biography. I. Title. II. Series.
SF197.4.R35 1993
636.2'13'0922—dc20 93-7187
 CIP

10 9 8 7 6 5 4 3 2 1

Published by the Texas State Historical Association in cooperation with the
Center for Studies in Texas History at the University of Texas at Austin

The paper used in this book meets the minimum requirements of the American
National Standard for Permanence of Paper for Printed Library Materials,
Z39.48—1984.

Number Two in the DeGolyer Library Cowboy and Ranch Life Series

Series Editor, David Farmer

Frontispiece: Mary Kidder Rak and dog. Photograph courtesy Cochise County
Historical and Archaeological Society, Douglas, Arizona. Accession #86.19.3A.

The DeGolyer Library
Cowboy and Ranch Life Series

SERIES EDITOR, DAVID FARMER

History of the Cattlemen of Texas
With a new introduction by Harwood P. Hinton

A Cowman's Wife
By Mary Kidder Rak
With a new introduction by Sandra L. Myres

INTRODUCTION

SANDRA L. MYRES

"WHY," Teresa Jordan asked in the epilogue to her *Cowgirls: Women of the American West* (1982), "in an America fascinated by the cowboy and his Wild West, have these vital women [the cowgirls] remained invisible? . . . The first and most obvious answer," she suggested, "is that historically their numbers have been few." But more important was the presence among women, especially cowgirls, of "at least some inbred sense of social propriety." In fact, Jordan concluded, "it may be this sense of social propriety that accounts, at least in part, for the cowgirls' invisibility. [They] wanted as little attention paid them as possible."[1]

Jordan went on to point out that the picture of the Old West as a fine place for men only served to keep Western women, especially ranch women, in their "proper" place. "From the first," she wrote, "the West was viewed as a particularly male domain. . . . The women came later as an afterthought . . . and no one paid them much mind. . . . When notice was made of a woman in an extraordinary role—such as the cattle business—no niche existed in which to catalog the information. It just floated in the netherlands of public

The author wishes to thank Dr. Bruce Dinges of *Arizona and the West* for assistance in researching the Rak materials at the Arizona Historical Society and the University of Arizona.
 [1] Teresa Jordan, *Cowgirls: Women of the American West* (Garden City, N.Y.: Anchor Books, 1982), 276.

consciousness, awaiting the time when scholars would grasp at the fragments and try to reconstruct the whole."[2]

There is a good deal of historical evidence, as well as folk wisdom, to support Jordan's contentions. Indeed, there was an old saying in the West that the country was fine for men and cattle but hell on women and horses,[3] and generations of Americans were taught, and believed, that women played an insignificant and largely invisible role in the great drama of Western expansion. If, occasionally, a woman did operate her own business, amass great wealth, find gold, run for public office, drive cattle, rob stages, or lead lynch mobs, she was not a woman "in the true sense of the word," but an exception, an aberration, a masculine rather than a feminine participant.[4]

Fortunately, we now know that women not only went West but played a significant role in Western development. Recent interest in women's history has focused attention on Western women, and one especially fertile field of investigation has been the lives of women in the cattle country. Moreover, contrary to the previous opinion that Western women left little in the way of written records and other primary source materials, we have discovered that a virtual

[2] Ibid., 279–280.

[3] There are several versions of this familiar Western aphorism. Another well-known one holds that "The cow business is a damn fine business for men and mules, but it's hell on horses and women." Alice Marriott, *Hell on Horses and Women* (Norman: University of Oklahoma Press, 1953), quoted in Dorothy Sloan, *Women in the Cattle Country* (Austin: Dorothy Sloan Books, 1986), item 385.

[4] Sandra L. Myres, "Westering Women—Myth and Reality," MS (n.d.), published in part in "Women and the North American Wilderness, Myth and Reality," *World Conference on Records, Proceedings,* III, *North American Family and Local History* (Salt Lake City: World Records Conference, 1980), paper 319. Also see Sandra L. Myres, *Westering Women and the Frontier Experience, 1800–1915* (Albuquerque: University of New Mexico Press, 1982), 1–11.

gold mine of such materials has survived, supplemented by a multitude of printed sources, both fiction and nonfiction. Dorothy Sloan's recent catalog, *Women in the Cattle Country* (1986), includes 712 entries relating to the topic, and since 1970 a number of accounts of women's ranch life have appeared, including three excellent compilations and interpretive studies: Joyce Gibson Roach's *The Cowgirls* (1977); Stan Steiner's *The Ranchers: A Book of Generations* (1980), which includes a number of women; and Jordan's *Cowgirls*. From these studies we have learned that women adapted quite as well as men to the exigencies of weather and environment which characterized much of the West, and that ranchwomen—the wives, widows, daughters, and sisters of men who owned and/or worked with cattle—played an integral role in the development of the Western livestock industry. Thus it is now possible not only to "grasp at fragments" but at least partially to "reconstruct the whole" and draw some generalizations about different kinds of ranchwomen and their place in ranching history.

Among the most interesting ranchwomen were those who owned their own spreads and knew as much, and sometimes more, than did the menfolks about the cattle business. Independent, self-reliant, and, according to some, high-handed, they refused to conform to Victorian ideals of "women's sphere" and competed successfully in what was generally considered an exclusively male enterprise. Typical of these women were Lizzie Johnson of Texas and Ellen Callahan of Arizona.

In many ways, Johnson was a woman ahead of her time. Conventionally raised in an academic family, she taught French, arithmetic, music, and spelling in her father's school, Johnson's Institute, near Austin. She also wrote for *Frank Leslie's Magazine* (under a nom de plume) and added to her income by keeping books for St. Louis cattlemen. These ventures enabled her to learn a good

deal about business, especially the cattle business, and she began to invest in cattle, registering her own brand in Travis County in 1871. Although she continued to teach and write, she was a shrewd cattle dealer, and her herds prospered.[5]

After Lizzie married Hezekiah Williams, she continued to operate her own cattle business and "made Hezekiah sign an agreement saying that after their marriage all her property would remain hers and that all future profits made by her would be hers alone." She retained her own brand, took her own herds up the trail, and arranged her own sales at market. According to her biographer, Hezekiah was "such a poor manager that Lizzie often had to get him out of a bad deal with her own money," and according to one story she occasionally instructed her foreman to "steal all of Hezekiah's unbranded cattle and mark them with her brand."[6]

Ellen Callahan of Sierra Valley, Arizona, was another capable rancher in her own right. She inherited two ranches from her brother and took over their active management, learning to break horses, harness teams, and run ranch equipment. A strong, independent woman, Callahan was suspicious of bankers, whom she considered little better than swindlers; she took her money from the bank in barley sacks, and would not take checks or gold notes. Nonetheless, her operations prospered. According to an 1887 newspaper account, her property was valued at $10,000, and she was a competent marketer and businesswoman who had "recently

[5] According to a newspaper account, "At one time she bought $2,500 worth of stock in Evans, Snider, Bewell Cattle Company of Chicago; this paid her 100 percent dividends for three years straight, and she sold it at the crucial time for $20,000." Austin *American Statesman,* Apr. 25, 1926, quoted in Joyce Gibson Roach, *The Cowgirls* (Houston: Cordovan, 1977), 9.

[6] Johnson's career is traced in some detail in Emily Jones Shelton, "Lizzie E. Johnson: A Cattle Queen of Texas," *Southwestern Historical Quarterly,* L (Jan., 1947), 349–366, and summarized in Roach, *The Cowgirls,* 8–12.

received the highest price paid for beef" in the area around Prescott.[7]

Other women ranchers went a few steps further and added equestrian skills, accuracy with firearms, and even rustling to their ranching activities. Among the more infamous of the "lady gun-fighters" was Mrs. Frank Adams of Texas, who, according to legend, rode, drank, and shot expertly and was thought to have "plugged a man in the back."[8]

Even better known was another Texas ranchwoman, Sally Skull (or Scull), celebrated throughout the South Texas border country as a "rancher, horse trader, champion 'Cusser,'" and expert with rifle, pistols, and whip. Three times married and three times divorced, Skull managed her own ranch, frequently "took-out" after bandits and rustlers who preyed on herds along the Mexico-Texas border, and carried on a considerable part of her horse-trading business in saloons and gambling houses and at ranches of questionable reputation south of the border.[9]

Equally notorious in her own way, Ann Bassett Willis, better known as "Queen Ann," was brought up on a ranch in Brown's Hole, Colorado, and educated at a Catholic convent in Salt Lake City, where she learned to "play the part of a gentlewoman" without losing her ranch-bred independence. From the time she was eight years old, Bassett engaged in various questionable activities

[7] Roach, *The Cowgirls,* 37–38. Other independent ranchwomen are discussed in Jordan, *Cowgirls;* Stan Steiner, *The Ranchers: A Book of Generations* (New York: Alfred A. Knopf, 1980); Myres, *Westering Women,* 259–261; and Dee Brown, *The Gentle Tamers: Women of the Old Wild West* (1958; reprint, Lincoln: University of Nebraska Press, 1981), 254–255.

[8] Roach, *The Cowgirls,* 41–42.

[9] Ibid., 47–52. Also see Joyce Roach, "Horse Trader," in Western Writers of America, *The Women Who Made the West* (New York: Doubleday, 1980), 178–

involving other people's cattle. In 1911, she was charged with stealing and butchering a heifer belonging to Ora Haley, a local cattle baron and owner of the Two Bar Ranch. Ann and her attorney counterattacked by accusing Haley of lying about the size of his herds to the county tax assessor. The court dismissed the charges against Ann, but as one of her friends later concluded, "That Ann Bassett was guilty as sin was beside the point. In her writings, Ann says, 'I did everything they ever accused me of, and a whole lot more.'" Bassett later married Frank Willis and moved to Arizona, where they ranched for a number of years. In Arizona, Ann also studied forestry and tried to get a job as a forest ranger—one of the few endeavors in which she failed.[10]

Other ranchwomen were far more conservative than these independent ladies. Although the more traditional women occasionally offered a helping hand and assisted their husbands with ranch work when necessary, they intended to maintain woman's "proper place" as much as possible, preferred the kitchen to the corral, and "sacrificed themselves to competitive housewifery."[11] Typical of these ranchwomen were Sophie Poe, the wife of the famous New Mexico lawman and rancher John Williams Poe, and Nannie Alderson, whose reminiscences of ranch life have become one of the most popular books on women's lives in the West. Poe, Alderson, and a number of ranch wives spent most of their time at

185, and the entry by Dan Kilgore in the forthcoming *Handbook of Texas* (Austin: Texas State Historical Association).

[10] Roach, *The Cowgirls*, 56–61; Esther Campbell, "'Queen Ann' Bassett Willis," MS (n.d.), in Denver Public Library. Also see Ann Bassett Willis, "'Queen Ann' of Brown's Park," *Colorado Magazine*, XXIX (Apr., 1952, July, 1952), XXX (Jan., 1953).

[11] Philip Ashton Rollins, *The Cowboy: His Characteristics, His Equipment, and His Part in the Development of the West* (New York: C. Scribner's Sons, 1922), 35, quoted in Roach, *The Cowgirls*, 17.

the home headquarters cooking, cleaning, caring for their children, tending small gardens, and attempting to introduce a little civilization into the Wild West.[12] Even when they were forced to take over ranching operations, they found the task difficult at best and, like Alderson, declared they had not "a speck of business ability, and . . couldn't get ahead with any of it."[13]

Other ranchwomen were ambivalent about their roles, caught, as Jordan suggested, between their real lives and the "pervasive concept of feminine perfection . . . the Prairie Madonna, the Perfect Lady, or the Total Woman, depending on the era. . . ." Agnes Morley Cleaveland was typical of this group. Although she grew up on a New Mexico ranch and loved riding, range work, and the independence of Western ranch life, she "constantly felt torn between the rugged outdoor life . . . and the more gentle life of a lady she 'should' like," a conflict clearly reflected in the title of her reminiscences, *No Life for a Lady*.[14]

The majority of ranchwomen, however, were not as independent as Johnson and Bassett, as conservative as Poe and Alderson, or as ambivalent as Cleaveland. This group enjoyed ranch work and knew something of the ranching business; they worked alongside their husbands and took an active part in ranching operations. Although competent housewives who took some pride in their domestic endeavors, a number of them preferred rangework to housework and were known as "good cowhands." "I love to work with cattle," one told an interviewer, "and have spent a good deal

[12] Sophie A. Poe, *Buckboard Days* (1936; reprint, Albuquerque: University of New Mexico Press, 1981); Nannie T. Alderson and Helena Huntington Smith, *A Bride Goes West* (1942; reprint, Lincoln: University of Nebraska Press, 1969). Also see Myres, *Westering Women,* 259–260.

[13] Alderson and Smith, *A Bride Goes West,* 266.

[14] Jordan, *Cowgirls,* 276, 278. Also see Agnes Morley Cleaveland, *No Life for a Lady* (1941; reprint, Lincoln: University of Nebraska Press, 1977).

of my time on the range in Southern Arizona."[15] Mary Kidder Rak belonged to this category of ranchwoman.

In some ways it is difficult to imagine a less likely "Cowman's Wife" than Mary Rak. Iowa-born but educated in California, with a B.A. degree from Stanford, Rak had been a public school teacher, social worker, and university lecturer before she took up ranch life at age forty.[16] Yet in some ways Rak's background was similar to that of a number of other ranchwomen. Of the twenty-five ranchwomen's autobiographies, memoirs, diaries, and oral histories included in Jordan's selected bibliography, twenty were by women who, like Rak, had been raised in towns or cities. All of the women had some education, including two other Stanford graduates, Jo Jeffers and Agnes Morley Cleaveland; and at least six, including Rak, had taught school at one time. Moreover, a few, like Margaret Duncan Brown, also began their ranch life after age thirty.[17]

<hr/>

[15] Myres, *Westering Women,* 260.

[16] Mary Kidder was born in Boone, Iowa, on August 14, 1879, the daughter of Ichabod Norton and Eliza Allen (Luce) Kidder. She attended Troop Polytechnic Institute in Pasadena, California, from 1893 to 1896 and received a bachelor's degree from Stanford University in 1901. For the next decade and a half she worked in San Francisco, first as a public school teacher (1902–1905) and then as a social worker (1905–1917), eventually becoming superintendent of Associated Charities. *Who Was Who in America* (9 vols.: Chicago: Marquis, 1896–), III, 708; Phoenix *Gazette,* Sept. 14, 1964, and unidentified clipping, datelined "Douglas, Ariz., Sept. 12," both in "Clippings Book," Arizona Historical Society, Tucson (cited hereafter as AHS). Also see Mary (Kidder) Rak Papers, Special Collections, University of Arizona Library, Tucson (cited hereafter as Rak Papers).

[17] Jordan, *Cowgirls,* 285–290. For other interesting comparisons and contrasts see the chapter entitled "Cowmen in Skirts" in C. L. Sonnichsen, *Cowboys and Cattle Kings: Life on the Range Today* (Norman: University of Oklahoma Press, 1950), 68–86.

Mary Rak's career as a ranchwoman, and eventually an author, began in March 1917, when she married Charles Lukeman Rak, a former Texas and New Mexico cowpuncher who was studying forestry at the University of California. Shortly after their marriage, the Raks moved to Tucson, where Charles worked for the state forest service and Mary lectured at the University of Arizona. In 1919, they purchased Old Camp Rucker Ranch, a 22,000-acre spread some fifty miles north of Douglas, which Mary describes as "the ranch nearest the high peaks of the Chiricahuas."[18]

When she first went to the ranch, Mary knew nothing about the cattle business. "I had absolutely no knowledge of cattle," she admitted. "Moreover, I was terrified when the mildest cow even looked my way. . . . Like Little Joe the Wrangler, 'I didn't know straight up about a cow,' and no one seemed to want to tell me anything." But Rak was not easily daunted. She watched and asked questions, and "Little by little I learned about a cow, and now I fear I have, along with that knowledge, a little of the supercilious attitude of the small boy who 'always know'd.'"[19] Indeed, Rak not only "learned about a cow," she became a capable cowhand, although she confessed that "After a day of riding up and down our rocky mountainsides and through oak thickets after cattle, I am convinced that the cattle are really working us."[20]

The ability to work cattle, however, was only a part of a successful ranching operation, and Rak went on to recount her struggle to learn the cattle business and cope with the numerous

[18] "Clippings Book," AHS; Mary Kidder Rak, *A Cowman's Wife* (Boston: Houghton Mifflin, 1934), 3.
[19] Rak, *A Cowman's Wife,* 18–19.
[20] Ibid., 20.

problems of life on an isolated ranch. In *A Cowman's Wife,* she detailed the seasonal round of ranch chores; the devastating effects of drought; the difficulty of finding, and keeping, competent hired hands; and the exigencies of marketing the cattle, especially during the depression years. With verve and humor she described their "pets and pests"; treating pink-eye and other "cow ailments"; problems with horse thieves; battles against elusive and destructive wolves; the hazards of the road from the ranch to the Douglas highway; and troublesome visitors, including drifters, "chuck-line riders," and deer hunters.

In addition to ranchwork, there was also housework, and housekeeping on a mountain ranch was impossible at worst and difficult at best. With no electricity or modern conveniences, Rak struggled to maintain some semblance of order in her home. She describes her adventures with "frontier" housekeeping and depicts the frustrations of learning "all the shifts by which one can make something out of nothing," such as "pore folkses' whitewash," a blend of buttermilk (which had to be churned) and wood ashes (which had to be shoveled), or making "legs for my bed" from wooden boxes "into each of which two five-gallon coal-oil cans had once fitted."[21]

Wood had to be cut, butter churned, bread made, clothes washed and ironed; and these tasks became more difficult when the Raks' original large adobe home at Old Fort Rucker was destroyed by fire and they began "living—it is more like camping—in the little five room cottage . . . a house so small that Charlie says, 'You can't curse the cat without getting fur in your mouth.'" "I dare not let myself think of our lost possessions nor of our big house," Mary wrote, but through it all she managed to retain her sense of humor.[22] She recalled her chagrin when one day after washing the

[21] Ibid., 104–105.
[22] Ibid., 2.

breakfast dishes, "punching down the light bread," and building a fire in her wood-burning stove she "sat down to churn while the white clothes were soaking in a tub in the yard." She continued:

> As time for reading is a luxury we seldom enjoy, I propped a newspaper in front of me so that I might be enlightened as I churned. . . . This is what I read. . . .
> "The days of bread-making, churning, and standing over the washboard are long past." The churn dasher thumped an echo to my sentiments. "Oh yeah? Oh yeah?"[23]

Fortunately, these onerous chores were frequently interrupted by Charlie's call to "leave your dishes and give me a hand," and Mary understandably came to prefer working cattle to housekeeping.

As she learned more about ranch operations, Mary took a larger role in the management of the ranch. Although she maintained appearances and conformed, at least in public, to the Western tradition that "In this country women are expected to keep very much in the background during business conferences," she was familiar with ranch operations and often ran the place alone when Charlie was gone. On such occasions she usually tried to do without hired help, since "I much preferred feeding a few cattle and horses to filling up a hungry man," and "secretly considered myself amply able to cope with any situation that might arise."[24]

In addition to documenting the perils and problems of ranch life, Rak also recounted its many pleasures: spectacular sunsets, glorious mountain scenery, refreshing cloudbursts after weeks of drought, the excitement of a shopping trip in town, the camaraderie of ranch people, a civic club barbecue, or an all-night dance at the

[23] Ibid., 201–202.
[24] Ibid., 61–63.

neighborhood schoolhouse. Clearly she loved the ranch and ranch life, and she became a successful ranch wife, partner, and rancher with her own brand (the CR) and a small ranch (Hell's Hip Pocket), which she owned in her own name but operated jointly with Charlie.[25]

Fortunately for us, Mary Rak did not spend all of her time riding the range or giving her house an occasional "lick and a promise." Despite her complaint that reading was a luxury "we seldom enjoy," she found time not only for reading but other literary pursuits. In 1921 the University of Arizona published her *Social Survey of Arizona.* In 1934 Houghton Mifflin published *A Cowman's Wife,* followed two years later by a sequel, *Mountain Cattle.* Rak then decided that she had "exhausted her ranch material 'for the moment,'"[26] and turned her attention to other topics. *Border Patrol* appeared in 1938, followed in 1941 by *They Guard the Gates: The Way of Life on the American Borders.* Her books were well received and favorably reviewed, although she had less success with the later ones.[27] She also found time to contribute to magazines and journals and wrote several other book-length pieces which were evidently never published, including "Roving Cowboy," "Mystery of Pecos High Bridge," and "At the Cross Roads of Life."[28]

Rak's literary career brought her into contact with a number of Western historians and writers, and she carried on lively correspondences with Walter Prescott Webb; Eugene Cunningham; Dane

[25] "Clippings Book," AHS; *Who Was Who in America,* III, 708.

[26] Quoted in Sonnichsen, *Cowboys and Cattle Kings,* 286.

[27] Rak became angry with Houghton Mifflin after the publication of *Border Patrol* and accused them of doing nothing for the book "except print it and put a cover on it." Mary Rak to Gertrude Hills, July 6, 1939, in Rak Papers. *They Guard the Gates* was published by Row Peterson of Evanston, Illinois.

[28] In Rak Papers.

Coolidge, who encouraged her writing and first introduced her to Harrison Leussler, her editor at Houghton Mifflin; and Agnes Morley Cleaveland, whom she described as "an old friend."[29] Another close literary friend and admirer, C. L. Sonnichsen, was also a frequent correspondent and visitor to the ranch. He described her as "vital and vigorous," a "solidly built woman with white hair and a bearing of great dignity . . . a respecter of order and decency with no compromise in her." She dressed "like a ranch woman," he continued, "in cotton dresses and comfortable shoes," but her house was filled with Navajo rugs, dogs, and books, and "the Underwood portable on the card table in her big bedroom gets lots of exercise."[30]

In 1943 the Raks sold Old Camp Rucker Ranch to Mrs. W. S. Dana of New York City and moved to their Hip Pocket Ranch, a few miles west of Douglas.[31] In 1949, Mary Rak suffered a stroke which ended her writing career and forced her to "resign herself to inactivity the remaining years of her life." She died on January 25, 1958, followed a few weeks later by her husband. They left their entire estate to the University of Arizona to establish the Mary Kidder Rak scholarship fund for deserving students in agriculture and home economics, an enduring legacy to the country and the people they loved.[32]

[29] Sonnichsen, *Cowboys and Cattle Kings,* 286; Rak Papers.

[30] Sonnichsen, *Cowboys and Cattle Kings,* 287. For other references to Rak and their friendship, see pp. xvi and 53.

[31] Dana and her partner, Sidney Vails, had been "associated in the operation of a cattle ranch near Elko, Nev., for several years. . . ." Unidentified clipping datelined "Douglas, April 1 [1943]," "Clippings Book," AHS.

[32] Phoenix *Gazette,* Sept. 14, 1964; *Arizona Daily Star* (Tucson), Mar. 12, 1958; unidentified clipping datelined "Douglas, Ariz., Sept. 12," all in "Clippings Book," AHS; John Burnham, "Better Than Granite or Bronze," *Progressive Agriculture,* XVII (Sept.–Oct., 1965), 22–23. According to Burnham, forty-seven "student-year awards" had been given by 1965, aiding twenty-eight young people.

An even more enduring legacy, however, were Rak's ranch books. When *A Cowman's Wife* appeared, reviews described it as "pungent," " articulate," and characterized by "imagination, wit . . . [and] genuine literary ability."[33] In later years, Western bibliographers and critics praised her contributions to the literature. J. Frank Dobie complimented her "Unglossed, impersonal realism," and Jeff Dykes noted that "Mrs. Rak . . . has made a distinct contribution to the slender list of range books that are faithful to women."[34] The highest praise, however, came from Sonnichsen, who wrote, "Of all the books which attempt to tell about life on a modern cattle ranch these two [*A Cowman's Wife* and *Mountain Cattle*] seem to me to be the truest and best."[35] More successfully than any of the other ranchwoman writers, Mary Rak captured the flavor of her ranch life. Thus the selection of *A Cowman's Wife* for this reprint series.

University of Texas at Arlington
June, 1986

[33] Tucson *Citizen,* Aug. 25, 1934, and other unidentified clippings dated June 27, 1934; Feb. 16, 1936; and Aug. 8, 1936, in "Clippings Book," AHS. For other reviews of *A Cowman's Wife,* see *Book Review Digest,* XXX (1934), 268–269, and the New York *Times,* Aug. 12, 1934.

[34] J. Frank Dobie, *Guide to the Life and Literature of the Southwest* (Dallas: Southern Methodist University Press, 1952), 114; Jeff Dykes, *Western High Spots: Reading and Collecting Guides* (Flagstaff, Ariz.: Northland Press, 1977), 80, both quoted in Sloan, *Women in the Cattle Country,* item 499.

[35] Sonnichsen, *Cowboys and Cattle Kings,* 286.

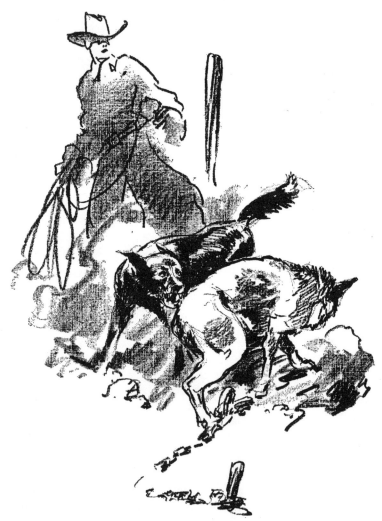

ROBLES AND THE WOLF (*page* 194)

A COWMAN'S WIFE

BY

MARY KIDDER RAK

BOSTON AND NEW YORK

HOUGHTON MIFFLIN COMPANY

The Riverside Press Cambridge

1934

The Riverside Press
CAMBRIDGE · MASSACHUSETTS
PRINTED IN THE U.S.A.

CONTENTS

vi CONTENTS

ILLUSTRATIONS

A COWMAN'S WIFE

CHAPTER I

THE HOME RANCH

TODAY, far up on a sunny mountain-side, we found our horses which have been grazing where they pleased all summer. We brought them home and have selected new mounts to replace those that have been working for weeks past. From the blacksmith's shop comes the clink-clanking of hammer on iron as my husband shoes horse after horse. Occasionally he shouts for me to come and hold some skittish pony while it is being shod. Usually these are young horses that have not yet grown accustomed to having their feet picked up and hammered upon. Eagle, old enough to know better, must always be held. He is a beautiful, white, Mexican pony, a good, all-around cow-horse, who allows no one but his master to ride him. When Charlie is not at home, I have to feed Eagle, and for that reason he is quite willing to stand still while being shod if I am beside him with my arm around his neck.

In this rocky country, when we buy a new horse and want to locate it on our range, we take off its shoes, whereupon it speedily becomes tender-footed and loses all desire to roam afar. An hour ago, Robles, my gay young shepherd dog, dashed out of the door with one of my precious new riding-boots dangling from his mouth and was out of sight in a moment. With all the trees, rocks, and bushes about this house behind which a boot could be hidden, I feared that I should be barefooted and 'located' like any broncho.

When I had given up the search, expecting never to see my boot again, in frolicked the dog and laid it at my feet with a joyous tail-wag.

When I am not holding horses nor cooking dinner, I am trying to make this little cottage look like a home. I dare not let myself think of our lost possessions nor of our big house, so recently destroyed by fire. When I pass its ruins, as I must several times a day, I avert my eyes, lest I lie awake at night or live through the fire again in my dreams. Little by little, we are again providing ourselves with the necessities of life and are appalled to find out how many of them there are. We are living — it is more like camping — in the little five-room cottage which cowboys formerly used. We have a much better house on the ranch, but it is a mile from the barns and corrals and we and the cows must stick together. Our burned home was Old Fort Rucker, built massively of thick adobe bricks during the days when Geronimo and his Chiricahua Apaches lived and fought in these mountains. The fort was once the principal building of a cavalry post and served both as a place of defense and a commissary. In wagons drawn by four horses, supplies were hauled fifty-six miles from Wilcox, the nearest railroad town.

Long before we came here, the fort had been converted into a rambling, up-and-down dwelling. Our women visitors from town used to patter around the vast rooms and down the steep stairs to the dark, basement kitchen, murmuring, 'How perfectly romantic!' One bright side to our present situation is the comparative convenience of the tiny house we now live in — a house so small that Charlie says, 'You can't curse the cat without getting fur in your mouth.' An adobe wall has been built to enclose this old frame house and make it warmer. A shining, new, iron roof of many angles has been cut and contrived to cover the old, sun-dried shakes which would burn like tinder if a spark fell on

them. So much for the outside of the house. The inside is for me to deal with as I find time, paint, and gumption. For the past month we have been cooking out-of-doors on a campfire in the back yard. It wasn't so bad at first, but when white frost covered the grass each morning, ice tinkled in the water bucket and Robles snuggled to the warm rocks of the campfire, we thought of the ancient monster of a range that stood in the kitchen of an unused adobe house on our upper ranch. It was brought down a few days ago and we are gratefully eating breakfast in a warm room.

Yesterday we went to town to buy what we could of a list as long as my arm. It was not a pleasure trip, for this is what going to town in cold weather involves when one lives, as we do, far up in the Chiricahua Mountains, in the southeast corner of Arizona, at the back of Beyond. We get up at four o'clock, cook and eat breakfast and do the indispensable chores of milking and feeding horses and chickens. Kettles of water are heated to warm the cockles of the truck's heart. A hind wheel is jacked up; motor oil is drained and warmed on the back of the stove until the whole house reeks like an engine-room at sea. While I dress in my town-going garments, Charlie pours boiling water into the radiator and warm oil into the crank-case. Then he cranks, cranks, cranks! The motor finally snorts 'Chuff!' just once. More cranking; two 'chuffs,' a few coughs — then it really sings 'Chooka-chooka-chooka!' with welcome clamor. I dash out to sit in the car with my finger on the gas throttle, warming up the motor. Charlie lowers the hind wheel to the ground; then goes inside to warm his half-frozen hands, put on a necktie and his best shoes. We are on our way.

Ours is the ranch nearest the high peaks of the Chiricahuas. To reach it one must follow the windings of a long canyon, cliffs opening fold on fold as the rough road ever ascends. The river, which winds with the road and must often

be forded, is a torrent, a brawling stream, a trickle or a dry waste of boulders, according to the time of year, the rainfall, or the melting of snows on the pineclad peaks which are its source. As one climbs up the canyon road, the gorge grows ever narrower, the road and river sharing the small space between abruptly rising mountains. Suddenly, as one emerges from a narrow, shadowy pass, the sun pours down upon the far reaches of a gigantic basin, enclosed by a ring of lofty peaks. Canyon after canyon falls away from these heights, each with a stream that unites with our river and replenishes it. This great, circular basin, with its wooded canyons, sunny ridges and pineclad slopes, contains the twenty-two thousand acres of grazing land which form Old Camp Rucker Ranch. It is one of the oldest ranches in our part of the country, established while hostile Indians still made an occasional raid. The brand on our cattle is

O
C R

called the 'O C R's' for Old Camp Rucker — only we now say that it stands for 'Old Charlie Rak.'

There is but one way for a vehicle to leave Rucker Basin; that is, by the road that follows the river, flowing westward toward Sulphur Spring Valley. It is a cold ride down the canyon on a frosty, fall morning. Oak trees and junipers overhang the road; white frost lies on the grass; mud is frozen in stiff, bumpy ridges. We see few cattle after entering the narrow pass. They are all on the high slopes, grazing and awaiting the sun. Five times we ford the river, swollen by a recent rain — bump, bump, splash — before the canyon spreads out into low, rolling foothills. We must open thirteen gates before reaching the highway. No two gates are alike. Some are of heavy lumber, sagging from loose posts, creaking open reluctantly when tugged and dragged. More are of wire — 'Texas gates' — either too tight or too

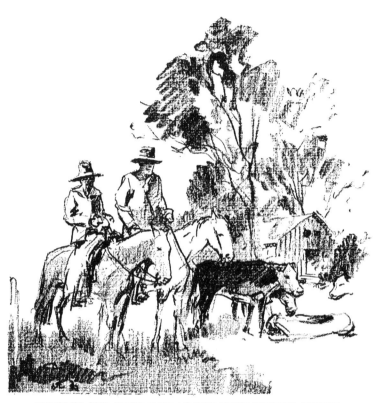

CHARLES AND MARY RAK AT OLD CAMP RUCKER RANCH

loose, fastened with wire contraptions that tear gloves and temper. There is one man living in the canyon against whom I bear a grudge. He barbarously makes his Texas gates of barbed wire, and once, when I was wearing my treasured and only pair of silk stockings, I snagged them while opening his old gate and cried all the rest of the way home.

As the canyon widens, to right and left we see among the trees, smoke ascending from ranch chimneys. Starkly perched on a barren hillside, windows broken, awry from the winds, is the abandoned shack of a homesteader who has sold out to the nearest cattleman and moved away. This unpainted, board-and-batten hovel, with rusty iron roof and mud floor, was once the home of a woman who disapproved of us.

'Those Raks are high-toned, stuck-up folks,' she complained, 'and I, for one, ain't goin' to have a thing to do with 'em.'

Where the canyon walls sink to the level of foothills, we leave the woods behind us, except for the tall sycamores, now bare of leaf, that fringe the river-bank. Apache-plume brush waves on each side of the road. In a field, milo-maize has been stacked and corn shocks await the farm wagon. We stop at the 'House-Top X' Ranch for a moment to talk to the Frank Moores, who urge us to come in and eat a second breakfast. We dare not do that, for every hour of daylight will be needed for our journey. From there on the road winds snakelike among mesquite bushes; then down Whitehead Lane, between the two landmark hills, Round Top and Square Top. We turn to the left where our river spreads out over Whitehead Fan and loses itself in Sulphur Spring Valley. We dread crossing this slippery, adobe slope and are never sure that we shall really get to town until we are safely over it. At best, when there are no punctures nor mudholes to take the joy out of travel, we

need five hours each way when we drive in the truck the fifty-six miles between the ranch and Douglas.

The Whitehead Fan once safely behind us, we ramble along somewhat faster than before over the well-traveled, dirt road, past the houses of cattlemen, of Mormon truck-gardeners, past the Mormon church, the schoolhouse, a store. The storekeeper may be eyeing us from his window as we hurry by. He once told Charlie that we need not go all the way to Douglas while he had a store so handy, and he was quite incensed when Charlie told him that we had needs which could not be satisfied in his emporium.

Nearer we approach the huge smelters, the smoke of which we have seen afar. We dodge the dogs and Mexican children which fill the narrow lanes of Pirtleville, cross the railroad tracks and chug up the main street of Douglas.

We are in TOWN.

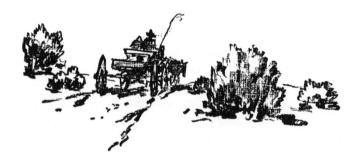

CHAPTER II

WE ARE IN TOWN

THE sheltered spot under the great wooden balcony of the Gadsden Hotel in Douglas has been the rendezvous of the cowmen for many years, and a miniature cattlemen's convention seems to be always in progress there. As soon as a cowman reaches town, he parks his womenfolk in front of their favorite shopping place, tells them that they may take the car wherever they please, and then he lights out for the Gadsden Hotel. If a man comes early to town, he stands by the curb, watching the cars as they come down G Avenue. Sooner or later he is sure to be rewarded by seeing the dusty or muddy automobiles of other cattlemen. There is no need to hail them. They will park their womenfolk also and head for the Gadsden. As the morning wears along, more and more men, wearing big felt hats and leathern jackets, join the group under the balcony, and there, to use their own expression, they 'talk about a cow.'

They are by no means loafing, even though they are leaning against the pillars, smoking and joshing. Most of a cowman's life is passed in comparative isolation; this meeting with his fellows is his chance to learn what is going on. Who has sold cattle and for what price? Are there buyers in the country and for what sort of cattle are they looking? More quickly than by any other means, news is broadcast from there to the local cattle world. One man may have driven in from Apache and knows what cattle have been shipped from the railroad yards there during the past week. One comes from Dos Cabesas, one from Pearce, two from Turkey Creek. Each brings his grist of news and will take

back to his own neighborhood all that he learns. The Gadsden is the central of our grapevine telephone.

We women go from store to store, each with a list to remind us of our errands. Politely we respond to the invariable salutations of the tradespeople.

'How do you do, Mrs. Rak?'

'When did you come in?'

'When are you going out?'

'Have you had any rain out your way?'

Once in a while, in a burst of originality, comes the added query, 'How are the roads?' There seems to be nothing else to say to the shopping ranchwoman.

At noon, hunger drove me to the Gadsden also, well knowing where I should find my husband. While we were lunching there, Charlie told me a piece of news he had just heard from the other men. A rich young woman from the East, who has been staying at a dude-ranch, recently married a good-looking, young dude-wrangler whom she met there. The girl has now bought a cattle ranch and is all set to lead the 'wild, free life' she has read so much about. Before settling down, however, she wants to take her husband East to visit her friends and relations.

'What a shock the poor girl is going to have!' exclaims Charlie.

'You mean when she sees him in her Eastern surroundings?'

'Oh, no! The shock I mean is going to come when they settle down on their cattle ranch and she realizes that her good-looking dude-wrangler doesn't know a damn thing about a cow!'

After lunch, more shopping, and now the boxes, tins, and sacks of supplies and provisions which we brought home last night are heaped everywhere in this cupboardless house. They are thrust under the bed, are stacked into corners.

They must be dumped from chairs before we can sit; they must be cleared from tables before we can eat.

A small, very black, implike Indian, answering to the name of Angel, is now delving into the steep bank back of our house. When he has excavated a space ten feet square, there will be a front of adobe bricks, a cement roof, and we shall then have a storeroom, quite as cool as a cellar and more conveniently reached. The house keeps off the sun from south and west and trees protect the roof from the morning sunshine. I need that storeroom badly. Here's more power to Angel's elbow!

Yesterday, after we had made our purchases and loaded the truck high with every sort of unrelated junk, topping off with a broom and a roll of wire-screening, I was sitting in the truck in front of a store, waiting for Charlie to do some last errand. A man who had been eyeing our outfit, finally came up to me and asked, 'What are you peddling, lady?'

The road was soft and our truck was heavily loaded; we ambled along slowly, our one idea being to get home if we could without grief of some sort. 'Chooka-chooka-chooka' right along, all too deliberately for our weariness, we re-traced our morning's journey. Tired, chilled to the bone, we approached the Moores' ranch, fearing they might have gone to bed. Good! A light still shone from the living-room windows. Inside a fire blazed on the wide hearth. We ab-sorbed heat with every pore, drank cup after cup of scalding tea, then started out again in the cold wind.

Our luck held until four miles from home. We were pass-ing through the little ranch of a woman homesteader when the ruckus started. In order to find a level and suitable place for a field, which she was obliged to plant to comply with the law and secure a title to her claim, this woman had plowed up the old, hard road, and fenced it off, thus forcing us to detour down into a steep, muddy ravine. We had

looked askance at this place in the morning when our truck was empty. Now the loaded truck balked on coming out of this boggy creek-bottom and killed the engine. Charlie let her roll back to get a fresh start and down, down, settled the rear wheels, a little askew, deep in the mud. He jumped out and struck a match to see what sort of a jack-pot we were in.

'I'll have to unload!' he roared, then leaped into the back of the truck and hurled out the first package.

'Crash! Tinkle!'

'Oh! My water glasses!' I cried.

Precious purchases from the five-and-ten were threatened with demolition. Although I had remained in my seat out of respect for my best bib-and-tucker, I now jumped out and ran around to the back where Charlie tenderly handed me a package.

'Horseshoes!'

We both laughed then and felt a little better.

Everything we had bought had to come off the load in order to reach the grain and heavy cases of groceries which were at the bottom. Finally we broke some brush to put in front of the rear wheels; jacked up one of them and put brush beneath it to give traction; let the wheel down again. Charlie cranked her, jumped in and 'gave her the gun.' I put my shoulder, and that of my only coat to the muddy wheel and the truck crawled up the hill.

Then, shades of Jack and Jill! How many dozen times we walked down that same hill, gathered up all we could carry of our load, and toiled up again. The truck's lights go only when she goes; we have no battery. Charlie's supply of matches gave out early in the fray, but we fortunately were able to locate a whole carton of them among our packages. At last we could find nothing more to be toted and were again on our way.

Not a word did we speak. All we could think of were supper and bed. When the truck balked again at the foot of the hill below our house, we drained the radiator and left it there. Cold, weary, and hungry, we walked into our house at last — to be greeted by cheerful voices from our bedroom.

Two men, traveling through the country on horseback, had come to our ranch and found everything unlocked, as it always is. They had eaten the food I had left prepared for our own supper and had gone to bed, in our only bed. They seemed to think it was a great joke.

We were too tired to light a fire and cook a meal. Some sort of cold snack we washed down with cold milk, we dragged two canvas cots into the living-room, threw some quilts and blankets onto them, then, without sheets, pillows, or prayers, so to bed.

CHAPTER III

'RIDING THE CHUCK-LINE'

THE custom of leaving our doors open so that strangers may come in and make themselves at home in our absence is one which dates back to the time when everyone traveled with horses. Distances were long and there were no places to stay except at ranches. A horse could do only so much, and whether you knew the traveler or not, whether you liked him or not, he stayed and was made welcome. Down near the highways things have been much changed by the automobile. Doors are locked now on the rare occasions when someone is not left in charge and we do not ask strangers in automobiles to 'light and stop.' The few who are now traveling on horseback usually have some good reason for doing so and are as welcome as ever.

We are troubled very little by tourists, since we live at the end of a long canyon and not on the road to any other place or ranch. Once in a long while a tourist finds his way up here and amuses us by his patronizing attitude. One had the cheek to look over our magazine table and exclaim, 'What! The *Literary Digest*, out here in these woods! I wouldn't have believed it possible!' They look around all our corrals and barns without asking leave and examine our household gods with the coolness of a visitor in a museum. Above all, they really expect us to be grateful because we have been given the treat of a visit in our isolation.

A couple, touring the United States by automobile, recently outdid any of the others. Charlie came home in our car and said that he was being followed by these people, whom he had invited to lunch. They had hailed him and asked for the Rak Ranch and had said that they were

friends of Otto Schoenberg, the Forest Ranger, who had told them to be sure and stop here to see us. They arrived a few moments later, amiable people enough, though given to asking more questions than we think seemly in these parts. As many of these questions were about the other ranchers in this vicinity, I became a little wary and answered the questions about our neighbors with much caution.

Presently I took my turn and asked after the health of the various members of the Schoenberg family, assuming that they were friends, and the replies given me were vague to a degree. The moment our strange guests departed, I ran to the telephone and called up the Ranger Station. Mr. Schoenberg answered and I was amused to hear that he had no idea who our visitors were. He had met them by the roadside the day previous and they plied him with questions about the ranchers near-by and asked his own name. Small wonder that they were vague as to his children's measles! It is quite possible that they went elsewhere and claimed hospitality on the strength of being 'friends of the Raks.' They looked like people to whom the trifling expense of a lunch was nothing. I believe they merely wanted to boast of having been entertained on cattle ranches.

When we first came to the ranch, we found a couple living in the neighborhood who 'rode the chuck-line' in a really professional manner. They were in the habit of forsaking their own roof-tree frequently and quartering themselves upon their neighbors without invitation, for days at a time. By way of ingratiating themselves, they were given to telling what they had to eat at this place and that. Some hosts, it seemed, proffered pies and cakes; others had only biscuits and syrup for dessert. They commented upon whether the beds assigned to them in various ranch homes were hard or soft. In such endearing little ways they had

succeeded in making themselves thoroughly unwelcome in most households by the time we arrived on the scene and they naturally regarded our ranch as 'green fields and pastures new.'

We had met these people casually and had heard about them a-plenty, so we were not surprised when they rode up on horseback one winter evening, just at supper-time. They explained that they wanted to get an early start on a long ride which they planned to make the next day and therefore had come to spend the night with us. Hastily I added to the supper which was already prepared for two and made it go around for four. We managed to find topics for conversation during the very short evening. I proposed that we go to bed early so that we might be astir betimes. As soon as Charlie and I were alone, I revealed my diabolical plan for making this their last visit as well as their first, while preserving the appearance of the utmost amiability.

At four A.M. the alarm clock went off and Charlie reluctantly arose and descended to the cold, basement kitchen to build a fire in the range. With all speed I dressed and started cooking as soon as the stove was hot. At half-past four I knocked on the door of the bedroom where our 'chuck-line riders' were cozily sleeping and announced cheerfully, 'Time to get up! Breakfast will be ready in half an hour!'

'What? What is that? Breakfast!' I heard them asking in tones of consternation. I had been told that they were not at all fond of early rising and I chuckled all the way back to the kitchen stove.

By the light of a kerosene lamp which feebly illuminated a cold dining-room, we stoked away our ham and eggs in stony silence, although I was secretly consumed with a desire to burst forth in the old song;

'There is no time for mirth or laughter,
On the cold, gray dawn of the morning after.'

On the instant that we finished eating, Charlie jumped up from the table and said, briskly, 'Your horses are fed and ready for you to saddle.'

We went outside and watched them mount as the first, faint streaks of cheerless light struck the frosty ground.

'Good-bye,' I called in dulcet tones. 'You are getting the good, early start that you said you wanted.'

Then I went, shivering, back to my warm bed and napped until sunup.

Years ago there used to be many 'chuck-line' riders; there are a few still. Most of them were cowboys who had spent their wages and had no prospect of work until the spring or fall round-ups began. Each had two horses, one to ride and one to pack his bed and 'thirty-years' gatherin's.' These men rode from ranch to ranch, spending a few days at each stopping-place. Their hosts enjoyed hearing all the news that the traveler had accumulated while on his rounds. Besides these rambling cowboys, there were prospectors, trappers, peace officers, and men who were moving across the country, driving horses or cattle before them.

There is very little of this sort of travel now, most of these people having taken to automobiles before I came to this country, yet we occasionally entertain some rider even now, for the next stopping-place on the south side is the Spear E. Ranch, eleven miles over the mountains.

One night last winter, I was on my way to close the door of the chicken-house after the hens had gone to roost, when I met a man coming through the big gate into the water-lot. He was riding a poor, little, bay pony whose ribs one could count, and was leading a huge burro, whose rusty, reddish hair was worn off in great patches. On the burro's pack-

saddle were hung large canvas kyaks and on top of all was a canvas-covered bed-roll.

The man, a weazened, sun-dried creature, whose age was anywhere from thirty to fifty years, was a cowboy. One could tell that by every move he made as well as by his garb. He asked me if I would show him how to get through our place and onto the trail for Tex Canyon. It had already begun to snow and the poor animals were in no condition to travel eleven miles farther. My visitor had no real intention of going on, but custom demanded that I make the first suggestion that he had better stay. This I promptly did and he said that he would be glad to pass the night here. He was on his way over to the Diamond A's in New Mexico. Charlie was not at home, so I told the man (I never did learn his name) that I would take him to an adobe cabin where there is a stove. He had his bed-roll and cooking outfit. On our way to the cabin, I showed him the wood-pile and told him to help himself, then I waited for him to unsaddle so that I might show him where he could put his horse and burro for the night. He threw his bed and camp outfit on the ground in front of the cabin and said he would rather leave his saddles with the animals. When we reached the place where the burro and horse might graze in a small enclosure, he threw the saddles and blankets on the ground, already sprinkled with snow. He must have had to dig for them under the snow the next morning.

'No wonder you have a mangy, chicken-eating outfit!' I thought, 'if that is the way you take care of things.'

The burro's back was pitifully sore from the rubbing of an ill-fitting pack-saddle on dirty blankets.

'The poor beast!' I commented audibly.

'I'll shore have to do something about that,' he agreed. No doubt he had been saying that every day for some time.

Before leaving the man to his own devices, I asked if he had plenty of provisions.

'I have only a little flour and lard,' he admitted. 'A dog got into my camp yesterday and ate up everything he could and spoiled the rest.'

We went to the storeroom and I dug out enough eggs, coffee, potatoes, bacon, onions, and apples for several meals and the cowboy went off to the cabin to set up housekeeping.

The next morning I went over to the gate which leads to Tex Canyon and found horse and burro tracks in the fresh snow. Our guest was on his way.

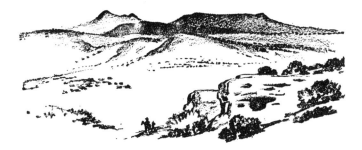

CHAPTER IV

'WORKING CATTLE'

I HAVE been having a lot of fun all by myself today, maintaining a decorous countenance as I listened to Charlie who was answering questions as to the very A B C of the cattle industry. The questions were propounded in all innocence and interest by a guest and his duty as host constrained Charlie to reply to them fully. It did me a lot of good, knowing that like all cattlemen, he believes that people should be born with a knowledge of cows and their ways. I have known him to assert that he was 'born on a horse, looking at a cow.' He is the son of a cattleman, grew up on a ranch, and has no recollection of acquiring the cow lore which I have accumulated so laboriously.

His attitude is that of a little boy up in the Sierra Anchas. The Forest Ranger there was trying to learn to swim and one day, as he struggled to keep himself afloat in a pool in the creek, a very small boy dove in beside him and paddled along like a veteran.

'How did you learn to swim?' asked the Ranger, enviously.

'I didn't learn,' replied the little boy. 'I always know'd.'

When we came to live on this ranch, I had absolutely no knowledge of cattle. Moreover, I was terrified when the mildest cow even looked my way. If I could have acquired the knowledge I needed as quickly as I got over my fear, I need not have asked all the questions that I now hear asked by others. Like Little Joe the Wrangler, I 'didn't know straight up about a cow,' and no one seemed to want to tell me anything.

'Watch — and see for yourself,' was the best I could draw from my husband. I did watch and saw a lot, but that only whetted my curiosity. It was by no means enough to see how things were done; my inquiring mind demanded to know 'Why?' Finally I hit upon a desperate ruse and it worked admirably. I would start for the telephone, saying to Charlie, 'If I can't find out what I want to know about cows from you, I'll ring up Mr. Moore. He'll tell me!'

'I don't want any of the neighbors to know what an ignorant wife I have,' was Charlie's flattering response to that, but he did relent and answer my questions. Little by little I learned about a cow, and now I fear that I have, along with that knowledge, a little of the supercilious attitude of the small boy who 'always know'd.'

I cannot imagine that the clergyman believes that every man should be able to deliver a sermon, or that the hardware merchant expects everyone to know the price of nails. Then why should the cowman judge the rest of humanity upon the basis of a familiarity with the cattle industry? I find that my husband is by no means alone in doing so.

I once had a visitor, a dainty, little town-body she was. 'All right enough, I guess, but pretty much of a lightweight mentally,' was Charlie's opinion of her.

One evening I had to go over to the corral to separate some cows and calves, and she walked over also, staying outside the gate to watch me. I was having some trouble with them, and all at once my guest came in with me and began dashing about among the cattle in a most efficient manner. Charlie came home just in time to see her running around the corral, forgetful of her white kid shoes. We learned then that she had spent much of her childhood on a ranch, and how Charlie's attitude did change! He told me sometime afterward that he believed the husband of my friend owed much of his business success to his having mar-

ried an exceptionally intelligent woman. And all because she could shoo a few cows away from their calves.

The question that is most frequently asked of us is, 'What do you mean when you say you are working cattle?'

It is not a question to which one may reply in a sentence. In fact, the words do not express the truth of the matter at all. After a day of riding up and down our rocky mountain-sides and through oak thickets after cattle, I am convinced that the cattle are really working us. However, this is what we do, following the year around:

In the spring the calves begin to arrive in this more or less hospitable world. Some of the cows and a great many of the heifers may not be in good condition to give birth to the calves nor have sufficient milk for them after they are born. For that reason we begin riding in March to find and bring in the cows which we think should have some extra feeding before the calves come. 'Heavy cows' we call these, and every morning we go out to the pasture and feed-lot to see what calves may have been born in the night. If it is a good spring, with plenty of grass and young browse, we need not keep these cattle at the home ranch very long. If it is a dry spring, we have the poorer cows and heifers with first calves around here for weeks.

As the big, strong cows on the range are 'dropping' their calves, we need to ride and see if the 'dod-gasted' screw-worms are attacking the babies. If they are, we must bring in the calves to be doctored, or rope and doctor them where-ever we find them. Each man who rides here carries a bottle of chloroform or some other medicine to kill the worms. One doctoring may be enough or it may take two or three. Sometimes a cow is lacerated and must be brought in to be doctored in the chute. The chute is a modern contrivance, so built that the cow is forced to enter a narrow place and cannot turn or move after the bars are shoved into place be-

hind her. It is much better than roping and throwing her
— if she only knew it. Some cattle take their medicine pa-
tiently; some bellow and paw the ground and, when the ·
bars are removed, 'come out of thar a-smokin'.' That is
the time to climb a fence.

After the calves are born and on their way to grow up
healthily, it is time to brand them. On the ranches in the
open country where cattle can be gathered easily, the men
help one another on round-ups until all the calves have
been branded, castrated, and ear-marked. On brushy
mountain ranges such as ours, we find our calves a few at a
time, drive them to the nearest corral, brand them, and turn
them out again.

While this work is going on, we may want to find the
steers and perhaps the heifers which were born a year earlier,
the 'yearlings,' and put them all together in a pasture where
they may be kept in readiness to show to cattle buyers. Our
own cattle are more apt to be sold in the fall.

Everything may be going along beautifully, and we are
thinking that the cowboy's life may be what some people
say it is, 'eat, sleep, and ride a pony.' Then we go out to
ride around and admire our fine prospects, and what do we
see? A cow who is weeping, to judge from her sad appear-
ance and the tears which are rolling down her cheeks.

'Hell and damnation! There's a cow with the pink-eye!'

We bring her in, no small job, because she is blind in at
least one eye and maybe both, and she travels every which
way except the one we want her to take. She is put in the
chute and her eyes are filled with a mixture of table salt and
boracic powder. A bell is strapped on her neck and she is
turned out in a small pasture where we can find and doctor
her until she is well.

Now we ride and ride some more, looking for weeping
cows, calves, or bulls which must be similarly doctored.

After a cow has been put in the chute a time or two, she looks upon it with deep suspicion. It takes all hands and the cook to get a bull into the contraption a second time. All of this trouble is caused by a nasty, little, old insect, which can think of nothing better to do than go about biting cattle on the eye and blinding them.

In July, the beginning of the normal rainy season, we have to see to the distribution of the bulls, which may have congregated on favorite parts of the range. We watch for sign of predatory animals; shove the cattle up into the higher parts of the range for their summer grazing; look out for any animal that is scratched and in danger from screw-worms. Lightning kills a cow now and then and her poor, little, 'doggie' calf has to be brought in and farmed out to a foster-mother cow. August passes in the same way.

By September the spring calves are big and sleek. It is high time to vaccinate them against the disease called black-leg, which may otherwise kill the fattest and best among them. There are always a few calves which were missed in the spring branding or were born during the summer. These must be attended to and there is the attendant doctoring if the season remains warm enough for the flies to get in their deadly work. We try to have this done before October brings its own pests in the shape of deer-hunters, who camp by our watering-places and salt-grounds and near our corrals and shoot everywhere and at everything. I would rather swat a hunter than a fly.

If we have not sold our steers in the spring, and we seldom do, we dodge the hunters as best we may during the deer season, gathering the cattle which are to be sold in November or early December. These cattle we place in a reserve pasture and pray that some benighted heathen of a hunter may not leave the gates open. Old cows must be sold, too. Each cow on our ranch wears, branded on her jaw, the nu-

meral that betrays the year of her birth. (How lucky we wo-
men are!) If a cow is ten years old, she is put in the chute
and we look at her teeth — 'Toothing 'em' we call it. No
dentist for her. If her teeth do not look as though they could
provide her with a living for another year, she is marked as
for sale by bobbing the long curl of hair at the end of her tail.
November means many trips to town to see buyers and hear
the news of prices and sales. When the time seems to have
arrived, off go the cattle which are to bring home the bacon
and pay for all our labor.

December and January are the slackest months. One
must still be riding to see how things are and how the feed
in certain parts of the range is holding out. If the grass is
short, the cattle must be shifted about, though we disturb
them as little as possible in the winter when a loss of weight
from handling, 'chowsing,' must be avoided. There are
usually some cattle to be dehorned and these flyless months
offer the only safe chance to do it.

The latter part of January and early February bring a
new job, weaning. Already a few of the largest calves, and
particularly those whose mothers seem thin, have been
'blabbed.' That means that a small piece of hardwood, cut
to fit the nostrils, has been hung in the calf's nose so that it
drops down in front of the mouth when the calf tries to suck.
It does not interfere with grazing nor drinking and the calf
may stay with the mother cow. Now we must do the wean-
ing on a wholesale scale. Cows and calves are brought to the
home ranch and the calves are separated from the cows and
are herded together in our very large feeding corral, which
is built of heavy juniper posts, tall and set closely. The
snakiest calf of the lot cannot hope to escape. The mother
cows are turned loose on the range again and for a few days
they return to bawl for their calves, until they become dis-
couraged and go off about their business.

Inside the corral where the calves are immured are low, table-like feeding troughs, spread with hay and cottonseed cake. A few milk-pen calves, accustomed to eating, and a gentle old cow or two, are put in with the frightened, protesting calves to teach them to eat and tame them down. In the center of the corral is a big manger full of hay, and a trough of water stands ready for youngsters that have never before had a drink except from a running stream. After a day or two, devoted exclusively to running and bawling, the calves are so hungry and thirsty that they discover what the troughs and manger are for. In a few days we can walk among them and they never look up nor miss a bite. The cows grow tired of returning to our gates to bawl for calves which forget to answer and go off to their accustomed part of the range and let us sleep of nights once more.

With the weaning, we are through with our year's work. Then new calves are born and we start in all over again — 'working cattle.'

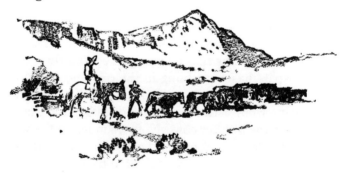

CHAPTER V

THE ORTIZ FAMILY

WE HAVE a real patriarchal Mexican family on the ranch just now. There is an ancient father, a tottering old creature with a face like a dried prune, who carries a staff taller than his bowed and shrunken frame. He climbs about on his insecure old legs, keeping track of the family burros and mules. Mexicans tell us that he was in the California gold rush in '49. Looking at him, one can almost believe it.

His wife, somewhat younger, is squarely built, as an elderly Indian squaw should be, and she rules the household with a will as sturdy as her frame. Mexicans whisper to us that she is a witch and woe betide those who dare cross her. In her kindlier moods she is a physician of wide repute and cures all comers with her roots and herbs which she gathers from the mountain-sides. When a spasm of cleanliness seizes her, she spends whole days down by the river, where she and the older girls wash the family wardrobe and hang the garments on the bushes until the river-bank riots in blue, yellow, and red.

The old couple have many children scattered about in Arizona and three are here with them. Porfirio, their oldest son, is a bachelor; Luis, a young man, is also unmarried and in great demand for playing the guitar for dances; their daughter has so many children that I have not made a complete census. Little faces are thrust from the bushes and shrieks resound when Gringos approach. We cannot see these wild babes-in-the-wood if they see us first. The son-in-law, father of the elusive infants, is a clean, lean, hard-working man who takes work by contract and dragoons

Porfirio and Luis into helping him with the toil of building fences and cutting cordwood.

We have a visitor, a young girl to whom everything about ranch life is new and zestful. By way of entertaining her, I took her to see this family yesterday, under the pretext of wishing to learn to make *tortillas*. It was not altogether a pretext, for I really do want to learn how to make them.

There is a large and dilapidated adobe house on the ranch about a mile from our own home, and we have allowed this big family to live in it. When Grace and I arrived there and presented ourselves at the front door, the children surged out of the back door in mass formation, returning at intervals, only to run away, screaming, if they were noticed. Mother Ortiz, the matriarch, invited us in, gave each a dingy, wooden box, covered with a dingier towel, to serve as seats. After exchanging a few compliments, I asked her if she would show us how to make *tortillas*. She agreed readily and said, '*Poco tiempo*' (In a little while).

She retired to the kitchen together with her daughter, closing the door. We heard a great clatter of pans, the roaring of a newly kindled fire, and lastly, the vigorous swishing of a broom. The last sound amused me, for I remembered that the son-in-law had recently asked Charlie to buy a broom for him and said, 'If the women don't use the broom on the floor, I will use it on the women!'

I wished to see the whole process of making *tortillas* and called out that we wanted to be allowed to come into the kitchen.

'*Poco tiempo! Poco tiempo!*' was all that Mother Ortiz shouted in reply and the door remained closed.

Grace and I waited with what patience we could until at last we were invited into the kitchen. Mother Ortiz and her daughter had stolen a march upon us and had made smooth

balls of dough, all ready to be patted into flat cakes. The old woman took a ball of dough in her hands and between her expert fingers it grew as though by miracle. She spread it on top of the stove with a practiced sweep of her great, brown arm, turned it with a flip of her wrist, and there was a *tortilla*, white and brown, all ready to melt in your mouth.

We wanted to roll our own. I took up a ball of slippery dough and it lumped dismally between my inexperienced hands. Grace gave hers a flop or two and it landed on the floor. José had bought a broom, but the floor had not known a mop in many a year. Mother Ortiz wanted Grace to take a fresh lump of dough.

'What's the use?' demanded Grace. 'It will go on the floor too.' She picked up her dough, squeezed it into a ball again, and we struggled on.

The children, who were peering in at the windows, stopped screaming and laughed at us instead. The two women held their sides with mirth before we had our *tortillas* flat enough to put on the stove. Grace had dropped hers so often that one could hardly tell it from the stove and mine was all lumps and holes. When our *tortillas* were cooked, Grace looked at hers in dismay. I knew that she was wondering if politeness demanded that we eat our own product. Robles was lying in a corner of the kitchen and Grace jumped at my suggestion, 'Try it on the dog.' Robles was called and came to us, all anticipation, gave one sniff at Grace's *tortilla*, then slunk out of the door with his tail between his legs.

Today I hear that Mother Ortiz has decreed that the whole family must move out of our house and the men are now building a hut of bear-grass, down by the river. She says that our old house is full of ghosts. I remember that in the grass hut there will be no floors to sweep. Mother Ortiz may not be a veritable witch — but she is a clever woman.

I have much pleasure in hobnobbing with our Mexican

workers and their families, remembering the days, not so long ago, when I made more signs with my fingers than I formed words with my tongue. To our door recently came an old Mexican who worked for us the first year we lived here. Charlie greeted him first, then I said to him in Spanish, 'Good afternoon. Whence did you come? How are all your family?'

The poor, old fellow jumped nearly out of his tattered boots. He turned to Charlie and in a tone of utter amazement cried, 'The *Señora* talks! When I was here before she couldn't speak! Now she talks!'

To him it was as though one dumb from birth had recovered use of the vocal cords. That I could have learned Spanish in the years that he had been away never entered his mind; he watched my lips as those of one upon whom the gift of tongues had been bestowed by miracle. He was not aware that a member of his own family had given me the impetus to delve into the Spanish dictionary.

When the Rivera family came to work for us and established a camp a mile from our house, there were in the group this old man, fat and greasy; the older son, a husky boy in his twenties; a grown daughter, homely, pockmarked; a little scowling girl; their mother; and lastly a boy of twelve, Carlos.

This lad was too young to be of much use to his father and big brother; being a boy, he did not expect to help the women with their work around the camp. His whole duty seemed to be that of errand boy and purchasing agent and I was the unfortunate one with whom he dealt. Twice a week, at least, he presented himself at my kitchen door, always at the worst possible hour, between eleven and twelve, when preparations for our noontime dinner needed all my attention.

'*Asucar*,' he demanded. I did know the name of the

staple groceries and the boy held up dirty fingers to show how many pounds of sugar he had been told to buy.

Having pushed my cooking pots to the back of the stove, put a stick of wood in the fire-box and peeked into the oven, I prepared to give the boy his sugar. That involved going outside, around the house to a basement door, through two rooms and into the cellar-storeroom, such being the conveniences of living in romantic Old Fort Rucker. When the sugar had been weighed and poured into an empty flour-sack which the boy produced from his pocket, I wrote down the transaction in his book, again in my own book. Then Carlos and I retraced the many steps to the upper regions. No sooner had I regained my kitchen than he said, '*Manteca.*' The wretched boy also wanted lard! Why hadn't he said so while I was still down in the storeroom? It was not at all uncommon for me to make four or five separate trips before he had all the things he had been told to buy.

He was only making his purchases in the traditional Indian way, as he had seen his mother and sisters do. One thing at a time and then wait for the shopkeeper's invariable question to jog their memories.

'*Que mas?*' (What else?)

It was really all my own fault because '*Que mas?*' was not yet in my vocabulary.

One day, when my dinner had burned while I was running up and down, waiting on Carlos, Charlie came in to find me boiling with rage.

'What is the word for "stupid," in Spanish?' I demanded as soon as he entered the door.

'*Tonto.* Why do you want to know?'

'Because I have to tell that Rivera boy what he is, or bust. I am going to learn enough Spanish to cuss him out properly!'

'And that,' as the autobiographers say, 'is how I got my start.'

CHAPTER VI

COWS OF CHARACTER

José, Porfirio, and Luis have been building miles upon miles of fence to divide our wide range into huge pastures so that we may have more control over the movements of the cattle and keep them where we wish according to the season. Besides this, trails sixty feet wide have been cut through the brush, sometimes along the ridges, always through the heavily wooded canyons. These trails make it easier for cattle to go up where feed is good and also make it infinitely simpler for us to get the cattle down again when we want them. It does me such a lot of good to see some old cow rushing off, determined to get away from us, when I know that she will presently bang into a good, tight fence that has been built since she last ran down that particular trail. Now that we need not fight the brush, we can keep up with the cattle and turn them unto the corrals that have been built in strategic spots, one in each of the principal canyons.

Blocks of salt for the cattle to lick are kept in each corral; the gates are left open and the range cattle, coming often to lick salt, are not afraid to enter them. By all these means Charlie has been gentling the mountain cattle and making them easier to handle, since we have bought out a former neighbor and now have the range to ourselves. Wily old steers and particularly 'snaky' cows have been brought in, one by one, and have been sold and driven away, to trouble us no more.

When we first came here, all cows looked alike to me except that some had horns and others, through selective

breeding, were natural muleys. Mr. Hampe, Charlie, and the men who worked for us would talk for hours about the cattle, mentioning this cow and that, evidently being able to describe an animal so closely that another man could tell which one she was. Mr. Hampe finally drew the outline of a cow for me on a piece of paper and showed me how I might distinguish any special characteristics she bore. I felt very proud when I was able to describe a cow that I had seen, saying that she was red, with white spots scattered over her like spilled milk. It turned out that she was an old Durham cow and was actually named Spilled Milk. After I had learned to differentiate the cattle to the point where even the red, white-faced Herefords had individuality, I found that cows were no more alike in intelligence or disposition than are people. From that time on I began to notice those which may be described as cows of character.

On our stable door is an intricate fastening; bars fall, knobs turn and buttons do this and that. An expert safe-cracker might need undisturbed moments to figure it out. I once found an irate visitor struggling with the knobs and gadgets. He had left his saddle in the stable and he wanted to get it, saddle up and go.

'How do you open this confounded door?' he asked, crossly.

'Get our old Jersey cow to open it for you,' I replied. 'She can do it in a jiffy.'

Indeed, Mr. Hampe, our predecessor here, had arranged the whole contrivance in an effort to puzzle her. The Jersey Beauty only cocked her head to one side, jiggled the bars and buttons with her clever horns, and sailed in and out as she pleased. We would not have trusted her alone with a padlock and key.

One day we rode in the two pastures near home, brought all the cattle from them into the corrals, and Charlie then

sat on his horse, looking them over, deciding what had better be done with them. Those with young calves should be kept up and fed a while longer; dry cows might safely be turned out on the range; the steers should be put in the beef pasture.

Charlie rode into the herd on his well-trained 'cutting' horse, Johnny. As well as a green horse and a greener woman could, my horse and I looked out for the gate. Once in a while an animal slipped into the inner corral where she was not wanted. Far too often, a calf or a steer rushed past me and back to the herd. Hard work for both man and horse at the best, and to do it with such a novice as I doubled Charlie's work and that of his horse. We had the cattle separated finally. Those which were to be turned out were escorted to the gate which led to the range. They could hardly believe their eyes or their luck when they saw the way open. Each cow approached the gate warily, then dashed out on the queer, crouching run that cowboys mean when they say, 'She came out of there a-stoopin'.'

Charlie looked up at the sky and decided that there remained enough hours of daylight to enable us to take the steers up to the beef pasture. Our horses were resting under the shade of the cottonwood trees and we walked over to get them, thus turning our backs momentarily upon the gate. We heard a creaking sound and wheeled about — too late. Old Jersey Beauty, feeling aggrieved at having been penned up all the afternoon with the common herd, had slyly unhooked with her horn the gate separating the two corrals. Steers, cows, and calves rushed from one corral to the other and in a moment were thoroughly shuffled together.

'That ends it! That's the last straw!' yelled Charlie. 'I've stood all I'm going to from that old Jersey. Come on, put her in the chute!'

Before Beauty fairly knew what was up, I hastened her

into the chute; Charlie thrust a bar behind her, dropped one over her neck. Out came the sharp dehorners and off came her horns. She had just emerged from the chute, shaking her head, trying to figure out what had happened, when Mr. Hampe appeared in the corral. He looked at the cow that he had raised from a tiny calf and said, shaking his own head, 'Oh, Beauty! Beauty! After all I put up with from you, look at yourself now!'

We rode into the beef pasture one morning last spring to see how the cattle were faring which we had put in there the day before and found them scattered about over the ridges, enjoying the fresh feed. Suddenly Charlie spied a motionless heap of red in a little ravine.

'I believe there's a dead cow,' he said, and rode down for a nearer view.

When he came back up the hill where I had waited for him, I expected to hear him mournfully extol the virtues of the poor beast and tell how much she and her calf might have brought in the fall. Instead of that, he seemed rather pleased than otherwise as he reported, 'It's Old Hippity-Hop, and there's a hell-cat that I'll shed no tears over.'

Hippity-Hop was a big, ill-tempered cow, crippled somehow in a way that did not affect her speed, for she could run like a deer. It did make her gallop along in a way that gave her the name. She had no need of correspondence courses in the development of personality. She had personality plus, and all of it bad. She was as vicious with her own kind as with humans and had long been dehorned for the protection of her sister cows.

Our first experience with her was in the early spring when we brought her in with some thin cattle to be fed for a while. They had all been fed before and came in so willingly that we turned them out in a small pasture during the day; most of them turning up at feeding time of their own accord.

Those cows which failed to come in were often fetched by someone on foot, if no horse was saddled and ready. One afternoon Charlie limped home, disheveled, muddy, mad through and through.

'That old Hippity-Hop cow chased me,' he explained. 'There wasn't a tree handy, so I stepped into some brush. She crashed in after me, knocked me down, and then tramped on me!'

Following that, he had crawled along through the brush, she snuffing at him as he went, until he found a sizable tree to get behind. After that day we always kept a good weather eye on her when in the corrals or near her on foot.

A time arrived when we felt that there was sufficient green grass in our reserve beef pasture to warrant our taking the cows up there and letting them rustle their own feed. We drove the small bunch of gentle cattle about a mile up the canyon to the gate of the beef pasture. A wing of fence has been built there, so the cattle may be forced to enter a corner where the gate is strategically placed. Everything had gone smoothly; not a cow switched her tail nor batted an eye. Charlie went around the cattle, opened the gate, then came back and we whistled a little to start the lead cattle through. In went the leaders and the rest of the bunch after them — all but old Hippity-Hop. Not she!

She wheeled about, face downhill, and ran for all she was worth, back the way we had come. We abandoned the gentle bunch, already through the gate, and took out after the outlaw. Charlie headed her in a thicket of oak; again in a clump of juniper; then back and forth they dodged on the open flat. My own pony is not good at that game and gave it up early. We stood out of the way on the sidelines and watched Charlie, riding Eagle, as they maneuvered around that old cow. Finally Hippity-Hop felt that she had had all she wanted of it and she did something that I have

never seen before and never want to see again. She deliber-
ately charged the man and horse, and only for the mercy
of her having been dehorned, she might have disemboweled
the horse and killed the man. She did her best, again and
again, but horse and man stood their ground. Then
Charlie shook out his rope, made a loop and swung it at her,
driving her before it, until he had her, panting and sweating,
through the gate which she had refused to enter.

By that time the sun had gone down and the chill of night
in the high mountains came abruptly into the air. The out-
law cow was burning with rage and overheated from run-
ning and fighting when we left her in the beef pasture. I
have heard of 'the tune the old cow died to.' Here it is:

> 'The shades of night were falling fast,
> Upidee, she up and died.'

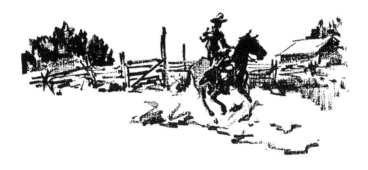

CHAPTER VII

THE LOST DEER HUNTER

THE man who drives the school bus scowls at me when we pass on the road. He considers me a meddlesome busybody who has added twelve rough miles to his route, lengthened his day and shortened the life of his tires, merely for the sake of toting two little Indian girls to school. He has written to the County School Superintendent, telling her that our road is 'impassable.' She has written the same to me. When Charlie asked me what I would say in my reply, I grinned and said there would be no reply. Why should I involve myself in a ''Tis-so — 'tain't-so' argument? The bus driver has already hauled the children to school for ten days and is still hauling them. He will have a grand chance now of proving that our road is impassable. All he can do is to drive our little Indians to school — and scowl.

The children, small granddaughters of Mother Ortiz, speak no word of English and the teacher no word of Spanish. Everyone in the neighborhood considers us slightly mad to insist upon their going to school. We do not explain to the world our reason, which has gained their families' consent. When Charlie and I approach their camp, the children all run away, screaming in genuine terror. We suspect that we have been used as bogeys to frighten them into good behavior. 'The Gringo man will catch you if you don't watch out!' José admits that his children are 'bronco,' and we are sending them to school for precisely the same reason that we place one or two wild, snaky cows in pasture with a tame bunch — to 'gentle' them.

Refusing my offer to clothe them, Grandmother Ortiz has made for Maria and Soura new dresses, cut on the tradi-

tional Indian pattern, a yoke and full, gathered skirt; the Mother Hubbard garment which nuns are said to have inflicted upon aboriginal womenfolk when they were first persuaded to don clothing.

Poor little creatures! I have no doubt that Maria and Soura felt that they were being cast to the wolves when I drove them down to the schoolhouse in our own car the first day and left them there, too terrified to stir from their seats. Ora Schoenberg, the Ranger's little girl, was their guiding star. She has lived in New Mexico and there picked up a few words of Spanish. She has taken our little girls under her wing; 'those Mexy-*kins*' she calls them. Under her direction the babes-from-the-wood stand up, sit down, go out for recess, and eat their lunch. Ora says they are getting a little tamer, but when the girls play drop-the-handkerchief, 'those little Mexy-*kins* run round and round and round and won't drop it.'

The first time the teacher beckoned them to his desk and Ora urged them on, Maria grasped the smaller Soura by the hand and both ran out of the schoolhouse door. The poor schoolmaster believed them to be headed for the mountains on the run and that he had lost two of his pupils for good and all. Then the little door behind his desk was opened timidly and there stood the little Indians, wild-eyed, apprehensive, yet clinging to a vestige of the stolid courage of their race. They had run out of one door, around the schoolhouse and in by the other door, rather than run the gantlet of *Gringo* children at each side of the middle aisle.

They are learning to speak pieces now, no word of which they comprehend. It will be worth driving twenty miles to hear them.

On my return from a visit to the Moores yesterday afternoon, I stopped at the schoolhouse, collected Maria and Soura and brought them home. It was the last day of Sep-

tember; the last day of peace for a month to come. Loaded to the limit with men, guns, and camping equipment, car after car roared into every canyon of the Chiricahuas. As I drove cautiously along the winding road, easing my car over the bumps, rocks, and roots, impatient drivers squawked their horns at me, hoping that I would leave the road and let them pass. I only ambled along at my ease until I reached a place where the road was wide enough for two cars abreast, stopped there, and let the impatient ones sail past me, smiling to myself at the thought of the rough road that awaited them. I am well acquainted with the rocky high-centers, the chuck-holes, and wrenching, hairpin turns; up Rucker Canyon, the race is not to the swift. Steadily, at a tortoise gait, I proceeded at my safe and sure pace and let the hurrying hunters tear along at non-stop, boulevard speed, break their springs, smash their crank-cases, and crack their differential housings, as some of them do each year.

If I were able to hibernate as bears do, I know just the very date upon which I would amble into a cave and pull vines across the entrance. It would be on the night of September thirtieth of each year. There in my cave I would stay, sleeping when I could and growling all of my waking hours, until October was past. I do growl nearly all through the month of October as it is. October is the deer-hunting season, when cars race into our lovely canyon all during the day and far into the night. Slovenly camps are littered with papers and cans; campfires, built in dangerous, haphazard spots, are often left untended while their builders rush off to pepper the woods with bullets. Careless hunters shoot at everything that moves, so that poor marksmanship is all that protects a cow or a horse. The poor, benighted hunt-ers, not having been told that the sun sets in the west and water runs downhill, get lost and turn up in our dooryard,

demanding to be told the exact location of their own camps. As if I knew where they had left their cars and bed-rolls! One man, worn out from hiking and famished for a drink, dragged himself to my door this noon and hoarsely begged for water. After he had quenched his thirst with several glasses of water which I drew from the faucet for him, I said, with an innocent air, 'I see by your wet boots that you have been wading through the river. Why didn't you drink there?'

He gave one startled look at his soaking boots, then sheepishly admitted, 'I never thought of drinking out of the river.'

Not all lost hunters are lucky enough to find our door so promptly and last year we had plenty of excitement over one of them.

Several men and their wives came out from town to have a picnic-hunting party and made their camp in the Main Canyon a couple of miles above us. They arrived late on Saturday afternoon and on Sunday morning, leaving the women in camp, each man struck off for himself to get a deer if he could. They planned to return to camp in the late afternoon, deer or no deer, eat dinner, and drive back to town Sunday night. All of the men returned but one. At first they thought that he might be in at any moment and prepared for their homeward trip, but darkness found the lone hunter still missing. His wife was in great anxiety and all of the party were obliged to conclude that the missing man had met with an accident. No one had the least idea in which direction he had gone and there was no chance of looking for him in the darkness. When Monday morning dawned, the outlook was not much better, for the woods had been full of hunters, wandering everywhere, and trailing one man was out of the question. The hunting party, the frantic wife and the sympathetic wives of the other men, all re-

mained in camp throughout Monday. The men hired horses from one of our neighbors, Alfred Mann, and rode about with him to guide them, firing their guns in hope of a response and looking for a signal fire. News of a lost hunter soon reached town and everyone who had been out hunting in the Chiricahuas on Sunday was asked if he had seen the missing man, and if so in what part of the mountains.

As it happened, Charlie had left home on Saturday to go to Tucson and I might have known little of all this but for the telephone which connects the various ranches. Every little while someone would pop in, asking permission to telephone to this or that ranch to ask for news, since everyone was on the lookout for the lost man. Everyone, that is, with one exception. That was Theo Hampe, the former owner of this ranch, who was here on a visit. During the twenty years which he spent here, his wrongs from hunters were many and his love for them is no greater than my own. He utterly refused to become excited over the loss of one of them. With the single exception of the calm Mr. Hampe, the canyon seethed with excitement and all to no purpose. The bereft hunting party moved camp to Alfred Mann's ranch so that the telephone and horses might be at hand. Other friends came out to join the aimless search. Thousands of acres, precipitous, wooded, and rocky, afforded limitless hiding-places for a wounded man. Of course they were now sure that he was dead or so severely wounded that he could not even build a signal fire.

It was Sunday morning when the lost man left his camp with a rifle on his shoulder and it was on Tuesday afternoon that I answered the telephone to find the Forest Ranger on the line.

'What is all this about a lost hunter?' he asked. 'My wife and I have been away since early Monday morning and have just come back. What did the lost man look like?'

'They tell me that he is a little man, wearing a big, red sweater,' I replied.

'Oh! He's all right!' the Ranger assured me. 'That fellow turned up at the Ranger Station in Tex Canyon on Sunday night just at dark and said that he had been lost. We told him that he had better not try to find his camp in the night, gave him supper, bed, and breakfast. Monday morning I put him on the old wagon road, pointed out the telephone line, and told him it would lead him straight to Rucker Canyon.'

'So far, so good,' agreed I — 'but that was Monday morning. He could have walked here in two hours. Now it is Tuesday afternoon and he isn't here yet.'

It was a puzzler. Knowing that a great many were already searching on this, the west side of the Chiricahua Mountains, and being himself on the east side, the Ranger said that he would start off in his car at once and see what could be learned from men in the wood-camps and ranches which were not connected by telephone. After we were through talking, I called up Alfred Mann's ranch and told him what I had learned. I could hear such a buzzing and yelling from that end of the wire that I knew the excitement and bewilderment my message had caused. How could the hunter have disappeared a second time after being started for Rucker on an old road with a telephone wire overhead all the way? His wife was greatly cheered, of course; otherwise no one was better off.

Mr. Hampe was thrilled by the news. At least, he raised his eyebrows and shrugged his shoulders.

Late that same night my telephone rang again; it was the Ranger with another bulletin. He had talked with another Ranger, Bob Moak, and Bob, in the middle of Monday afternoon, had seen Mr. Red Sweater. Weary, wabbly and again lost, he had wandered into Ranger Moak's camp in Price Canyon and asked the way to Rucker Canyon.

Bob told him that Rucker lay to the northwest, over the ridge. After giving him a meal, Bob walked with the hunter until he put him on a plain trail, told him to stay on it and he would come out in Rucker Canyon. Of course, if the Ranger had known that Red Sweater was worse than the average hunter about getting lost, he would have kept him where he was, but how was he to know that the man had already been lost for twenty-four hours and was being sought high and low?

I rang up the Mann Ranch again with this news and now there was exasperation as well as consternation at that end of the wire. Men who had lost two days' work and two nights' sleep began to feel something more than anxiety about the one who had caused all this grief.

Mr. Hampe chuckled, sardonically.

There was now at least some chance of finding Red Sweater, for we knew in what part of the mountains he must be roaming. On Wednesday the ridges and arroyos between here and Price Canyon were ransacked without result. When the searching parties returned to camp that night, they were agreed that only one thing remained to be done. In the morning they must send to Tombstone for a pack of bloodhounds that belonged to Sheriff Hood.

I was washing the supper dishes on Wednesday night when I saw Mr. Hampe coming toward the house. By the arm he was supporting a weak, unsteady creature, wearing a red sweater and still toting a rifle almost as long as the man was tall.

'I'm the one who found the lost hunter, after all,' announced Mr. Hampe, smiling.

'Where in the world did you find him?'

'In the corral in front of the barn.'

Between us we helped the exhausted man up the steps and he stood there, propped by his rifle, swaying.

'Will you tell me the way to Rucker Canyon?' he half whispered. He had hardly strength to speak.

'Come inside,' I answered and took him by the arm, leading him to a bedroom. 'Lie down!' I commanded. His tired head did not seem to take in the order, but his weary legs obeyed by doubling up under him, letting him collapse on the bed. As I picked up his feet and put them on the bed, again he asked feebly, 'Will you please tell me the way to Rucker Canyon?'

'You are in Rucker Canyon and you are going to stay right here until your wife comes after you,' I replied. 'If you try to leave, I shall lock you into this bedroom.' Then I proceeded once more to the telephone.

When I announced that we had the lost hunter at our ranch, the first thing I heard from the other end of the wire was, 'For God's sake, lady, don't let him get away!'

The supper fire was still hot and I warmed some soup, knowing that it was over forty-eight hours since the exhausted man had last eaten. He had just managed to drink a cupful when cars roared up to the door and out jumped the hunter's wife and a host of other people who were still hardly able to believe that the elusive man was actually found. When his wife saw him, she collapsed into a chair beside him and I ran for restoratives. Strangers were rushing in and out, other cars were arriving, when up drove Charlie, to find his erstwhile quiet home a bedlam. Since he had not even heard that a man had been lost, it took some time to acquaint him with the whole tale. By that time our visitors had gone, though not until I had the pleasure of hearing the wife say to her recovered spouse, 'You shall never go into the woods again!'

When the sun rose the following morning to show us a changed and wintry world, we realized by what a narrow margin our farce had escaped being a tragedy. White frost

sparkled in the first rays of sunlight; vines drooped limply from the trees and yesterday's verdure was a tangled mass of black, frozen leafage. The first ice of the winter tinkled crisply when cattle bowed their heads to drink.

If, instead of stumbling into our corral at dusk, the lost man had entered some boulder-strewn canyon and had there fallen into the sleep of exhaustion, we might long after have happened upon a rusty rifle and a little mound, shrouded in red wool.

CHAPTER VIII

THE COMING OF WOLVES

IF IT isn't one thing it is another. The day after the deer-hunting season closed, Charlie came home feeling very blue. Lying by the trail in Red Rock Canyon, he had found a fine, big calf, newly killed and partially eaten. The poor creature had been seized by the hind leg and hamstrung in the manner characteristic of the big gray wolf, or lobo. Not only are we sorry to lose the calf, but we know very well what it means to have wolves on our range; the days which must be spent in setting the traps and the daily round to watch the traps and rebait them. Charlie wrote at once to the Biological Survey asking that a wolf trapper be sent here. Then, to waste no time, he went out with our own traps and spent a whole day in setting them.

There is one good thing about a wolf, though I do not like to admit even that much in his favor. He does like to travel on a trail and that makes it easier to set traps where he may come across them. A lion strikes off across country anywhere. On the other hand, a lion buries his kill under leaves or brush and returns to eat again, perhaps to find himself entrapped. The lobo — alone, in pairs, or in a pack — kills anew whenever he wants to eat. The Government trappers who have been here tell us that the wolves that bother us are just traveling through the country; they do not breed in these mountains. Many of them come up from Mexico, cross the wide San Simon Valley, and climb our mountains, using horse and cattle trails and following the old route of the Chiricahua Apaches. From one end to another of the Chiricahua Mountains they ramble, traveling by night, eating whenever they find a fat deer or calf. Like

men, wolves prefer 'baby beef,' but if that is scarce, they can and do kill grown cattle and even attack full-grown bulls. We are only twenty miles from the frontier and we sometimes find on the trails the smaller tracks of half-grown wolves, showing that a lobo mother has brought her children into our country to show them the world and give them a taste of Arizona beef.

On our range there is a level place from which three canyons fall away in different directions. We call the place Lobo Mesa. It is rare that a wolf comes into these mountains without leaving his tracks there. When there is a pack of them, they play about in the sandy, open space, and a deer hunter, just at dawn, once came upon four wolves there and killed one with a rifle bullet. Perhaps the wolves rendezvous there to decide which canyon to follow. 'Shall it be Coal-Pit, Cottonwood, or Ocotillo?' At present we need not care which they choose, for there are traps in all three canyons and on Lobo Mesa besides.

The first year we were here, a great, lone wolf paid us a visit. Charlie knew very little about trapping then and I am sure the wolf would have gone scot-free had he not taken a jaunt into John Long Canyon. That is the range of our neighbor, Tom Hudson. He has hounds, and when he rides to look after his cattle, he watches for sign of predatory animals and so do his dogs. He found the wolf's track and set traps. Had it been a lion, he would have followed the trail with his dogs. He had not much hope that the lobo would return, but back he did come — and this time he stayed.

The next time we found a dead calf, Charlie asked for a Government trapper. The man who was sent to us had been at work in another Arizona mountain range and from there he drove over in a wagon, pulled by two big horses, and made a camp in our canyon. His wife, wearing a long, calico dress and high-heeled, black velvet slippers, rode

down to see me, sitting sidewise on one of the big, bay, draft horses. She explained, 'My husband don't hold with women's wearing pants and riding straddle.' So I knew what he thought of me. He was an expert trapper, no doubt of that, but how mysteriously he went about it! Badger skins were pulled over his boots and he brushed out the traces of his own footprints with the gray brush of a lobo's tail. Later I learned that nearly all of the trappers dislike telling the secrets of their trade and surround their every move with hocus-pocus to make one think that catching a wolf requires a touch of witchcraft. Skill is needed and plenty of it, especially if a wolf is an old one that has once escaped from a trap or been snapped at by springing steel jaws. It was raining nearly all the time the trapper was here; tracks were washed out; we found no fresh kill. No one could tell whether the wolf was still about or had quit the country. Just as we feared he would never be caught, down came the trapper one day, and tied to his saddle was a grizzly token that one wolf would kill no more cattle. Charlie nailed it to a tree — a great, gray paw.

It was a year or more before we saw wolf tracks again and we saw enough then to make up for lost time.

'This canyon is a regular wolf race-track!' exclaimed Charlie when we rode into Coal-Pit one day and found tracks both big and little, going up and down the canyon and around and around on Lobo Mesa. Charles Gillham, a Government trapper, happened to be working over the divide in Tex Canyon and Charlie rode over to see him. Over in Tex, too, were plenty of tracks and the trapper did not want to leave there. Knowing the distances that a wolf covers in a night, the tracks in the two canyons might easily have been made by the same pack of wolves. Mr. Gillham decided to add a small portion of our range to his trap-line, walking over here every other day. He was camping and as

a cook he was not as expert as he was at catching the wily wolf. I confess to having bribed a Government official. I told him that for every wolf he caught, I would bake him a pie. After earning and eating two pies, he moved over to our canyon to be nearer both the wolves and the pastry cook. Then, for which we are forever grateful, he taught Charlie how to make the scent for lure and how to set and bait a trap properly. Following that came one of the long waits that are so tantalizing to one who must see a trap-line daily. The wolves seemed to have quit the country. A skunk frequently stepped into a trap set for his betters; a bob-cat snarled at his captors; but never a wolf did we see. Trappers were needed elsewhere and Mr. Gillham finally said that he would have to move to some other range. Charlie had now mastered the rudiments of trapping and had some bait. If the wolves returned, he could set out a line of traps and try his own luck.

Every day Charlie managed to see those parts of the range where wolf tracks had last been seen, and on the Sunday after Mr. Gillham's departure, away up above the forks of the main Rucker Canyon, he found tracks of two great lobos. On following them up, Charlie came upon their kill, poor young Happy, a fine heifer, granddaughter of old Jersey Beauty, a pet that had been raised in our home pasture. She, like her grandmother, knew her own name, and when Charlie called loudly, 'Happy! Happy!' she always answered, 'Baw! Baw-a-a!' and came running to him, expecting to be fed. Now she lay dead among the rocks of a narrow arroyo, mangled by the long teeth of cruel wolves. Losing his pet made Charlie even more determined to catch those wolves, if he had to trap all winter. She was killed on Saturday night and before darkness fell on Sunday, traps were awaiting the return of her slayers. All that week Charlie rode up the canyon and in a scabbard slung from his

saddle was a rifle which he was aching to use. No luck, no wolf, not even a track, until the next Saturday night, when again two wolves came down the cow-trail in the floor of the canyon, passing close to the trap-line. Another week was spent in the same manner and again the wolves came through on Saturday night. This time they were attracted by the scent and one of them walked within a few inches of the jaws of a trap and left long, deep scratches in the dust of the cattle trail.

'Coming every Saturday night, are they?' raged Charlie. 'Week-ending in Rucker Canyon with the Raks! Well, I'll give them a pressing invitation to stay here permanently!'

Not knowing what an experienced trapper would do, he studied the situation and decided that the best plan would be to set a second trap, right across the cow-path from the one that had attracted the attention of the wolves. It was impossible to set traps on the trail itself, for cattle, coming to the river for water, would be sure to throw them, even if they were not caught and crippled by the great steel jaws in which were sharp, meshed teeth. Now, skillfully buried on opposite sides of the trail, were two traps. Two wolves, with four paws apiece, surely could not frolic about in that narrow space without stepping on the trigger of a trap. More hopefully we awaited the next week-end visit of those lobos which had such admirably regular habits.

'Watch me come home with a wolf,' said Charlie, as he rode away the following Sunday morning. I was too busy at home to watch for him, but I ran over to the barn when I heard Robles barking a welcome to his master. Excited, impatient to get back to the trap-line, Charlie hastily told me what he had found. Where the two traps had been set on opposite sides of the trail, he had seen yawning holes, and several feet from each, aiming in opposite directions, wolf tracks began and the deep marks where the drags had

plowed through soft soil. Reading the sign, he knew that two wolves, each caught in a trap, had leaped from the spot in terror, dragging behind a great, double hook, attached to the trap by a five-foot length of heavy chain. Charlie followed the trail that led up the canyon and soon lost it when the wolf entered the river. On the right side of the stream rose a cliff. Searching the left bank, Charlie found where the wolf had come out of the water and had taken to the cattle trail. For some distance the frightened animal had encountered no trees nor brush in which to entangle the hooks of the drag. Then, not knowing the nature of the clanking horror he trailed behind, the wolf entered a patch of thick brush into which the hooks wound themselves. Charlie, following where the trail led, crept into this thicket, heard the clank of metal, and looked up — right into the eyes of a wolf. Startled, he gasped; then said, 'Welcome to our city!'

Knowing that the trail might lead through brush where a horse could not go, Charlie had left his horse, Leppy, down in the canyon, but he had not left his rifle behind, being too anxious to use it. Having heard that wolves are hard to kill, Charlie took careful aim on a vital spot. Just as he was ready to pull the trigger, there was a wrench, a smashing of brush, as the wolf, exerting frenzied strength, broke clear of the entangling limbs and bounded away. By the time that Charlie could back out from the thicket and run around it, the lobo was out of sight. Greatly disappointed, he picked up the trail again and followed it until it entered a vast stretch of solid rocks where neither paw nor hook could leave a trace. Man's eyes could do no more, and Charlie came home to get Robles, hoping that a dog's nose might serve better.

Robles is a dog of proved valor. He would tackle a lobo and allow him a handicap of the first two bites. It would never do to take the dog unleashed and let him trail a wolf.

When the two met there would be a battle and a shepherd dog's courage would not help him much with a wolf twice his size. With bits of soft rope, Charlie contrived a little harness, and when this was adjusted to Robles, tried to lead him. In his free life as a ranch dog, Robles had never once been tied nor put upon a leash. When he felt himself so restricted, he howled, lay down and whined, bit at the rope, dug his toe-nails into the earth, and refused to budge. When it became apparent that Robles would not take a step while harnessed, Charlie took off the hateful ropes and Robles became our willing, tail-wagging comrade again.

'I'll have to get Tom Hudson and his hounds,' declared my exasperated husband. He went to the telephone and gave the rings, two-short-and-one-long, that calls Mr. Hudson's ranch on our country telephone. There was no answer.

'See if he is somewhere in the neighborhood,' I suggested. Charlie thereupon gave two long rings for the Winklers and when they answered, he learned that, by the best of luck, Mr. Hudson was there, mounted on his best horse, Skeetchy, and had his two hounds with him. When Charlie told Mr. Hudson what was afoot, Tom shouted that he would be here as soon as the big, brown horse could bring him.

'Have you had your dinner?' asked Charlie.

'Don't want any dinner!' roared Tom. 'All I want is a sight of those wolves!'

Charlie snatched a few bites while Tom ran the three miles up here, and the instant he arrived, the men loped off, for the winter day had none too many hours of daylight left to trail two lobos. Padding along after the men were the two hounds, Rowdy and Mutt. Although they were still young, they were well trained by their master and during their puppyhood they had run with an old, wise hound that knew every scent and taught them to tell wolf from lion and bobcat from both. There was no danger that Mutt and Rowdy

would be lured astray to follow deer or rabbits. They were not on a leash, but to make sure that they followed closely and stayed on the trail, they were yoked together by a short chain. About a mile before reaching the spot where the two wolves had been caught, the hounds paused, bristled up, and growled. Tom paid no attention to that other than to tell them to come on, and reluctantly they obeyed.

In the floor of the canyon the men dismounted. Tom then put his hounds on a leash and quickly they walked to the rocky waste where Charlie had lost the trail of the wolf. There the dogs were taken off the leash and unyoked. Excitedly they sniffed and circled, struck a trail and were off. Tom called them back.

'I don't believe the wolf went that way,' he said.

Again the dogs were freed and took the same direction as before. Tom had his horn to his lips to call them back when Charlie begged him to let the dogs go, for they were on the run as though they were very sure where they were bound and gave tongue as they ran.

'I'll go back and get my horse!' shouted Tom, who does not believe in walking.

'And I'll try to keep up with the hounds afoot,' cried my husband, as Tom clattered away down the trail.

Burdened by a rifle, Charlie took after the hounds, scrambling over boulders, through brush, up hill and down. Through that rough, wooded country, the wolf had somehow managed to keep going, dragging trap, chain, and hook. Once Charlie thought he had lost the hounds, for he could no longer hear them. Rounding a sharp turn in the mountain-side, he came up with them; they were running in circles, sniffing anxiously. The sun, beating on the rocky, western slope, had nearly dried up the scent. Hardly had Charlie caught up with the dogs when Mutt gave tongue again. He had picked up the trail at the edge of the rock-

slide. Rowdy joined him and away they went following their noses around the contour of the mountain and about the head of a small arroyo.

Not having the keen nose of a hound, Charlie was using his own eyes and ears. Across the draw he heard a clanking sound as of steel on rock, and on looking closely, he could see something moving behind a bush. Scrambling down one slope and up another, he arrived at the spot where the wolf was once more hung up by the dragging hooks, just as Mutt and Rowdy dashed up and bayed him. Fearing that the hounds might charge the wolf and be cut by his fangs, Charlie aimed quickly and shot back of the wolf's shoulder. To his surprise, the wolf still stood erect, snarling at him. Mutt was ready to spring upon the wolf when Charlie grabbed the dog and jerked him back, then shot again. This time the bullet struck squarely between the lobo's eyes.

Tom, climbing the hill on a panting horse, heard the two shots and yelled, 'Don't let the wolf hurt my dogs!'

'Mutt and Rowdy are all right,' Charlie called back, 'and the wolf is dead.'

Tom wanted Charlie to put the heavy wolf in the saddle across his lap, but Charlie shook his head as he looked up at the sky to estimate the little daylight that remained in that December day.

'I'll pack the wolf and rifle and go down afoot until I reach the trail,' he decided. 'Tom, if you will ride on ahead and put your dogs on the other wolf's trail, we may have time to get him, too, before dark.

Tom yoked the hounds once more and they followed him back to the spot where the traps had been set. There he unyoked them, put them on the second wolf's trail, and they were off. After a short run, they lost time where the wolf had entered the river; presently they found where the frightened lobo had come out again, doubling, twisting

through rocks and trees, the chain tugging, the hooks grappling as he leaped. Charlie called out to let Tom know when he reached the floor of the canyon, and Tom yelled back, 'Come on down here. The dogs are going through thick brush where my horse can't travel.'

Dropping the heavy, dead wolf on the trail, Charlie ran after the hounds, crossing and recrossing the river.

'Can you see sign?' asked Tom, who was riding as near as he could.

'The drag has made a furrow like a turning plow,' answered Charlie.

The dogs were on a hot trail and when it presently led them through more open country, they increased their speed and Tom took after them on his brown horse. Unable to keep up with that pace, Charlie waited, listening. The hounds bayed — then came a single shot.

'Good-bye, wolf!' he said. 'I'll bet that lobo was hung up near where the hounds stopped and bristled as we were on our way up here and they would have found him then if we had let them.'

It was long after dark when I heard horses coming into my dooryard and I knew by their riding to the door that at least one man had a wolf thrown across the saddle in front of him. I threw open the door and, seeing only dim shapes in the black night, cried out, 'What luck did you have?'

Thud! A heavy body hit the gravel in front of the door.

'Oh! A wolf!'

Thud! A second time.

'Another wolf!'

I ran for my flashlight. Robles came out to bristle and growl and gloat. Peter Cat came out, shrieked 'Yeow!' and scooted for a tree. We were like the children in the fairy tale who danced in a circle, singing, 'The wolf is dead! The wolf is dead!'

Tom supped with us; Mutt and Rowdy shared Robles' bones and bread and Skeetchy munched hay and oats with Leppy, after which Tom started on a long, cold ride back to John Long Canyon.

'I'll have to put those wolves inside somewhere to keep them from freezing,' said Charlie; 'otherwise they'll be awfully hard to skin in the morning.'

'It won't hurt anything if you put them in the storeroom for the night,' I suggested.

The next morning, rushing into the storeroom for breakfast bacon and jam, I shrieked as I met the glassy, wolfish glare of four green eyes, and shrank back from the bared and gleaming fangs. Recovering from my panic, I looked well at the wicked, gray-furred beasts and said, 'Poor little Happy Cow, at least you are avenged.'

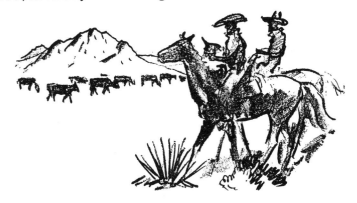

CHAPTER IX

SELLING OUR STEERS

IT WAS well for us that our fences, trails, and corrals were nearly completed, since Grandmother Ortiz, the matriarch, suddenly decreed that all her family, including the fence-building sons and son-in-law, must leave our mountains and go to the Salt River Valley. José, with whom we transacted our business, asked that his fence be measured, his posts counted, and said that they wished to go as soon as the accounts were settled. As an excuse, he told us that there was much work at good wages in the cotton fields near Phoenix and they could make more money there. He did not suspect that we knew the real reason for their departure.

Carlotta, the oldest girl in the family is now sixteen, a big, buxom creature. I had my eye on her as a possible washer of clothes, but I averted my eye very quickly when I was told that she could come to work for me only on the condition that I drive a mile to get her and again to take her home. She is now a *Señorita*. It would not be proper for her to walk down to our house unattended, even though we and her own family alone inhabit these woods.

Others besides myself have observed her and this fall an offer of marriage was made by a middle-aged wood-chopping widower with a family of motherless Indian children. This mésalliance was refused, of course, but it had the effect of determining the grandmother that the time had come to arrange a suitable marriage for Carlotta. Bright cloth was made into dresses for the girl and Phoenix was chosen as a place where there might be found some young and eligible man to appreciate her charms.

On the day they left, we went down to the forks of the

road to bid them good-bye. In the lead rode the grandfather, José, and Porfirio, all on mules. Next, driven by Luis, came a mule team, hauling a farm wagon, on the bottom of which sat the grandmother, surrounded by the smaller children and the household goods. To pass the time away on this long, leisurely journey, Grandmother Ortiz had brought along some baskets of bright cloth scraps, which she was already beginning to piece into quilts as she jounced over the rocks. Behind the wagon rode Carlotta, her mother, and the older children, Maria and Soura, all on burros.

To those who met them on the road, they seemed only a lot of Mexican Indians, bound somewhere to look for work. We knew them for what they really were; a large family group, traveling in search of wider social opportunities.

Their departure left us without help and we decided to get along by ourselves for a while, since our work must now be altogether with the cattle. We took up the wolf traps which demanded more attention than we were able to devote to them and put aside all other jobs in order to spend all our time in riding the range.

This fall, though buyers were few and prices low, we were obliged to sell some cattle. Not only did we need the money: we also needed to keep for the cows and calves the grass that the steers would eat if they remained on the range. After the Ortiz family left, we began to ride constantly, gathering the two- and three-year-old steers. At first we brought home those which ran in the lower country, gentle ones, used to seeing men and horses. We thought we were getting along wonderfully and would have our steers together in no time at all. When these easily found ones were secure in pasture, we hunted farther afield, away up on ridges, at the end of wooded canyons. One or two steers fetched home was soon regarded as a good day's work. Each day we started out a

little earlier, rode farther and faster, came home more frequently with nothing to show for a hard day in the saddle. We had a very accurate estimate of the steers that should be in the mountains. Charlie had entered in a book an account of each steer and heifer that he had branded. He knew how many had been sold; with our fences they could hardly stray and we felt sure they had not been stolen. Except for a very few that might have died, we knew we should find our steers if we kept on looking.

One day we saw some cattle so far up on a mountain-side that it was impossible to tell whether steers were among them or not. I was told to remain in the canyon in a spot from which I could see the cattle, while Charlie rode toward them, winding through the rocks to avoid the steepest climbs. I saw the cattle scrambling up the side of the mountain and, when Charlie followed them over a ridge, I knew that there must be steers among them and that Charlie, on his large, blue roan, would stay as closely behind them as possible. Now it was up to me to guess where the cattle would elect to descend from the heights and I should be on the spot, if I could, in order to turn them down the canyon. I could not see the cattle nor hear them as I scrambled down the draw and stationed myself in the place that I thought most likely to be the right one. As moments passed in anxious waiting for a glimpse of running cattle or sound of rolling rocks, I knew that I had made a wrong guess. Miserably I waited for Charlie and at last he rode up on a sweating, panting horse. Running ahead of him, the cattle had scattered to the four winds because of my failure to be at the right place. Among the runaways had been the big steers which we were especially anxious to catch. Goodness alone knew when we might again find them all in one bunch.

There was no need for Charlie to reproach me. Full of my own inadequacy, I bedewed my horse's mane with tears all

the way home and spent a sleepless night reproaching myself. In the morning we saddled up and started back to where the cattle had been lost, without the least hope of finding them, but we had to look somewhere and that place would do as well as another.

Far down from where the cattle had been lost to sight the previous day, a drift fence crosses the main canyon. Since we often drive cattle through a gate by the river, we have had the brush cut for some distance on either side of the fence. With difficulty we were able to believe our eyes when we rode up to the gate and saw near it all the cattle that had escaped us the day before. Opening the gate, we rode through slowly and quietly, while the cattle stood watching us. Cautiously we rode around them and urged them toward the gate. One or two gentle cows led the way through and took the trail down the canyon on a gentle trot, the steers following. All the way home they ambled without a bit of trouble and before noon they were grazing in the pasture with their fellow-steers. These were the last to be brought out of the mountains; our work was done.

And didn't some pestilential picnickers stroll through our pasture the very next Sunday, leaving the big gate wide open? Only by the miracle of my finding it open before the steers did, kept them from scurrying back to their mountain fastness.

After we finished combing the hills for steers and had them at hand where we could show them to prospective buyers, there seemed to be no demand for cattle. Charlie made frequent visits to town and talked to other cattlemen, bankers, or any stray commission men whom he found there. As far as we could learn, the trouble lay with the weather in California; it was altogether too good. The fall rains had not begun as early as they should and, until the grass started to grow, the California ranchers and

feeders dared not buy steers. It was not enough that we must worry over our own Arizona weather; we must pray for rains in California as well.

We decided to feed thirty of our largest steers and sell them to the local market in the form of beef. There was much work involved, and we were glad to see Porfirio Ortiz when he returned to the ranch one day on foot, hungry, weary from days of walking. He knows nothing about cattle, but he can carry feed and pitch hay. Grass in our holding pasture was growing scarce and that worried us until a neighbor came to our rescue. Mr. Heyne used to have cattle on his own, but no longer has any and he offered us a good pasture near his house. We had only a mile to drive the cattle, yet through heavily wooded country where we might easily lose sight of them. For safety's sake, we divided the steers into small bunches and took them down a few at a time, losing none of them, though we had some narrow escapes from 'spilling the beans.'

For fear that the cattle might damage Mr. Heyne's apple trees Charlie built an extra fence around his orchard. Mr. Heyne plants apple trees, grafts them, prunes them; raises apples, sells them, gives them to his friends, and eats them. His orchard is renowned in the countryside and the Mexicans, who nickname everyone, call him *Tio Manzana*, Uncle Apple.

When we had become very discouraged indeed over our prospects of selling the steers, there came into our part of the country a California speculator. He was not a feeder of cattle nor a commission man; he was on the lookout for small bunches of cattle which he could buy cheaply from those who had to sell. These cattle he expected to ship to California and sell them at a profit. 'Sharpshooters' we call such buyers. Some of our neighbors had already agreed

to sell to him and on the day he had set for receiving their cattle, he said that he and another man would come up to see ours. We knew that these men were bargain-hunting and might offer us an absurdly low price. They were used to dealing with ranchers who were so desperately in need of money that they feared to refuse any offer, especially in such a year as this. We talked over the situation and decided that we would not accept an unreasonably low price. Although as yet no cattleman in this part of the country had shipped his own cattle to the Los Angeles Stockyards to be sold there, we would do that and hazard the result, rather than sacrifice the cattle here.

We rode down to Mr. Heyne's pasture about ten o'clock in the morning, leading two extra horses, saddled, for the buyers to ride while looking at our cattle. The pasture is a beautiful, wooded enclosure, through which winds the river. In one corner is a large, grassy meadow and to that open space we drove the steers and, by riding back and forth, held them in the corner as in a corral.

We had a long, hungry wait, as the men did not arrive until two o'clock in the afternoon. They left their car in the road, climbed the fence, and mounted the horses which we had provided for them. From my place on the far side of the cattle, I could see that one of the men sat on the horse as though his clothes had merely been stuffed with straw and tied to the saddle. The other man looked like a neat little clerk, more at home behind a desk than on a horse. In this country women are expected to keep very much in the background, although I notice that behind the scenes they have fully as much to say here as elsewhere. It would not have been considered proper for me to be present during this business conference, so, although I knew all about the matter and was deeply concerned in the result, I sat on my horse in the lower end of

the holding ground. At that distance I could not have been distinguished from a Mexican cowpuncher. As the men rode back and forth, looking at the cattle, the wind bore an occasional word of their conversation to my anxious ears. When the buyers had left, I was not surprised when Charlie loped over to me and said that he was going to ship the cattle himself. Not only had the men offered him a price that we could not consider; in addition, they wanted to 'top out' our herd, meaning that they would take only the very best and leave the 'cut-backs' on our hands.

All this happened on Friday. The following Sunday we rose long before dawn and rode down to the pasture in a rainstorm. By the time four of our neighbors joined us, we had nearly all of the steers gathered again in the corner. When the pasture was entirely rounded-up, Charlie rode into the herd and cut out the steers which were least desirable and might injure the sale of the rest. As each rejected beast came out of the herd, Mr. Meadows ran him off to an open space by the river where Dolf Winkler was holding these 'cut-backs.' Two men and I held the herd in the corner of the pasture. When the herd had been trimmed of any that were not desirable, all of the men, except Charlie, drove the herd out of the pasture and down the road, where they would join other bunches of cattle which were being driven on a two-day journey to the railroad shipping-pens.

Charlie helped me drive the 'cut-backs' through the gate and start them back to our own range, where they would be turned loose to wander where they pleased. After giving me this start on my homeward way, Charlie loped down the road to overtake the main herd. He had decided to act as his own shipper and go to Los Angeles with the cattle.

The gates were open ahead of me and I did not bother to keep up with the steers which had been left in my care. They were going to be turned loose on the range anyway, so it did not matter which way they went. They had been penned up for hours, and now ran away, frisking their tails, kicking up their heels. Halfway home I overtook them, all in a bunch, facing me. I whistled and they scattered like quail, crashing through the brush in headlong flight. Walking my horse, I proceeded up the road, climbed the hill, and entered the big corral — to find every steer I had started with awaiting me there. As I sat on my horse, looking at them, they wheeled about, rushed for the open gate, splashed through the river and disappeared.

The ranch looked very lonely as I rode in, unsaddled my horse, and walked over the disheveled house which I had left at six o'clock that morning. Except for Robles and Peter Cat, I should be entirely alone during the ten days of Charlie's absence. Porfirio, whom we had counted upon to stay and help me with the chores, had left early one morning right after pay-day, without troubling to take leave of us. He knew that Charlie might go away and was ashamed to say he did not intend to stay here to help me. There had been no time to look for another Mexican and I absolutely refused to have a white man. I was tired of the double duties of cooking and cattle. Dog and cat might eat raw meat and I raw apples if we were alone. I much preferred feeding a few cattle and horses to filling up a hungry man. A telephone connects our ranch with those of several neighbors upon whom I might call in any real emergency. I secretly considered myself amply able to cope with any situation that might arise.

For three days I had no reason to distrust my own powers. The rain of Sunday lasted but a few hours and was succeeded by the beautiful, warm days we often enjoy

in late November. In the mornings I rose an hour later than I had been in the habit of doing and then only because I knew that hungry animals were depending upon me. Chickens were expecting me to open the door of their house and scatter grain. Horses came down from the pasture and looked over the corral gate to see if I had come with the morning's feed. The big steers, which lived in the round corral by day and slept under the trees in the water-lot, watched me as I traveled the path from house to barn. There were two milk cows and their calves, pampered creatures, used to special privileges in the way of feed and shelter.

It was all easy enough for me to handle, except for the hay which had to be thrown down from the haymow in the barn and be carried to the big square manger where the steers spent the day munching. If I managed to pick up a goodly load of loose hay on the pitchfork, it slipped off as I went through the barn door. There should be some better method of toting hay and I invented one. I built a frame of boards and chicken-wire, wired that to the wheelbarrow, and found that I could fill the manger with a few trips, propelling my improvised hay-wain.

'The elephant ate all night, the elephant ate all day' — I sympathized with the man who had an elephant on his hands. I had thirty big steers on my hands and the manger had to be filled each night and morning. The steers also ate cottonseed cake which I poured into the feeding-troughs for them. They took themselves to the spring for water and I was grateful for that.

The milk cows and their calves were fed in a separate corral in front of the barn. Beauty, the old, gate-opening Jersey cow, had died early in the fall. Surprisingly, we found that we had become fond of her and had fed her grain of all sorts, bran and apples, after she became sick, all to

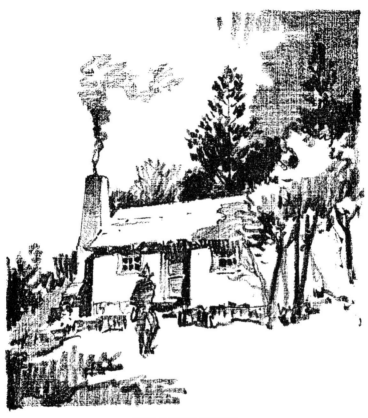

THE RANCH HOUSE

no avail. Her demise made our gates no more secure, for she left a daughter and worthy successor. Sired by a muley Galloway bull, the daughter had no horns, but she strove with much success to overcome that handicap. Almost anything that Beauty had been able to do with her horns, her daughter managed to do with her nose. It was significant that long before we came here, Mr. Hampe had named her Mrs. Trouble.

Intending to leave her no opportunity of entering the barn and living up to her reputation, I went in and out with the utmost care, sliding the big, double doors open just enough so that I might pass through with a bucket of feed. I was bending over the grain-box to fill my bucket, when a sound made me look toward the door. Mrs. Trouble had thrust her head through the opening. Before I could reach her, she impatiently threw her head from side to side, heaved her shoulders, and the sliding doors jumped from their iron track and crashed on the ground in front of the barn, Mrs. Trouble beneath them. Giving me no time to worry about her, she crawled out from the wreckage, and, while she was still in a daze, I managed to drive her out of the corral.

For the night it didn't matter about those doors, which were too heavy for me to budge. Somehow, before the next afternoon feeding time, they must be put back on their track. Remembering that I had declared myself able to cope with anything that might arise, I dreaded having to ask someone to travel up the canyon to help me. The following morning, before I had brought myself to telephone for help, two forest officers happened to ride in and they stopped to talk for a few moments. As they were leaving, I said, with a careless air, 'Oh, before you go, would you mind helping me put the barn doors back on their runway? A cow has knocked them off.'

I hope I thanked them adequately. I know I gave them no idea of how extravagantly grateful I felt when I saw those great doors up where they belonged.

After weeks of constant activity, I enjoyed hours of rest between morning and evening chores. Basking in the sun, sometimes I sat and thought, sometimes I just sat. Charlie, I am sure, would have recognized the unseasonably warm days for what they were, weather-breeders; but I was entirely unprepared for what was to come.

One morning I woke to find a gray sky, a still, oppressive air. When all the animals were provided with their morning ration, I took some little heed of the comfort of Robles and myself. I fetched inside a goodly store of wood for fireplace and kitchen stove, filled my coal-oil lamps, brought in apples, and a piece of meat from the quarter of beef which hung in the storeroom. By three o'clock in the afternoon, the air had become colder and occasional flakes of snow drifted lazily down. Not knowing how soon it might snow in real earnest, I surprised the steers by feeding them an hour earlier than usual. Before I finished filling the hay-manger, there sprang up so strong a wind that I propelled my wheelbarrow with difficulty and saw part of the hay whisked away. Soon I could no longer see the near-by mountain peaks, so thick was the falling snow. Falling is not quite the term for it, either. Snow seemed to fill the air, coming from every direction at once. Even after it had reached the ground, whirling gusts seized upon the snow and bore it aloft, juggling the flakes in the air.

The poor chickens went insane when the familiar brown earth turned white. They perched, squawking, on rocks, posts, and gates; squatted in mournful groups under bushes and huddled into fence corners. Only a very few older hens had the sense and courage to make their way

through the snow to the shelter of the warm hen-house. While the light still served, I ran about, locating my chickens. Then with the lantern I again made the rounds; gathered my hens one by one and carried them to the nearest shelter, barn, chicken-house, or milking-shed.

Cold, wind-blown, and weary, I returned to the house, and as I entered the door the telephone rang. It was our neighbor, Alfred Mann, asking if I had wood to keep up my fires. That kindness was my last contact with the world for several days. During the night a tree blew over, taking the telephone wire down with it.

After a night of howling winds and drifting snow, I rose to find myself almost imprisoned by frozen snow-banks, and the thermometer just outside the back door told me the astonishing news that it was five degrees below zero. I had every reason to be glad that some instinct had prompted me to bring home a shovel from the barn the night before; without it I could hardly have managed to go back to the barn that morning. With Robles going before to find the path, I dug my way to the barn and next to the feeding-troughs, which I had to clean out with my shovel. The night's supply of hay had been buried in snow and the steers were cold and hungry, great icicles hanging from their shaggy sides. They crowded and shoved against me while I poured grain into the troughs, and when I came into the corral with a forkful of hay they mobbed me, tearing off great mouthfuls, so that I arrived at the manger with an empty fork. Already I was weary from shoveling paths wide enough to walk in, and I knew that I could never shovel one through which to push my wheelbarrow with its wide hay-rack; yet somehow all these cattle must be fed. Out in the hayfield was a small stack of hay for which there had not been room in the barn. I shoveled my way across the water-lot, the steers following me,

climbed over the fence and attacked that haystack. A forkful at a time, I flung the hay over the fence and the steers fought and jostled as they devoured the hay. I was safe from being trampled, on my own side of the fence.

The milk cows were easily fed in their shed; the horses did not come down from their pasture. Wherever there were hens, I scattered corn, digging my way laboriously to those imprisoned in the hen-house. During all the time I spent in feeding there was a respite from snow, but I had barely returned to the house when wind and snow joined forces to reproduce the storm of the day before. I had fed the cattle liberally and did not attempt to go out again that day. Out in the wind-swept, open country, cattle were drifting along, wet, hungry, shivering, growing thinner by the hour. For the animals on our mountain range I had no anxiety. In every canyon they could find shelter, and browse would keep them from hunger, even though the grass remained covered with snow for some time. In the days before men built fences, nearly all the cattle would have headed for the hills.

Except that the horses came in, wet and shaggy, begging for grain, the third day was a repetition of the second. The fourth day there was a decided improvement. Snow ceased to fall, and paths, once dug, stayed clear. I carried all of the hens to the chicken-yard and opened the door of the dark hen-house so the hens might come out into the sunshine. Bewildered and blinking, surrounded by high banks of sparkling snow, they stood in the doorway and made no attempt to leave the small space I cleared for them.

Then, on the morning of the fifth day since the beginning of the storm, I heard a sound that made my heart drop down into my rubber boots. Snow, melting on vast slopes, had reached the river, which now would roar down

the canyon for days, fed from huge drifts on the high mountains above us. So far I had done my best in the tradition of pioneer women, always buoyed up by the belief that my pioneering would be only a matter of days. Charlie must have read of the storm in the newspapers and would come home as soon as he could. Now that the river, which has to be crossed five times as one drives up the canyon, was rampaging along, how could he possibly manage to come home?

Meanwhile, after having had the satisfaction of selling all of his steers for a fair price to that very same 'sharp-shooter' who had tried to buy the best of them for very little here, Charlie left the Los Angeles Stockyards and started for home, anxious because of what he read about heavy snows in southern Arizona. Mr. Meadows had agreed to meet Charlie in Douglas, and he did his best. Starting out from his own ranch, he stuck in a succession of deep snowdrifts and after several hours of struggle he had to turn back home. When Charlie got off the train in Douglas and found no one there to meet him, he realized that our road must be impassable and decided to attack the mountains from the south side, where there is no road, only a horse trail. Mr. McKinnon offered to drive him along the highway south of us, twenty-seven miles to Chiricahua Station. From there Charlie walked four miles to the Spear E Ranch. The snow was frozen and made fairly good footing, but he suffered from snow-blindness for days afterward. At the Spear E Ranch he spent the night, and on the following day Frank Krentz lent him a horse and saddle upon which he rode home through twelve miles of deep snow, over fallen logs and under snow-laden branches.

Of all this I knew nothing until I saw him entering our door. I wonder if real pioneer women ever cried for joy?

CHAPTER X

CATCHING A CHRISTMAS PRESENT

WHILE the snow of the big storm still lay upon the ground, we saw the tracks of wolves imprinted in its whiteness; traps were set once more as soon as the snow melted sufficiently to make it possible. To my dismay, I found that I must take an active part in the trapping. Every day the long trap-line must be seen, and it was difficult for Charlie to find time for other work that needed to be done. It is not merely that we must visit the traps to see if a wolf has been caught; we must keep the line in order so that there may be nothing to scare the wolves away. If Br'er Wolf should come spanking along some bright moonlight night and find a skunk or bob-cat thrashing about on the end of a chain, he would say, 'Good-night! This is no place for me!' The scent which lures animals to the traps must be renewed; a trap, sprung by a cow, must be reset. And besides all this, trapping is a sorry business, however necessary for a cattleman, and we want as soon as possible to give even a wolf the *coup de grâce*.

Some of the things that have to be done are beyond me. I cannot open the powerful jaws of a wolf trap and set the trigger. When I find one that has been sprung, I fetch brush to cover it from the keen eyes of a passing wolf. If I should find a wolf in a trap, I would not be able to lift him to my saddle after killing him. I hate the idea of killing anything, and ride from one trap to another in a most un-trapper-like frame of mind, murmuring, 'I hope there's nothing caught. I hope there's nothing caught.' Most of all, I do not want to find a fox. I remember one that we found one day, caught by a front paw. The poor creature

cringed and looked up with eyes filled with dire apprehension as Charlie got down from his horse and walked up to the trap.

'It is a vixen,' he told me, 'and she has babies in a den somewhere, waiting for her.'

Grasping her by the back of the neck with one hand and by the flank with the other hand, so that she could neither bite nor scratch, he sprung the great trap with his feet and freed her. As fast as she could go on her three good legs, the other dangling, she sped away for a short distance; then stopped and looked at Charlie as though she wanted always to remember how he looked. A moment later she whisked into a by-path and hastened to her hungry babies.

'Men are not such bad creatures, after all,' she may have told them. 'I was caught in a trap and a man came and set me free. Believe it or not!'

Charlie and I have been taking alternate days at the traps. Every other day, a package of lunch tied to my saddle, I start off through the home pasture, up the glade where a trap lurks behind a clump of bear-grass, over Ocotillo Mesa from which the trail descends to Blue Spring and down Ocotillo Draw. The trail winds constantly so that I cannot see ahead more than a few feet. Before coming to a place where there are traps, I grasp the horn of my saddle, so that I may not be thrown if Eohippus is frightened by a trapped animal. Always he shies when he passes the tree from which a bob-cat once snarled at him. Up Ocotillo Draw, a steep climb through manzanita thickets, to a wide, level space, surrounded by trees, Lobo Mesa. There I must bait three traps, cunningly set where wolves may come upon them from any direction. We descend into winding Coal-Pit Canyon, following it until the last trap there has been visited, cross over the hill on which grow huge juniper trees, laden with green berries,

splash through the river and enter main Rucker Canyon. The going is now much better; no brush to dodge and I can see a long way ahead. My horse knows the way and where each trap lies; if I fell asleep in the saddle, he would stop at each one and wait for me to dismount and rebait it. Just above the last set there is a beautiful, clear pool in the river. There I unwrap my sandwiches and wash them down with sparkling cold water. If it were summer-time, I might have a plunge. Eohippus nibbles the bushes until I mount; then 'home again, home again, jig-a-jig-jig.'

One day, when I was unable to make an early start, I was much later than usual in returning from my rounds. The cattle had awakened from their afternoon siesta and were grazing on the mountain-sides or licking salt in their accustomed places. Suddenly I encountered an animal that I had rarely seen at close quarters, one of the few big steers which are still on our range and which we fatten for beef as we catch them. This big, black, part-Galloway steer was making one of his rare trips to the lower country near the home ranch. If I did not catch him, by morning he might again be hidden in some high, inaccessible spot. To bring him in would be a big feather in my cap.

Alone, much on the alert, he stood his ground and eyed me coolly, confident that back of him were the familiar trees and boulders among which he could whisk if I made a move in his direction. I knew all that as well as he did and carefully made no move toward him. Instead, I galloped off to where, near-by, I had seen some gentle cattle and I drove them to the place where the big steer still stood. Leaving the cattle together to fraternize, I hurriedly rode to the nearest gate leading to a small pasture where I could safely leave my precious catch for the night. It was a miserable gate for the purpose, none too wide,

unflanked by a wing or a fence corner. Unpromising as the narrow opening was, it had to do. I opened the gate, propped it in place with a stick, and rode back to my cattle. Gently I urged them along the fence toward the gate, hoping that it might occur to the lead cow that the feed was better inside the pasture. The steer seemed to like his new companions and came along with them very amiably. Up they came, clear to the gate; the lead cow looked upon it favorably. Then, just as she had made up her mind to enter the pasture, a sudden gust of wind blew up from nowhere and slammed the gate squarely in her face. Frightened and incensed, she took to her heels, the rest of the cattle running after her in a panic.

Once more I propped open that gate and this time I did a good job of it; barring a hurricane, that gate would stay open until the cows came home. After half an hour of hunting through the wooded river-bottom, I found my cattle, the steer still with them, brought them back to the gate and coaxed them through it. Not until I had closed the gate firmly and wired it for greater security did I realize that it was almost dark. By now Charlie would be imagining all sorts of dire things: that I had been caught in one of my own traps; had been thrown or knocked from my horse by a low-lying limb. I mounted my horse, who was anxious to go home, too, and flew down the road. As I came in on the dead run, I found Charlie saddling up his own horse. He was equipped for a relief expedition, with a dog to find me, a flashlight to see me, a blanket in which to wrap me, and restoratives and bandages galore.

'All right this time,' he conceded, when I told him about catching the long-wanted steer, 'but don't do it again.'

For the time being, the trapping is over. The ground is frozen and we cannot see the wolf tracks if there are any wolves here. We have found no new kills, no sign of any

sort. The last time I made my rounds, I sprang the traps, covered them with brush, and left them there so that they may be unstaked and brought home. On that last day I did catch something, too.

Charlie celebrated the holidays by having the flu; not very seriously, but enough so that he could not safely prowl about on windy mesas and damp, drafty canyons. We had a boy visiting us, and after dinner on Christmas Day, he and I saddled up and rode out on what I knew would be my last trip along a trap-line for some time to come. The day before I had sprung all of the traps in the main canyon, thus shortening the line by a half. We rode along the familiar way, pierced by a wintry wind, crashing the ice in frozen pools. As we reached each trap in turn, I was delighted to find it empty and sprang it with pleasure. The boy was not so pleased. He was all eagerness to find a wolf, or, if that failed, any animal at all. Down into Coal-Pit we descended and, as we neared a trap, I saw a slight movement, then a little animal peered at me through the trees.

'Oh, dear! We've caught a poor fox!' I exclaimed, hoping it might not be badly crippled and that I might be able to let it go.

'No, it is a small coyote,' I guessed again as we approached. Closer still we came and the little animal, deeply held by a front paw, cringed, bared a row of little, white teeth in a snarl — then wagged a pitiful, propitiating tail!

'A dog!'

'Poor little doggy,' I said coaxingly, as we dismounted and went up to her. Prepared for anything that we might do, the doggie snarled at one end and wagged at the other. I took off my heavy, mooseskin jumper and threw it over the little dog's head so that she could not bite me. Then

I knelt and took hold of her. Ray stood on the jaws of the trap, rested his hands on my shoulders and, when I gave the word, he came down on the jaws with all the force of his slender legs and I lifted up the little, mangled paw as the trap opened for an instant just enough to free it. Gently I rolled back the jumper, still holding the dog, and now there was no more snarl, only a tail-wag, as grateful as the starved, half-frozen little creature could manage. Not much to look at, our catch, brown, gray, white, spotted mongrel that she was, but I adopted her instantly.

'She looks like a fox. Foxy shall be her name.'

We took her down to the river and let her drink the little she wanted of the icy water. Ray held her while I swapped saddles on our two horses. I had let him ride Eohippus, as being the more willing to carry a tenderfoot. Now we were on our way back and Blue Bell would not mind whom she carried if headed for home. I did not trust her to behave very well if the dog struggled and clawed her. I mounted the little Eohippus, who carries anything anywhere. Ray lifted the little Foxy dog up in front of me and, to my surprise, she leaned against me and made no effort to escape. As I held her with one hand and guided my horse with the other, she swayed with every movement of the horse like a born equestrian. Ray wondered where she came from, and my only surmise is, that, like many other poor, animal pets of which callous people are tired, she had been brought into the mountains and turned adrift to make her living in the wilds as best she could.

Charlie was sitting in front of the fireplace, in a big chair, wrapped in a blanket like a proper convalescent, when we came in and put the little dog in his lap. Robles was all excitement, but the newcomer seemed to understand that his demonstrations were friendly ones. I warmed a bowl of milk and dropped in bread with such a liberal

hand that the poor starveling would have been promptly killed by kindness had Charlie not stopped me. We fixed up a boxful of sacks and a piece of an old quilt and put her on the porch by the kitchen door to sleep. In the morning she was not to be found and already I mourned for her, fearing that she had wandered off on her mutilated paw, to starve miserably.

'Foxy! Foxy!' I called. To my delighted surprise she hopped into sight, dragging along a huge bone, buried treasure of Robles. She was foraging for her own breakfast. Her little paw had to be taken off at the first joint; it was crushed and frozen beyond saving. She gave only one moan when Charlie held her on his lap and with his knife severed the few shreds of skin and sinew from which the paw dangled. Then she settled down on the warm hearth-rug to lick her wound.

A little later I heard a very vigorous smacking sound — 'Lick! Lick! Lick!' Lying beside her in front of the fireplace, Robles was licking Foxy's paw.

CHAPTER XI

'CHARLIE RAK IS LUCKY'

WHEN I awoke for the second time this morning, a forgotten kerosene lamp was still burning on a wall-bracket in the kitchen. The stove was cold. The remains of a four-o'clock breakfast littered the table in an unappetizing mess. Looking at the clock, I figured that since I had crept, shivering, back to bed, Charlie must have had time to reach Douglas, providing that no road or tire grief had delayed him. I blew out the pale, artificial light, for that of the sun shone into the kitchen windows, making our night's work seem like a bad dream. Yet it has a grim reality and a commonplace quality from having been repeated thrice a week for some time past.

There is absolutely no chance to sell cattle by the head. There is no demand for steers this time of year and we have plenty of demands for money. We said 'Hello!' and 'Good-bye!' to the cash that Charlie received for the steers he took to California, on the day the check was deposited. The only tangible thing that remains from the price of those steers is a felt hat which Charlie bought in Los Angeles, so that he need not advertise our lean purse to our relatives there by shabby, broken headgear. Even of that hat we see little. Goodness knows when he can buy another, and this new one is dusted and kept in a box on the closet shelf, for worthy occasions.

The only ways that Charlie can think of in which to get cash for our expenses are by selling wood and beef. To make money, one must first spend money. Wearing his old hat and a pair of clean, much bepatched, corduroy trousers, Charlie went to town and borrowed from the bank enough money to buy grain with which to turn our grass-fed

steers into grain-fed beef which can be sold in the local market. I wanted Charlie to put on his best clothes when asking for the loan, but he would not.

'If Jim McKinnon sees me coming into the bank in these clothes, he will know that I need the money and let me have it,' he asserted. It seems to have turned out that way.

Hay we have, and elbow grease to pitch it into the mangers is not lacking. We began feeding these steers before the big snow from which we now date time; now they have reached a stage of fatness that enables us to sell them.

The wood-selling part of our attempt to turn an honest penny involves still more work. Some months ago, Mexican wood-choppers cut the cordwood and it has seasoned all summer and fall. On burros it was packed here and stacked in long rows beside a fence. To sell it, we must saw it into stovewood lengths or into big chunks for burning in a fireplace. Charlie uncovers the thundering, screeching monster that is the power saw. Greatly I fear it, but I do not tell him so because there is no one else to help him. We put on lumber-handlers' gloves, re-enforced with steel in the palms. We wear clothes that have been snagged and torn in previous sawings. Stick by stick, I pick up the four-foot lengths of wood. Charlie pushes it toward the whirling, circular saw.

'Whe-e-e-e! Zup!' screams the saw.

We feed its insatiable appetite with another stick and another, which it savagely bites in two. We cannot even lighten the work by conversation, as much as we like to talk. Saw and engine deafen us; we communicate when we must by signs. When a cord and a half has been cut, Charlie turns off the engine, the saw turns slowly and more slowly and more slowly until it comes to a standstill. We shake clouds of sawdust from our clothing and wipe it from our faces. Tenderly, Charlie daubs the saw with oil and

ties a canvas cover around it. 'A merciful man is merciful to his beast.'

Next, Charlie fetches the truck and backs it up to the pile of wood and we throw the sticks into the high frame, built to hold a cord and a half. Eighteen whole, round dollars he will get for that when it has been hauled to town. My! My! That is, he will eventually get eighteen dollars. Frequently, men who are regularly drawing good wages ask Charlie if he can't 'wait until next pay-day.'

We like to have the wood-sawing over and the truck greased and ready for the trip by the middle of the afternoon. Then follows the most miserable part of the business, taking a heavy toll from both of us, to whom it is revolting. I collect all the knives, cloths, buckets, pans, and other tools that we shall need. Charlie takes a rifle and goes over to the corral, to isolate, then shoot, the fattest steer. After I have heard the shot, I go over and together we work until we have the beef, unskinned, suspended high by a pulley hung on a cottonwood tree. We clean our tools, ourselves, eat a little supper, and go to bed. The alarm clock is set for three A.M.

When the alarm wakes us, Charlie builds a fire in the kitchen stove while I am dressing. We fill the stove chock-a-block with wood, put on kettles of water which the truck will demand before it starts, and then, unwillingly, we leave the warm kitchen and go forth with a lantern to do the coldest job at the coldest hour in the twenty-four. We still have to skin the beef. Leaving the hide on overnight means that the beef will be of a better color and that may add a cent a pound to the price. We lower the beef to a canvas spread below where it can be worked upon. I hold the lantern so it will cast the light wherever it is needed. Charlie, with hands numb from the cold, skins the frozen beef, then splits it into halves. We

pull it up again into the tree and run back to the warm kitchen. While Charlie thaws out his hands, I prepare the breakfast. Before we eat, he goes out to the truck with kettles of boiling water for her breakfast. If luck is with us, the engine turns over promptly, and, when we have eaten, we drive over to the corral and stop under the tree from which the beef is suspended. A clean canvas is spread over the load of wood and the beef is lowered gently until it just touches the canvas. Charlie cuts away one fore-quarter. I stand by to take the weight of the remaining half so that it will not come down with a jerk. The other fore-quarter is cut; then the hind-quarters are lowered into the truck; the canvas is wrapped and lashed down. I run ahead to open the gates and Charlie starts off on his long, cold drive. He must arrive in town with the beef before the sun beats down upon it.

The last time that Charlie returned at dusk from one of these trips, tired, cold, and hungry, he was more discouraged than I had ever before known him to be. The butcher to whom he sells the beef had, as usual, many complaints to make. According to him, our steers are always too thin, too fat, too small, or too large. We expect him to run out of disparagements in time and repeat himself, but he is an expert at fault-finding. Charlie has to take it, for we have put our borrowed money into grain and fed it to the steers. He can't quarrel with a purchaser, however much he would enjoy doing so. As an added grievance, a blowout had made it necessary to buy an expensive new tube and casing.

'If I ever do make money and have a good ranch and fine cattle, all paid for,' said Charlie, 'I know that some poor fool, who never did an honest day's work in his life, is going to say, "Charlie Rak is lucky" ... And when he does, I am going to hit him, right square between the eyes!'

CHAPTER XII

WILY WILHELMINA

A LONG-AWAITED Government trapper arrived last night. He says this place is a little heaven and that he is tickled to pieces to come here. For months he has been camped on the cold, wind-swept foothills, and he spent most of last summer in the hot, dusty, Sulphur Spring Valley, trapping for some mangy, chicken-stealing coyotes. When he heard that there was wolf sign in the lovely, wooded mountains, he came as soon as he possibly could. His name is Eddie Anderson and his fame as a trapper has preceded him. Look out, wolves!

We offered him an old adobe house for a camp, which he declined, saying that he likes better to live in the open when he is in a sheltered canyon, full of trees and streams. He has a boy with him and today they built a convenient fireplace of rocks, arranged their camp, and hobbled the two old mules, Jim and Jack, that Charlie is lending them to ride. Drawing on the ground with a stick, Charlie traced a careful map of the canyons and ridges where he has seen wolf sign recently. While he and the trapper were talking, Robles sat down and waved his tail back and forth across the map and it had to be drawn all over again. Tomorrow, unless it storms, Mr. Anderson will go out to set his traps, and he says that Charlie may go with him, thus admitting him to the fraternity of trappers, since he knows that Charlie has himself caught several wolves.

Like all the other trappers, Mr. Anderson must throw an air of mystery around his proceedings. He told us in a

very low, confidential voice, as though a wolf might over-
hear, that he intended to set the traps in a certain way and
bait them thus and so. If a wolf came around and was not
caught, the traps would be taken up and reset in another
method which was much better. If the wolves still shied
away from the scent, he would then resort to a very supe-
rior way of arranging the traps — one that never failed.

'If the third method never fails, why do you not try it
in the first place?' was my natural question.

He answered only with a grin, leaving me to puzzle
that out for myself. I believe that I have done so. Mr.
Anderson is giving the wolves an intelligence test!

The sky has been gray all day, the air still. It is late in
the season for snow, but that does not count at our altitude.
Flakes of white floated past the windows by the middle of
the afternoon. Wilhelmina, a milk cow, was due to have
a calf, and it was better to have her under cover, lest the
baby perish from being born at night in a snowbank. I
went out to see if I could find the cow and bring her in
before dark. I found her all right, a hundred yards from
the barn, on the ground, groaning and moaning. She
paid no attention to my persuasion and when Charlie
arrived on the scene he had no better luck. She refused
to stand, even when he tried to 'tail her up.' Mr. Hampe
is visiting us, and we three walked around and around the
cow, coaxing her and saying, as the man did in the old
song, 'Consider, good cow, consider.'

Since she declined to consider, we had to, and the ways
and means committee decided that there was only one way
of getting her into the barn. Charlie took her by the horns,
Mr. Hampe by the tail, and alternately they pulled. Foot
by foot, Wilhelmina was dragged nearer to the barn. Luck-
ily, the way lay downhill, which helped quite a little. All
that I could do was to go ahead to open first the corral gate

and next the barn door. Finally we had her at the entrance to the shelter of the barn, and then we did consider for sure. The barn door is a double, sliding affair, made to admit a wagonload of hay. Sunk in the ground between the halves of the door is a post for them to rest upon when closed. It is several inches high and there was not room on either side of it to drag Wilhelmina through.

Exhausted from hauling her, Mr. Hampe and Charlie leaned against the door frame and looked at that cow. She looked at the post. All at once, to our utter amazement, she got up with no help whatever, walked into the barn, and again collapsed on the barn floor.

There was nothing said. Words were inadequate. We closed the barn door and left her there.

Twice since, Charlie has lighted a lantern and gone to look at the cow. The first time he went, he found that the calf had been born. The second time, Wilhelmina was up and eating hay. I am afraid she put one over on us.

CHAPTER XIII

BROTHER ANDERSON

I REMAINED at home to dig and delve in dusty corners this morning while Charlie rode off on his shiny bay horse, Chukie, in search of the horses running loose on the range. He likes to see them frequently and thus be sure that they have not been cut by wire or met with some other accident.

My mare, Blue Bell, was left in the corral for my use this afternoon. Although she had a mangerful of hay, Blue Bell was not a bit pleased at being left there all by herself. She is a small blue roan, beautifully formed, both spirited and gentle. Mr. Meadows, of the O K's, one of our neighbors, gave her to me when we first came to the ranch and to me her price is above rubies. Although she was born and raised a few miles from here, she had never worked cattle until I owned her. Her former owner, from whom Mr. Meadows got her, used her only to jog about the countryside. At that, he frequently limped home, leading her by the bridle, complaining, 'Blue Bell threw me off!' She and I went into the cattle business together, and I must confess that she learned her part a very long time before I learned mine. She loves to work cattle, and if I ride out upon her and pass a bunch of cattle without stopping, she herself halts, stamps her foot and paws the ground, as though to say, 'What is the matter? Are you asleep? Here are cows and you are doing nothing about it!'

Once she knows what we want to do with the cattle, I need do no more than stick on her back. She does all the rest. No brush is too thick, no hill too steep and rocky, if

there are cattle to be kept in sight. One day we were in full cry after a bunch of wild, young cattle and I was so intent upon trying to keep them in sight, as they scampered through the woods, that I paid no attention to anything else. Sure-footed Blue Bell could safely be trusted to find the shortest way and the best footing. Suddenly I felt my legs growing cold, and there we were, in the deepest pool of the river and Blue Bell was swimming her best for the opposite shore. She wanted to beat the cattle across, and she did beat them, too. When we are driving cattle, if they move along too slowly to suit her, she goes back and forth behind them, biting the slowest ones on their tails. One or two nips are enough to teach the pokiest old cow that she had better strike up a faster pace.

Charlie came in at noon to report that the horses on the range are all well and accounted for. After we had eaten our own dinner and the horses had their grain, we saddled up. I mounted inside the corral and Charlie led Chukie through the gate and closed it before mounting. Talking to me and thinking of anything except his horse, Charlie put his foot in the stirrup, swung into the saddle, and said, 'Let's go.'

I started off ahead, then turned when I heard a commotion behind me. There was Chukie, pitching for all he was worth, doing his best to sun Charlie's moccasins. Charlie was still riding him, with such a look of astonishment on his face. Here was a supposedly gentle horse, grain-fed and ridden for weeks past, starting in to pitch like any raw colt on a frosty morning. When Charlie had the horse quieted down, he again said, 'Let's go.' Once more I started. Again Chukie ducked his head, bowed his back, and tried changing ends with himself. This time the horse succeeded in coming back under the left stirrup and Charlie lost the right one and could not get it again. Fences,

trees, a well-pump, corral posts, and rocks of all sizes and shapes surrounded us. There was little chance of landing in a soft spot in case of being thrown. In one corner of the water-lot a gate which led to a small corral stood open. Chukie pitched his way toward it, and as he bucked through it I saw Charlie kick his left foot out of the stirrup, drop the reins, and throw both arms around the tall gatepost. Chukie pitched on, riderless, and Charlie dropped to the ground, laughing.

'Shall you get another horse from the pasture?' I asked.

'And spoil Chukie? I should say not!' he answered. 'He has to be ridden this afternoon or he will think he is an outlaw right.'

We went into the corral where Chukie was now standing quietly, looking as peaceful as any elderly plow-horse. When Charlie walked up to him and picked up the reins, he jerked back and tossed his head as though he feared punishment, knowing mighty well that he had misbehaved. Charlie talked to the horse soothingly, tightened the cinches, and prepared to mount. I rode nearer and Charlie turned his head to look at me, his eyes big and almost bulging out of his head. I knew what was the matter. Almost every man who has broken horses during his boyhood is afraid of a pitching horse in after years and never mounts one if he can avoid it. Charlie explains that this is because they have all been thrown repeatedly; have picked themselves up, badly bruised; or have been picked up with broken bones. He was wondering which might happen to himself within the next two minutes. There was no use in putting off the attempt, for that would only make the horse nervous. Charlie mounted swiftly and sat deep in the saddle, waiting for something that never happened. Chukie walked off as staidly as though he had never heard of pitching and we rode out to do our afternoon's work.

'That horse just had to have his fling,' I commented.

'He's welcome to it,' replied my husband, 'just so long as he doesn't fling me.'

The particular work we had to do that afternoon was to decide upon what part of the range to turn out some cattle that we had been feeding for some time. They could have been turned out much sooner had this spring been a normal one; yet it was not for lack of rain that we suffered this time. There was an abundance of rain and snow as well. Cold, frosty weather, continuing later into the spring than is usual, even at our mile-high altitude, checked the growth of the grass and held back the sap in the trees. The oaks are not yet fully leaved out anew; the walnut trees, incautiously putting forth a few leaves, still bear them, black, shriveled, frozen. We shall not sit on our horses under the wild-cherry trees this year, reaching for handfuls of their bitter-sweet fruit. The cherry blossoms were nipped by frost. The wild-grapes, wisest of weather forecasters, festoon the trees with loops of brown vine on which there is neither leaf nor bud as yet. Foxes shall have their grapes — if they can reach them.

In some of the sheltered canyons, on sunny, southern slopes, the season is farther advanced. To such a place we intend to take the cattle we have been feeding and be through with that work. The steers which we fattened have all been sold and the cows should be able now to take care of themselves. We are tired of making our rounds with hay and cottonseed cake. We are even more tired of the man who has been helping us and earnestly desire to see the last of him. We needed a man for only a short time and, not being able to get a good one for temporary work, we took Mother Ortiz's youngest son, Luis, who had returned to our mountains and was working in a wood-camp.

As a guitar-playing wood-chopper or a wood-chopping guitar-player, he may be a great success. As a puncher of cows, he just is not there. He mopes along on a gentle horse, looking neither to the right nor the left, apparently in a day-dream. When there is a gate to be opened, Charlie wakes Luis and tells him to do it. After we have passed through, Charlie tells him to close it. He does remount his horse without being told. On foot in the corrals he is totally helpless, except that he can follow us about with buckets of grain or forkfuls of hay and put them where he is told. Charlie is in a rage most of the time because he has to put up with such a helper, and I try to calm him with old saws, such as, 'Half a loaf is better than no bread.' 'With all the work we have to do, even an extra pair of arms and legs are useful. We can use our own heads.' Daily I make these soothing remarks and Charlie grits his teeth and resolves to endure Luis for one day more. And now the laugh is on me.

Charlie had to go to town to meet some friends who were to spend a few days with us. I had my hands more than full while he was gone. The house had to be tidied, for I had been spending much more time in the corrals than in the house. Pies and cakes had to be baked and these preparations for our guests' comfort were sandwiched in between demands for my aid and advice outside. I expected Charlie to be back with our guests by six o'clock, and at five I had everything ready in the house and my dinner as nearly prepared as I could before they arrived. Now it remained to feed fifty cattle of all ages, sizes, and tempers. They must be separated into small groups and some timid ones must be fed in little pens, quite alone. I went over to the corral, told Luis to work the gate for me, and sailed into that bunch of cattle, now herded together in the big, round corral. I cut out one

that I wanted to feed separately and started her toward the gate. Luis fell over his own feet, let some cattle through that I didn't want, then slammed the gate in the face of the particular cow that I was after.

Spanish words of dire import surged, sizzling, to my lips. I wanted to annihilate that man. Just in time to keep myself from trying to do it, I recalled all the preaching that I had inflicted upon Charlie, with patience as my text. It would never do for me to fly off the handle and get rid of the man the first time I was left alone with him.

I left the cattle and walked over to where Luis was leaning against the gatepost.

'It is growing late,' I sweetly said; 'I think you had better go home. That is all for the day.'

Without showing the least surprise, although he knew that we were in the habit of feeding the cattle every afternoon, he strolled off in the direction of the wood-camp. When he was out of earshot, I arranged the gates and tackled the job by myself. The cattle knew pretty well what was wanted of them and where they had been in the habit of eating, and somehow they were separated and fed. I had just finished when Charlie and our visitors arrived. When we had them settled in their room and Charlie and I were momentarily alone, he asked, 'Where is Luis? Wasn't he here to help you feed?'

'I guess I'll have to confess to you,' I replied. 'I sent him home for fear if he did one more dumb thing, I might kill him.'

After looking over the range this afternoon, we stopped at Mr. Anderson's camp as we were riding home from Red Rock Canyon, where we have decided to take our cows. He has seen nothing of the wolves beyond the tracks which

Charlie showed him shortly after his arrival. Around his camp he has the skins of skunks and bob-cats, stretched and hanging, and he says, 'Just let that big old loafer come back and I'll stretch his hide too.'

He and Charlie are becoming quite cronies. There is a school-teacher down in the Sulphur Spring Valley who belongs to the same church that the trapper does, and last week, when he came up for a visit, he called Mr. Anderson, 'Brother Anderson.' Charlie heard that and now he 'brothers' him too. We have learned that Mr. Anderson is a Connecticut Yankee and he told us how he happens to be away out here, trapping. He came to New Mexico many years ago for his health and he lived in camp away off in the mountains. Having nothing else to do, he rambled around and made the acquaintance of some men who were trapping for furs and catching predatory animals for bounty paid by cattlemen and sheepmen. These trappers would not tell the Yankee tenderfoot the least thing about their methods and just for that he determined that he would learn in spite of them. Bit by bit, he acquired the skill that won him a place on the United States Biological Survey staff. He says that he has since had the satisfaction of catching animals that had repeatedly gone past the traps of the very men who would not teach him. Now, he admits, he is just as loath to tell the secrets of his trade as they were.

Brother Anderson, tall, slender, and blond, rides the mountain trails on his mule, dodging the oak limbs that threaten to sweep from his head a straw hat of most unusual shape. Living out here in the woods, far from fashion's haunts, we were puzzled by that hat. Never have we seen one like it and asked, 'Is it the latest thing from Connecticut?'

Not at all. Finding a felt hat too warm while trapping

in another part of Arizona last summer, he bought that straw at the one remaining store in a dead mining camp. The proprietor told him that the hat had been in the store since silver was discovered in that place in 1885, and parted from the relic reluctantly for two-bits.

CHAPTER XIV

RED ROCK CANYON

WHEN we want to hear our visitors say 'Oh!' and 'Ah!' we take them to a little knoll back of our house and show them the mountains that rise on either side of Red Rock Canyon, crimsoned and glorified by the long rays of the setting sun. Glowing with reflected fire, the rocks stand out against the purple of more distant peaks and the pale azure of the evening sky. The canyon, a wooded gorge with a stream running through it, with walls which are mountains of red rock, ends in the silence of virgin pines, on smooth hills matted with the pine needles of centuries.

Alas! Cows are mundane creatures. They look upward only while they snatch a mouthful of leaves from a tree or a tuft of grass from a steep hillside. They do not admire Red Rock Canyon in the least. We have known that few cattle grazed there and that each year the grass on the benches above the floor of the canyon grew rankly, only to wither, untouched except by deer. In the winter the sun reaches the depths of the gorge for so short a time that the ground remains frozen for weeks and there is no colder place on the whole ranch. In summer the rock walls radiate a fierce heat and the windings of the narrow canyon give no sweep to cooling winds. I can't really blame the cows for not liking to live there. I no longer care for Red Rock myself — except at sunset and from a distance. One of our reasons for taking into Red Rock Canyon the cattle we had been feeding was the hope that their calves might come to like it and regard it as their home when they were grown.

The trail is uphill all the way and we wanted to land

the cattle in their new home before they were hot and tired. All night before the drive they had an abundance of hay and access to water; that prepared them to start off as soon as we could see. There was no reason why they should not drive like a bunch of saddle horses. At least we saw no reason why they shouldn't until we left the corrals and were driving them through the home pasture. The trail follows a fence along the bank of the river, and weeds had sprung up there, tenderly green. For weeks the calves had been kept up in the corrals and water-lot while their mothers were daily turned out to graze. Milk from their mothers the calves had, also hay, and barley mixed with corn-meal; all nourishing but not enticing. The smaller calves had never seen the world at all; the older ones had forgotten how it looked. All now frolicked, scampered from side to side, or lagged behind to snatch at a mouthful of green feed. When the calves deserted their proper place at the mother's heels, the cows became anxious and turned from the trail to bawl, refusing to move on until each had found her calf. Unceasingly we rode back and forth, traveling ten steps while advancing one. The sun was warming us by the time we reached the river crossing, less than a mile from home. There, although they had spent the night by a pool of water, all the cows and calves wanted to drink, after which each cow had to locate her calf and bawled until she had done so. On the opposite side of the river was a steep bank, ascended by a cow trail, at the top of which was a Texas gate. While the cattle were drinking, Luis was sent ahead to open the gate. It was the only use we found for him so far. While we had been trying to keep the cattle in motion, he had merely ambled on behind, half asleep in his saddle. There was little profit in waking him up and telling him to go to work because he would probably have done something to make matters worse.

All the cattle were induced to go through the gate except one little calf that lagged behind, then scurried past the opening without seeing it and ran beside the cattle, along the wrong side of the fence, bawling distractedly, butting his head against the wires in an effort to rejoin his clamoring mother. I ran around the cattle and stopped them. Charlie untied his riata from his saddle, dismounted, and climbed over the fence. The calf was used to seeing men on foot and Charlie was able to slip up close enough to rope him easily. Then he took the rope from the calf's neck, held him firmly by the flank, and shoved him under the fence. Again we proceeded, through the Hermitage corrals, across the river whose windings overtook us again, and drove our cattle into Coal-Pit Canyon. The calves were a little tired now and more willing to stay near their mothers. Without much trouble, we covered the half-mile to the junction of Coal-Pit and Red Rock, where there is a well-patronized salt-ground at the forks of the two canyons. Several cows and calves were licking salt or lying in the shade near-by as our cattle approached. These joined our bunch and renewed their acquaintance with old friends.

'Oh, Mrs. Whiteface! What a beautiful little calf you have this year! Is it a heifer or a bull?' — Or moos to that effect.

Very enjoyable, no doubt, but we had no time for bovine gossip and were obliged to break up the party. It would have been simpler to take along with us the cattle we had found on the salt-ground, but there were calves present who hadn't their mothers with them and cows that had come to lick salt, leaving their calves behind. I held the cattle, with some slight help from Luis, and Charlie cut out the Coal-Pit cattle and kept them from rejoining us as Luis and I turned our bunch into Red

Rock. A little way and we reached a gate, put our cattle through; dismounted to sit a few moments in the shade while the cows and calves cooled off and rested.

The creek-bed of Red Rock is porous and full of boulders; water runs on the surface in the lower part of the canyon only during the seasons of heavy rains or melting snow. Farther up there is plenty of running water nearly all of the time and there is one pool that does not fail except in the driest of dry seasons. To this pool, a mile above the gate, we planned to take the cattle; we were going to enclose them tightly in the canyon and must make sure that they knew where to get a drink. We mounted again and roused the cattle, some of which had lain down under the trees, and started them up the winding trail. The last to rise from her bed of leaves, the slowest to start, was a small, fat, red cow, which on that day we christened 'Pokey.' It was never necessary to wonder which cow would be at the very end of the slowly moving line of cows and calves. Even Pokey's calf moved faster than she and preceded her instead of trotting behind. Trees and thick brush lined both sides of a broad trail that had been chopped out for the entire length of the canyon, to enable us to handle the cattle there. Into the brush at this side and that, the cattle slipped, hoping to hide themselves so that we would pass them by and drive them no farther. This they did not succeed in doing because we were watching every move and always routed them out. Presently Charlie dismounted and handed me his horse's reins.

'I am going to prod these cattle on foot,' he said. 'I can get through the brush better.'

It did work well, but he was constantly having to leave one side of the trail for the other, when I called out to him that there were cattle hidden away on the opposite side.

Luis was placidly doing nothing in the rear. I dismounted also, gave Luis both Charlie's horse and my own to lead and took to the brush on the opposite side of the trail from which I could hear Charlie cussing the cattle into motion. The few animals that stayed in the open trail moved on reluctantly as Luis rode behind them, leading the two horses. At that, we were hot, exhausted, and thirsty when we reached the flowing water and next, the pool. There the cattle had preceded us and muddied and fouled the water so we could not drink.

Home once more, we paid off Luis and let him go back to his wood-chopping. We thought we were through.

The following morning we rode up to Red Rock to see if our cattle were taking advantage of the trails that had been cut for them and were going up to the higher slopes to graze in the sunshine. They may have anticipated our visit. At all events, there they were, every last, lingering one of them, waiting for us at the gate. We groaned in unison. There was nothing to do but drive them all the way back to the pool. This time we dismounted and left our horses at the gate. Never had we expected to regret Luis, but we did then, knowing that we should have to walk all the way back to our horses, for lack of him to lead them. Again we whistled, shouted, crawled under the brush, and prodded those cattle up the canyon, old Pokey still poking as before. Again we thirsted and went without a drink.

'Tomorrow I'll bring a canteen,' croaked Charlie through parched lips.

'Tomorrow! Do you think we shall have to do this again?'

Except for the canteen, the next day was but a repetition. So was the fourth day and yet the fifth. Only one thing encouraged us; each day there were fewer cattle at the gate and more on the hillsides, grazing. The morning

of the sixth day found only one cow and calf awaiting us. It was the persistent old Pokey, of course. Apparently she enjoyed the routine of up a mile and down a mile of the canyon each day; we had had enough of it. Opening the gate, Charlie drove them outside.

'Take your calf and go where you please, you old pest of a Pokey,' he said. 'If I never see you again, it will be too soon.'

Then we rode off to see the cattle on other parts of the range.

When we came home at noontime and rode up to the gate leading to the corral, lying in front of it, waiting to be let in, were a cow and calf that rose when they saw us. Having actually hurried to beat us home, there was Pokey!

CHAPTER XV

I HAVE AN IDEA

LITTLE Foxy dog, who has grown very dear to us, has given us the best token of her gratitude that her loving heart can suggest — a litter of puppies, of which Robles is the father. We were wakened early by a new sound from the clothes closet on which an old, sheepskin-lined coat made a bed for her.

'Oo-oo-oo! Ee-ee-ee! Uh-uh-uh! Oo-oo!' A never-ending querulous sound. I looked into the closet and Foxy peered at me over the heads of a row of squirming pups. No two of her children are alike; Foxy must be the result of the melting-pot of Dogdom. Robles, as a father, disappoints us. He averts his face as he passes the open closet door; he growls and goes out-of-doors so that he need not hear his children whimpering, 'I want a drink! I want a drink!' I can see that he is not the kind of father that will get up in the night and fetch a drink for them. I shall have to do that.

When Foxy left the house for a brief outing, going out by the back door, Charlie scooted out at the front with some of the puppies, 'Oo-oo-ooing' in a sack, and ran to the river with them. We were afraid that Foxy might make an outcry on her return. Instead, she reviewed her diminished family, wagged her tail to indicate that she was glad we had relieved her of so great a responsibility, and curled herself cozily about the two pups that remained. One looks like her, not too great a compliment, brown, white, yellow, black. One is black, with minute white paws and a little white vest. I gave Foxy a bowl of milk fresh from the cow and she lapped it up eagerly. Then

I called Robles and we went over to the barn where the horses awaited us. We shall miss Foxy at our heels when we ride. She has adjusted herself to her handicap of three legs in a marvelous manner. Her one front paw has grown perceptibly larger from doing double duty and the shoulder muscle bulges from use. With that paw planted directly under her chin to balance her, the little stump of the other leg hugged close to her breast, she propels herself by the hind legs so rapidly that the short-legged Robles is always panting in her wake. When they start up a rabbit, her shrill 'Ki-yi!' is way ahead of his deep 'Bow-wow!'

That Foxy has puppies is not the only event worthy of note which has taken place on our ranch recently. I have had an idea! Let the wild bells ring out! I have had a constructive idea about a cow!

After years on a cow ranch, learning with painful slowness the ins and outs, the whys and wherefores, I had entirely given up hope of ever making a suggestion which would be accepted and put in practice if it concerned the handling of cattle. Even now, my modest idea is not an epoch-making one that may presently revolutionize the cattle industry. It may even not work right here. Still, it is to be tried and I am vainglorious.

To one of my neighbors I shall tell all this and be sure of a sympathetic hearing. That is Mrs. Frank Moore. As a girl, Augusta Heyne, she came to this cattle country direct from New York City. She married a cattleman and, as fast as she was able to grasp the conditions under which cattlemen lived and worked, she applied her goodly store of common-sense to their problems. Those were the days of the open range, when cattle drifted wherever they chose between the semi-annual round-ups. Naturally the beasts liked to stay where the feed was best and the water accessible, and as Moore's range was better than some of

the surrounding country, cattle came from long distances to hang about Moore's well and eat his grass. To be sure, these cattle were gathered up from time to time and taken back to the range where they rightfully belonged, but that did little good. They headed right back and sometimes arrived again at Moore's ahead of the very cowboys who had driven them away.

Exasperating and injurious as all this was, the men saw no help for it. The young girl from New York did see a remedy.

'We should have a fence around our ranch,' she declared. 'Every cattleman should have a fence around his ranch — and keep his own cattle in and others out.'

Oh! My! My! What a good time all the countryside did have, joking Frank Moore's New York bride about her fences! — And now there is a fence around every ranch in the whole countryside, including Frank Moore's.

Well, to go back to my own idea.

A few days ago we rode out in the late afternoon to see what we could see. Cattle were coming down to water at the river and there was a chance of finding there some cattle that usually run a long way off and in rugged country. We saw a good many cattle and among them a heifer which was dangerously thin, having just had her first calf. We rode among the cattle and every calf there ran to its mother. When all the calves had paired with mother cows, there remained none to be claimed by our little heifer. She had left her baby, goodness knows where, in the care and custody of some kind friend. It does seem almost too good to be true, but cows that range a long distance from water are in the habit of leaving their small calves with one cow to look after them, while they go for a drink.

This heifer needed to be kept up in the pasture and be

fed grain besides, yet we must first catch her with her calf and bring them in together. If we let her go, she might go elsewhere to drink the next time she was thirsty and in our wooded range she might not be easily found. Charlie solved the problem very simply.

'We shall drive her to the home corral,' he proposed, 'together with some of these gentle cattle. There we'll put the big Swiss cowbell on her neck and turn her loose. In the morning we can find her easily enough by listening for the bell; she will be with her calf and we can catch them both.'

We carried out that bright suggestion and it worked perfectly. On the way home with the heifer and her calf, I pondered over an idea which I was reluctant to put into words, so many of my other ideas had been scorned when they had to do with cattle. At last I voiced it.

'If we could find this cow so easily because she had a bell on, why do we not buy a whole lot of bells, put them on gentle cows, and then, when we go into the mountains looking for cattle, one bell may lead us to a whole bunch of cows which are in the thick brush where we can't see them?'

Charlie, riding ahead, turned to regard me sternly. While I awaited the withering of my suggestion, he said, disgustedly, 'Why didn't you think of that long ago?'

And the wild bells shall soon be ringing out.

CHAPTER XVI

'PORE FOLKSES' WHITEWASH'

IT IS too late in the spring for a snowstorm; nevertheless, we have just had one. The snow is now melting fast and the river rampages. Charlie is over at the Spear E Ranch for a few days and I have been prowling around to see what is going on, as I always do when he is not here. In rubber boots I waded through the soupy corrals where I have choked with dust so many days that I never complain if it is muddy.

Before Charlie left, he told Luis to take extra good care of Sunday, a milk cow which was soon to have a calf. She must be put into the field in the morning and be brought back at night; she must be fed liberally on grain and hay. Luis told me this afternoon that she would not eat her hay and was bawling. Perhaps she was sick?

I looked her over and asked, 'When did that cow have a drink of water?'

'I do not know,' replied Luis. 'I have not seen her drinking.'

Wretched cow! There was no use in scolding Luis. He came here to work for a day or so, for lack of a better man. The boss had not included watering the cow among his instructions and he had not thought of it for himself.

'Take her down to water now,' I commanded, 'and see that she has a drink every day from now on.'

Of course the poor beast had refused to eat dry hay. I would not care to munch on soda crackers when I had been two days without a drink.

Luis left the cow down by the spring, with the gate open so that she could come back to the barn. A little before

dark I went out to see that she was brought in for the night. There might be a heavy frost following the storm and a calf that is born outside at night, and has no chance to dry off, may die of pneumonia. Sunday had not returned to the barn and I followed the sound of the bell which she wore. There, under a tree near the pool, in a mess of half-frozen mud and snow, lay her baby calf, two minutes old. The mother was up and licking it. I slopped back to the barn and found some old grain-sacks and down I went again with them under my arm. I threw the sacks over the wet calf, already shivering pitifully in this cold world. Then I dragged the calf to higher ground. Being a milk cow, the mother did not object beyond waggling her head at me. She did resent the presence of the dogs, Robles and Foxy, and ran at them when they dared come too near.

Using the sacks for towels, I dried the calf somewhat and next tried to help it to stand up on the four, knobby, wabbly legs. After several efforts, the baby calf co-operating nobly, we got her on her pins and she started nosing around for the bag of milk that Nature told her should be somewhere around. At this point, Sunday gave the calf such a vigorous swipe with her rough tongue that the precarious balance was lost and the baby collapsed in another slushy mud-puddle. All had to be done again, toweling, lifting, and wabbling. I wanted to get them to the barn, but I couldn't carry the calf and it could not climb the snow-covered hill.

'There's never a man around when you need one!' That is the time-worn complaint of every ranch woman.

Luis finally did show up and we started a procession toward the barn, Luis in the lead with the calf in his arms. Sunday followed, sniffing anxiously at the calf's dangling legs; I next, with a stick, lest Sunday should decide to

molest Luis; the interested dogs bringing up the rear. Wilhelmina and her calf were already in the stable, snug and dry. Snow or no snow, the belated spring is on its way to Rucker. We have two baby calves in the barn to prove it.

Spring — housecleaning. Unhappy sequence!

Lately, when Charlie has gone off for the day to ride on a part of the range so far from home that he has taken a lunch along, tied to his saddle, I have spent hours with saw and hammer, cutting and contriving. The Dane Coolidges are coming to visit us and they are both authors. I must make a desk for the guest-room — for who could be more out of their element than authors without desks? Unless it be a cattleman without a cow?

With pride I have written the words 'guest-room.' Until this past week it was merely a tiny, back room with a big bed in it. When I announced my intention of beautifying it, Charlie sniffed at the idea.

'Call that little hole a guest-room? Why, you have to go outside to change your mind.'

Naturally I was then determined to make him change his own mind.

Ceiling and walls, of bare and knotty lumber, were my first problem. Paint costs money, making it quite out of the question. Paper, over those great cracks, would not do. How about whitewash? That was a possibility, but I did not have the least idea how to go about making it. I called upon a neighbor who is known as 'Grandma Winkler' to the whole countryside. She has spent a lifetime on the frontier and knows all the shifts by which one can make something out of nothing.

'Whitewash?' she asked. 'Well, all I know is pore folkses' whitewash.'

'That is just the kind I need!' I cried. 'For goodness' sake, tell me how to make it!'

Simply enough, as I soon learned. Take a lot of butter-milk; into that sift wood ashes until the mixture is stiff enough to cling to a broom; then smear it on the wall. With this splendid recipe, she presented me with a gallon of buttermilk and I hastened homeward. First I tried the stuff on a board and let it dry. It came out the prettiest French gray that can be imagined. I dipped the brush deeply into the bucket and sailed into my room. The gallon of buttermilk would have done the ceiling, I feel sure, only that the force of gravity poured so much of the whitewash down upon the floor and me. Until I bathed and washed my hair, I was a lovely French gray too, from head to toe. To get more buttermilk I had to churn. For days I churned, sifted ashes, painted and churned again, until ceiling and walls were all daintily smeared.

Before doing the whitewashing, I had taken down the bed and carried it outside. It was a huge, old-fashioned, wooden double bed, which we found on the ranch when we came here to live. The headboard rose almost to the low ceiling and when the whole contrivance was put together, it wabbled. The headboard leaned forward; the footboard leaned inward. No amount of propping with blocks of wood could make it stand straight. To roll over in the night was to invite a slat to fall out with a clatter. I hated to bring that monstrosity back into the house.

Now the room was a curious 'L' shape and perhaps — just perhaps — the springs alone could be set up in that 'L' and make an alcove bed. I measured the springs with a tape-measure and then measured the alcove. The springs would fit in there — maybe.

Long hidden and hoarded, I had four wooden boxes, all alike, into each of which two five-gallon coal-oil cans had once fitted. I put those in my alcove to serve as experi-mental legs for my bed. I bided my time until I was alone

on the ranch with two Mexicans. I called then upon Luis and José, told them to bring in the spring and set it up on the boxes. To my great disappointment, it just missed going in by the merest fraction of an inch.

'Go over to the shop and get an axe and a sledge-hammer,' I told them. When each was supplied with a weapon, I started the spring in the way it should go and said, 'Now! Hit it! First one of you and then the other!'

The first strokes took the spring in an inch or so.

'Charlie won't like this!' warned José.

'Hit it again!' And it went in a little farther.

'The *patrón* will be very angry!' predicted Luis.

'The *patrón* runs things outside of the house and I run them inside,' asserted I. 'Keep on hitting it.'

The spring is there for keeps, until the house falls down. The experimental legs of coal-oil boxes are there too. My bed has a permanent Rockefeller Foundation. Valances, curtains, all are in order. It only remains to print a little verse and tack it up over my alcove bed:

> 'Come one, come all! This rock shall fly
> From its firm base as soon as I!'

CHAPTER XVII

'THE BIG OLD LOAFER'

ONE afternoon, Brother Anderson returned our visit, seeking sympathy. He was disconsolate; his professional pride had been injured. The wolf had come — and gone again. When he set his trap-line upon coming here, the trapper cunningly arranged one trap on Lobo Mesa, employing his utmost skill. After he had it set to his satisfaction, he said to Charlie, who was looking on admiringly, 'If that big old loafer comes along and smells the scent, he is going to put his foot right here.' He touched his finger lightly on the hidden trigger that springs the trap. The 'big old loafer' did come along one night; he did smell the scent and paused to investigate its source; but he put his foot just one inch too far to the left and never learned that a steel trap was concealed there.

'Just one inch to the right and I'd have had him!' mourned Brother Anderson. Hands clasped before him, teetering back and forth on his toes, he gloomily told us that there were two wolves, one large and one small, judging from the size of the footprints and the length of the stride. The big wolf left on the ground the mark of a crippled paw. Sometime in the past he had been caught and had purchased his freedom at the price of two toes.

'That's bad! Awful bad!' lamented Brother Anderson. 'Once a wolf has been caught or snapped at by a trap, he is mighty hard to catch.'

'Why do you not try your method number three?' I asked. 'The one that never fails?'

'Oh, I'll get him! Don't worry, I'll get him. Only it will take me longer, that's all,' declared Brother Anderson.

For ten days after that, the wolves forsook our range and the trapper made his daily rounds for nothing. When the lobos again paid us a visit, instead of coming down the Main Canyon, where traps were set in an enticing row, they came through Brushy Canyon, where there were no traps at all. Turning down the automobile road, they impudently left two sets of footprints above the tire tracks; then turned into Devil's Canyon, crossed the divide and passed out of our range by way of Bruner Canyon.

Brother Anderson trailed them for several miles, then returned to teeter on his toes again and tell us of his hard luck. It seemed that he needed those wolves. There is a keen competition among the Government trappers, based upon their monthly catch. Two lobos would almost certainly ensure Mr. Anderson the coveted place at the top of the honor roll for the month. Also he had been receiving letters from the Inspector of the Biological Survey for this district, telling him that other ranchers were clamoring for trappers and that he must go elsewhere soon, since he was catching nothing on our range.

An urgent call for a trapper came within a day or so, from Mr. Lutley, one of the owners of the Bar Boot Cattle Company, whose range is in the Pedregosa Mountains, just a little southwest of our Chiricahuas. 'Bill Lutley of the Bar Boots,' everybody in this part of the country called him, until Lupe Ramirez, cowboy of the Spear E, found Lutley difficult to say and nicknamed him 'Bill Boot.' Over on the Bar Boot range, a yearling steer had just been killed by wolves. The cowboys found the tracks showing where the lobos came into the range, trailed their movements and found where they went out again. Mr. Anderson decided that he would take some traps and drive over to the Bar Boot range to spend a few days. Charlie said that he would watch the trap-line here meanwhile.

Mr. Anderson and his helper drove over to the Bar Boot Ranch early one morning, borrowed horses, and rode out with one of the cowboys to see the trail of the wolves. In a damp spot where the print of paws were clearly defined, he saw two familiar sets of tracks. They were those of Two-Toes and his running-mate. After setting ten traps, all that he had with him, the trapper waited impatiently for the next morning, and made his rounds as early as possible. It was the time of the full moon, which tempts a wolf to make long jaunts. On that night, Two-Toes and the little wolf had rambled far and wide for the last time. The trapper caught them both.

He came back to Rucker straightway to take up the traps which he had left here and proudly to show us the hide of Two-Toes. He had boasted that he would stretch it and now he was doing so. He felt quite sure of the place at the top of the honor roll, but he hated to leave the pleasant mountains and go back to catching coyotes in the wind-swept valleys. Today we passed the shady spot on the bank of the river where he formerly had his camp. Beside the blackened stones of his fireplace, abandoned, forlorn, impaled upon a stick, hung the straw hat of Brother Anderson.

CHAPTER XVIII

WE KNOW FEAR

THIS spring there has been an outbreak of foot-and-mouth disease among the cattle of California and it spread in spite of every governmental effort to control it. Dogs carried it on their paws; men on their clothing. Birds bore it aloft and alighted to infect new fields. Rabbits, automobile tires, the hoofs of roving deer, all were suspect. In Arizona the fear was very great that the scourge might reach us and our authorities took every possible precaution to keep it out of our herds. Cattlemen had already coped with bad seasons and low prices. If the foot-and-mouth disease reached us, we would be through. 'Broke!'

With this fear always at the back of our consciousness, we tried to keep up our courage and carry on our affairs as in the best of times. One good thing that ill winds had blown our way was the lowered price of pure-bred bulls, whose value had swung downward in keeping with the decreased price of range cattle. Charlie had taken advantage of this to purchase from Colonel Packard six registered yearling bulls, descendants in direct line from Plato, prince of a royal line of Herefords. At their usual price we could not have afforded such animals. We hoped to see a great improvement in our own herd when calves had been sired by these fine bulls.

The Packard Ranch is not far from Douglas, a long journey for cattle to travel on foot. The best way to fetch them to our ranch seemed to be by truck, hauling three at a time. Charlie started off early one morning to make his first trip. Calculating the time it should take him, I began listening for the truck before dark and it was three hours

after the proper time when I first heard the engine laboring, then silence. I ran over to the road, for I knew pretty well what had happened. The only steep hill on the entire trip from Douglas is that which ascends the mesa on which we live. Again and again Charlie has come all the way from town with a heavy load, only to stick on that wretched, abruptly rising hill. Since it is almost in our own front yard, he usually throws off enough grain, salt, or other heavy cargo to lighten the load, leaving them at the bottom of the hill until morning.

Sure enough, there he was, halfway up the hill. Stuck; waiting impatiently for me to hear the sound of the engine and run to the rescue. With his precious bulls penned in the back of the truck, he dared not trust to the brakes and leave the car.

'Chunk me!' he yelled impatiently, as I bobbed into view with a lantern in my hand. It was a familiar job to me and rocks that had often before been used for that purpose lay near at hand. I thrust a good-sized one behind each of the rear wheels. The truck settled back against them and Charlie got out stiffly and wearily. All the way home he had been having engine trouble and had nursed the truck sputteringly on its way. Had the cargo been grain or salt, he might have left it on the hillside until daylight. It was impossible to do so with these treasured young bulls, huddled together, on uncertain, slanting footing, against the tail-board of the truck.

Perhaps the engine was not getting gas. An unusual amount had been used up on the trip and gravity might not bring gas to the carburetor from the lowered tank while the nose of the truck was pointed sharply upward. I remained by the truck while Charlie walked home to the garage, filled a five-gallon can from the drum of gasoline, and returned to pour it in the tank of the truck. Then he

cranked; the engine turned over merrily and he mounted to the seat and released the brake. I knew too much about the business to imagine that I might also ride up that miserable hill. I ran to the rear of the truck and picked up another large, chunking stone. As I expected, an advance of three feet up the hill from a standstill killed the engine. Charlie put on the brakes and once more I 'chunked' the rear wheels. Crank. Brake. Chunk. Two or three feet at a time we advanced to the level ground. With each climb and lurching halt, the bulls were thrown together and against the sides of their pen. At last we arrived in the water-lot and Charlie backed up to a bank, unfastened the tail-board, and the bulls gladly escaped from their moving prison.

Wearily Charlie rose again in the morning and by lantern-light tinkered with the engine of the truck, filled up with gas, and started on his second trip, to get the remaining three bulls. When he had gone, I went over to see, admire, and to feed the ones that he had brought the night before. Two were down by the pool below the spring, looking at the water with curiosity. By their gaunt flanks, I knew that they had not yet attempted to drink. Water on the ground was new to them. It smelled like water. It looked like it. Still, they were suspicious because it did not come in a trough. Venturing too close to the muddy bank, one finally slipped, fell into the pool, and doused his nose in the water. He was convinced then and stood in the pool, drinking greedily. The other saw him and jumped in too. While they drank, I looked around for the third bull. Humped up by the fence I found him. His whole attitude and aspect was that of a sick animal. Mucus streamed from his nostrils, one hind foot was swollen. Symptoms of foot-and-mouth disease! My heart went down into my boots!

Too late now to isolate him, of course. He had spent the night in the water-lot with his fellows and with our milk cows as well. Still, I must do something, however futile. I drove him, too sick and listless to object, to a small corral where he could be entirely by himself. I fetched a bucket of water. He would not drink. I filled the manger with hay. He would not eat, nor even look at it. I closed the gate and left him there and went about my day's tasks, filled with dire forebodings. All of our investment, our years of planning, stinting, and hard work, gone for naught. Our cattle, in which we took such pride, would be slaughtered and buried in quicklime. How could we get another start?

All this anxiety must have shown plainly in my face as I opened the gate when Charlie drove up the hill, without difficulty this time, and came into the water-lot to unload the new bulls.

'What's the matter? What's happened now?' he asked, before I said a word.

'One of the young bulls is sick.'

'In what way is he sick?'

'His nose is dripping mucus and one of his feet is badly swollen,' I replied, and I burst out crying.

'Good Lord! Foot-and-mouth disease! We're done for now!' cried Charlie.

He liberated the three bulls which were in the truck. All had come from the same place, so there was no use in keeping them apart from the earlier arrivals. When Charlie went with me to where I had penned up the sick bull, we found him still standing up, though he was bearing no weight on the swollen foot. His nose still dripped; his eyes watered. We drew only slight comfort from the fact that as yet no sick animals had been reported on the Packard Ranch. In every outbreak of epidemic, there must be a first case.

'We'll doctor him tonight,' said Charlie, his tone hopeless. 'Then, if he is no better in the morning, I'll go to town and bring out the veterinarian. We'll protect the neighbors if we can.'

When he said that we would 'doctor' the bull, I knew what to do, for there is on a cattle ranch one sovereign remedy, 'good for what ails 'em' — Epsom salts. While Charlie was urging the bull into the chute and fixing a halter and rope on him, I went to the house and weighed out a pound of the salts, dissolved it in warm water, and filled two long-necked, quart bottles with the liquid. Charlie held the bull's head high with the halter. I pried open his jaws, inserted one bottle and then another, until the heroic dose had all gurgled down the beast's unwilling throat. We drove him back to his corral and left him, not expecting to see him again alive.

After a restless, wakeful night, we went over to the corral as soon as it was light enough to see, dreading that the sick bull might be dead and that others might have sickened. No! As we approached, we could see that the bull was standing up; when we reached the little place in which he was penned, he turned toward us, chewing lustily on a mouthful of hay! We leaned weakly against the corral posts and gazed at him. His nose was still caked with yesterday's mucus, but his nostrils were no longer dripping. His foot was decidedly less swollen. Charlie fetched a bucket of water and the young bull drank thirstily.

'A cold in the head and a bruise from riding in the truck,' diagnosed Charlie in a voice full of the deepest relief.

Leaving the convalescent to the enjoyment of his breakfast, we went home to eat our own with newly recovered appetite. Our intolerable burden of anxiety was gone, washed away by two quarts of Epsom salts!

CHAPTER XIX

CLEARING A FIELD

WHEN we need help, or, more accurately, when we can afford help, we rarely look for men in town. That they are town-dwellers by choice usually implies that they do not like to work in the country and do not know how to do ranch work. For our help, it is better to inquire in the wood-camps where there are apt to be men who know how to do what we need to have done. We have been clearing a new piece of ground for a field. After wood-choppers had cut the trees into cordwood and it had been hauled away, we needed men to grub out the stumps. The wood-choppers did not want to do it and could not find men for us. We needed to have the land cleared and broken at once if we were to raise a crop on it this coming summer. So Charlie drove off in the truck one morning and said he would come back with men if he had to pick them up on the street-corners of Douglas.

He drove home with a truckful of Mexicans. There were two men, their wives, one old woman, and three children. One man, Ernesto, had been working in a wood-and-coal yard for years, shoveling coal from railroad cars and putting it into sacks. He had a cough and the doctor advised him to get other work for a while. But for this he never in the world would have left town. The other man, Arturo, is his brother; the old woman his mother. The women were not at all pleased with the ranch. They immediately asked me where were the neighbors and the shops and complained that we live too far from *las vistas* — the movies.

For our part, we were not too well pleased with the men, but their work was to be done by contract, grubbing at so much a stump. We should not be out of pocket if they

proved to be lazy or slow. Charlie took the men over to the field and introduced them to the stumps, watched them work for a while, and on his return said, 'One of those men is forked lightning with the shovel.' It was the coal-heaver, and he went after those stumps like a man killing rattle-snakes, fiercely and without judgment. Where a little excavation with a pick would bare a root for a blow from the grubbing hoe, he insisted upon shoveling a vast hole.

When the men had several stumps uncovered and partly grubbed out, Charlie went over with powder, sticks of dynamite, caps and fuse. Carefully he placed his explosive where it would do the most good, and touched a match to the fuse. Then he and the men ran for the shelter of a huge juniper tree at the edge of the clearing and behind its trunk awaited the big 'Boom!' and the shower of rocks and chunks of wood that followed. I stayed at home with Robles and Foxy, who crawled under the bed and shivered. When Robles was a puppy, he came very near being blown to atoms when he lingered near a stump after the fuse had been lighted. By the time Charlie saw the puppy's peril, it was too late for him to risk a rescue. He could only whistle and call to the dog. Robles got away just in time to save his life, but his nerves will not stand the 'Boom! Boom!' even now.

The clearing progressed so much more rapidly than we had anticipated that we were puzzled to know what to do with the men when that work gave out. Before bringing them out here, Charlie had promised that they should have a month's work, believing it would take that long to grub the field. We were obliged to find other jobs for them to last out the time and it was hard to think of any that they had brains to do. One day I borrowed Ernesto, the demon shoveler, and I was glad enough to return him to Charlie by nightfall. We had a bathtub and a place in the house pre-

pared for it. We had some sewer pipe, and water has long been piped to the house. Time only has been lacking to combine these things and I determined to take advantage of Ernesto's proficiency with the shovel and have him dig a ditch, aiming it downhill so that the bath water could run into a little ravine. While he dug fast and furiously, I made trip after trip to the blacksmith's shop where lengths of red, earthen pipe lay stacked, and brought it back by the wheelbarrow load. When the ditch was finished, I expected Ernesto to lay the pipe.

'No! No! *Señora!*' He assured me that it was quite out of his line and beyond his capacity. Down into the ditch I jumped and placed the lengths of pipe in a row and, as I progressed, he covered my handiwork with earth. No wonder that Charlie dreaded having to find jobs fitted to men like that.

The mother and the wives of the two men were afraid of everything, of the cows that might hook, of the trees that might conceal wild animals, of the rocks behind which snakes might lurk. They burned a lamp all night because they feared the dark and told me of night-prowlers which they were sure must be mountain lions or wolves. Every mouse that rustled in their thatch roof terrified them. They sent the small boy to me on errands and he braved the perils of corral and dooryard, armed with an old boxing glove and a broken-bladed penknife, which he told me were to use if he met a bear. Wanting very much to leave here and not knowing how more than willing we should be to let them go, the women made a plan to force us to take them back to town.

One morning they sent word that the old woman was very sick, and I went over to see her, since I am expected to be doctor when one is needed here. Sticking, as I do, to castor oil and Epsom salts for their insides, to iodine and hot-

water bottles for their outsides, I have done no harm so far.

The sick woman, '*La inferma*,' did not have a very convincing list of symptoms. She complained of pains everywhere in general and nowhere in particular. She was suffering terribly, to judge by the faces she made up. Neuralgia, perhaps, if it was anything. Something about the whole scene, sepulchral groans and children gathered about the bedside, suggested a stage-setting to me. I felt sure that she was malingering and went home to tell Charlie so. He went over a little later and my suspicions were confirmed. The old woman was seated outside of the house in the sun, but when she saw Charlie coming, she nimbly scooted inside and was groaning on her pallet when he entered. With a long face, Ernesto said that his mother, *La Inferma*, must be taken to town and his family would go with her.

'Pack up, then,' said Charlie, secretly delighted. 'We shall leave here in half an hour.'

Arturo then snatched his baby from its bed and pointed to its granulated lids, saying that he must go, too, or his baby might be blind for lack of a doctor's care.

'I'll take all of you. Get ready,' answered Charlie, laughing to himself.

Soon he had a truckload of happy Mexicans, *La Inferma*, a rapid convalescent, on the seat beside him. Just as he was driving away, he gave me a parting direction.

'That little shower of rain we had last night has made it safe to burn the brush piles in the new field,' he said. 'I wish you would do it this afternoon.'

When I had straightened out the house somewhat, I put on my riding-breeches and a flannel shirt so I should not be in danger from sparks, thrust my feet into a stout pair of high, laced boots, and went over to the clearing. Under my arm was a book; in my pocket was an orange; Robles and

Foxy trotted behind. The brush was already piled. I needed only to go from one heap to another and apply matches; then sit down comfortably to watch the brush burn.

Lighting the first pile, I turned my back upon it and proceeded to the next and the next after that. Then I turned, and horror filled me! Racing across the grass which Charlie had thought would be so safely damp, the fire had already reached a pile which I had not set ablaze and soon fire was roaring skyward from every brush pile in the big clearing, although I had put match to but three. In my first moment of terror, I feared a conflagration. Calming a little, I realized that there was no great danger threatening the forest if I could protect it on the one vulnerable side. At one edge of the clearing was a fence, beside which the cattle had trampled the earth on their way to water. Two sides were protected by an elbow of the river. On the fourth side, the field was bordered by a narrow wash where the water drained from the hillside at flood-time. If I could keep the fire from crossing that wash, no harm would be done, as the light breeze was not strong enough to carry brands afar.

I ran over to this wash and began to fight the fire in the short grass with the only means I had — my feet. Scraping the line of fire as it approached, I put it out in one spot, then scurried to another. Panting, my thick shoes scorched, I worked until I knew I had the fire under control. It would not cross the wash. Then I paused for breath, looked about me, and saw at one side of the clearing a big juniper tree, the one behind which Charlie and the other men used to stand while stumps were shot skyward. Beside that tree was a tin lard pail and it was in just such a bucket that Charlie had been accustomed to carry his explosives. He must have forgotten and left it there. Now the fire had whipped around and was headed in that direction.

That the world would soon end for Robles, Foxy, and me

in one big 'Boom!' was all I expected when I raced for the new fireline. I did not run toward it from any bravery. I did it because there was no shelter to be reached quickly and I still had a fighting chance of keeping the fire away from that bucketful of destruction.

Puffing, scraping, my breath coming in gulps, I stopped that fire just in time. Meanwhile the brush piles had burned down to a few embers which could not harm the blackened grass around them. Wearily I dragged myself home, sucking at my orange as I went. My book was burned. The bucket of explosive still sat beside the juniper tree. Not for worlds would I have touched it.

Instead of dinner awaiting him on his return from town, Charlie found me in a heap on the couch, smutty, grimy, too weary even to wash my streaked face. He heard my story through and it lost nothing in the telling. Heroically I had saved Robles' life, Foxy's, and my own.

'Ha! Ha!' chuckled he. 'The lard bucket you found beside the tree was the one I kept my drinking-water in!'

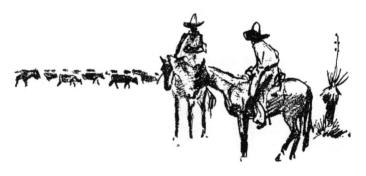

CHAPTER XX

HORSE–THIEVES

'THE land is well prepared and the seed is planted,' said Charlie when he came in, dusty and footsore, a few nights ago. 'Now, if we don't raise a crop of hay this year, it will be through no fault of mine.'

We are dry-farmers, dependent wholly upon the sky for moisture to sprout the seed and keep the hay growing. There is another method which each new dry-farmer is chaffingly advised to try. 'Plant a row of onions; next, a row of potatoes; lastly, a row of corn. The onions will make the eyes of the potatoes water and that will water the corn.' We may be driven to trying it yet. Our hayseed should have been in the ground ten days earlier and would have been but for an unexpected interlude.

Charlie rose one morning with the full intention of beginning to plant the Sudan grass seed that day. He had finished the harrowing the night before; greased the seeder and tightened the bolts. To save time and walking in the morning, he had kept Tom and Antonia, the mule team, in the corrals and water-lot overnight. After an early breakfast, we walked together toward the barn and chicken-house. The mules were not in the corral eating hay, so Charlie went on down to the spring to look for them. From there I soon heard him shouting.

'Mary! The mules are gone! Look in the barn and see if the saddles are there!'

After a hasty survey of the saddle-rack, I shouted my reply. 'Your saddle is gone and mine, and our bridles and chaps!'

I joined Charlie and together we hastened toward the

little *jacal*, half adobe, half bear-grass, where two Mexican workers had been camping. They were Federico and Baltazar, good-looking, young, husky fellows, who had worked for us before as wood-choppers. This year we gave them work on a fence which they were to build under contract. As we expected, their camp was deserted; a mess of papers, rags, and old tin cans, and their blankets and clothes were gone.

'I'll bet they stole the mules and saddles last night just after we had gone to bed,' said Charlie. 'You remember that the dogs barked just after we put the light out.'

'Yes, and I remember that we hadn't sense enough to get up and see what they were barking about,' I mourned.

'I'll go to the house and try to get a telephone message to the sheriff through the Forest Ranger,' Charlie decided. 'You go up to the pasture and get the horses so I can leave on the trail of the thieves as soon as I have telephoned.'

Over I went to the gate of the home pasture, and as I opened it I saw, above the old hoofprints of cattle and horses, the fresh tracks of mules going into the pasture. I sprinted back to the house and told Charlie this new development.

'The thieves turned out the mules to leave me afoot so I couldn't get away quickly to follow them. Eagle and Blue Bell were the only horses in the pasture; they must have been stolen!' raged Charlie.

Eagle is the very apple of his eye as Blue Bell is of mine. Again I started off, jog-trotting as long as I could, then walking to catch my breath; tears rolling down my cheeks all the while.

'Poor Blue Bell!' I sobbed. 'She is old. They will ride her to death and not feed her. My lovely mare will be a poor, lame rack of bones. I'll never see her again!' I knew

that Charlie, at home struggling with an exasperating tele-
phone, was mourning his beautiful Eagle horse.

The mules were not grazing on the big, open meadow
where I had hoped to find them. I pressed on through a
patch of woods, and, as I came out of the trees and into a
wide, grassy glade, four animals lifted their heads to look at
me. I had a queer, all-overish feeling when I saw them.
There were the two mules that I had been seeking, and pla-
cidly grazing beside them were brave, white Eagle and that
dear little blue roan, Blue Bell! Whatever could those
thieves have stolen? I started the horses and mules in the
direction of the corrals and had more than my accustomed
thrill of joy as Blue Bell flew down the familiar trail, neck
arched, mane tossing, as she frolicked along. Charlie met
them at the gate and had not yet recovered from his glad
surprise when I jogged, panting, into the corral.

'Let's get into the car and drive down the road while the
horses are eating,' he suggested. 'I want to see how those
Mexicans caught the horses and try to tell from the tracks
which ones have been taken.'

We drove down to the fence upon which the missing men
had been working. Near-by is a little-used corral and it bore
signs that horses had lately been enclosed there. Tracking
two sets of hoofprints to a secluded spot between a thicket
and a cliff, we could see that two horses had been tied to
trees for several hours. Apparently the thieves had led the
horses close to the home ranch after dark; then watched
our house until the lights went out before slipping into the
barn to take the saddles and bridles.

Charlie fumed with impatience until he learned that his
relayed telephone to the sheriff had been delivered. While
awaiting that news, he rigged a dismantled spare saddle with
stirrups and a rifle scabbard. Now that Eagle had been
found, the loss that enraged him most was that of his bridle,

for the bits were those in his horse's mouth when, as a boy, he had ridden away from Texas. When Charlie finally started on their trail, the thieves had been gone twelve hours and as yet we did not know which horses they were riding. We could not know until we had checked up on all the horses on the range. The missing horses were large ones, judging by the tracks which Charlie followed when he picked up their trail, which led to Tex Canyon and followed the most direct way to cross the line into Old Mexico.

From the Spear E Ranch, eleven miles away, Charlie telephoned to me. He said that he had given two wood-choppers, Nacho Flores, and Santiago Garcia, a good scare. Seeing them at a distance, he had slipped around them and got the drop on them with his rifle before he recognized them. Nacho and Santiago told him that they had been awakened the night before by shod horses which galloped past their camp. There was no one at home at the Spear E ranch-house, but Frank Krentz's touring car was in the garage and there were tracks which showed that his truck had recently gone down the road. Charlie unsaddled Eagle and turned him into the horse pasture, helped himself to the touring car, after writing a note to say that he had done so, and started off on the trail of the truck. Mr. Krentz and his men were working on a tank a few miles from the home ranch and had stopped to eat the lunch they had brought with them when they heard a car coming and were astonished to see Mr. Krentz's own car bouncing down the rough road from the mountains.

'What did you think when you saw your own car coming?' asked Charlie on his arrival.

'I thought the old jitney had got lonesome and was coming down to be with the truck,' Mr. Krentz replied.

Then he got in and took the wheel and they drove as

quickly as they could to the Slaughter Ranch, where a road passes through a gate in the fence along the international boundary line. Already a deputy sheriff had preceded them, making inquiries, and there were no horse tracks to indicate that Federico and Baltazar had crossed the line at that point. There was a chance that they were in hiding on the Arizona side for the day and would make a dash to cross over into Mexico during the night. Mr. Krentz and Charlie went on into Douglas and there Charlie found Constable Ash, who returned with him to Slaughter's. Well before dark they hid their car among the mesquite bushes near the gate in the boundary fence between Mexico and the United States and prepared to pass the night in watching for Federico, Baltazar, and the horses. A brilliant full moon shone on the bright metal of the lamps and radiator, obliging them to throw a blanket over the front of the car. When the thieves rode up, they planned to jerk off the blanket and turn on the lights of the car, which were trained upon the gate.

'We must shoot high,' cautioned Charlie, 'for the horses are mine.' A remark which indicates that the Mexicans were not expected to proceed much farther on their journey.

They did not shoot, however, high or low, and the long night dragged through uneventfully. In the morning, Bob Giles asked them to have breakfast at the ranch and also lent them horses and saddles so that they might ride along the boundary fence to see if they could pick up the trail of the fugitives. In this, too, they were unsuccessful, and did not know what their next move should be until they encountered Jesus Ramirez, a big, blue-eyed Maya Indian, who was working on that part of the Slaughter Ranch which lies across the line in Mexico. Ramirez had seen nothing so far, but offered to watch for tracks and let them know if he found out anything. He then made a suggestion. On the

second day following, there was to be a great *fiesta* at Chino Vinateria, close to the border. All the Mexicans for many miles around would be sure to come to enjoy themselves and it was quite possible that Federico and Baltazar would be unable to resist the temptation offered by the *fiesta*. Charlie decided, then and there, that he would go to that *fiesta* if he could get the credentials and the help he would need to pursue the thieves into Mexico.

All the following day, therefore, he and Deputy Sheriff Sam Hayhurst traveled from one person to another among the officials on both sides of the line. The *Presidente* of Agua Prieta, the Mexican town which is separated from Douglas only by a fence, was quite willing to oblige the officers from the Arizona side. It appeared that this was not the first theft of Federico and Baltazar. They were wanted in Sonora for stealing horses and in Arizona for having stolen the clothing of their fellow-workers in the mines. Don Antonio Gabilondo, the chief of the Mexican immigration officials at that port of entry, gave permission for Charlie and Mr. Hayhurst to come into Mexico without formalities and bring in their car without bond. One of the Mexican officers was detailed to accompany the *Americanos* and give them all the help he could.

On the day of the *fiesta* the three men started for Chino Vinateria. It is not a town, only a big distillery, owned by Chinese, where *mescal*, a native whiskey, is made from what we commonly call the century plant. Near the distillery is a commissary and around it are grouped the bear-grass huts of the Mexican-Indian laborers. In preparation for the *fiesta*, a large piece of ground had been cleared, smoothed, and sprinkled with water to serve as a dancing-floor. Horse-races and games were in progress and plenty of beef, *frijoles* and *tortillas* were provided, together with an abundance of *mescal* to wash them down. Men, women, and children

poured into the little hamlet, arriving on foot, on burros, and on horseback. The *fiesta* was in full swing when Charlie and the two officers arrived. Since the coming of an automobile would have been the cause of much curiosity and excitement in that primitive gathering, the car was left hidden some distance away and the men walked quietly without causing comment or alarm.

First they visited the distillery, where the host, a Mexican *Major Domo*, offered them *mescal*, handing them a cow's horn to be used in turn as a cup. Mr. Hayhurst took the first *trago*, which may be translated as a 'swig.' Next, the horn was passed to Charlie, who held it out as the host poured. Always before that, Charlie had supposed that a cow's horn was hollow only part-way, but this one seemed to be hollow to the very tip. To avoid giving offense, he felt obliged to drain that heroic cup of raw, two-day-old *mescal*. He says that his throat burned so that he would not have been surprised if fire had come out of his nostrils. After that hospitality, they scouted around among the merry-makers and watched for newcomers, all with no result. They neither saw the men they were seeking nor heard of them.

On their return to Douglas, Charlie had the luck to find Mr. Krentz in town so that he was able to get back to the Spear E that night and telephone to me, knowing that I was awaiting him, alone and in much suspense. In the morning he saddled Eagle and rode home.

A round-up of horses was made on Charlie's return and we found that Apache and Nester were the missing ones. Both were big, fat, showy horses and had been good ones until misfortune overtook them. Apache, a fine, black horse, had developed a queer disease of the eye, called 'moon blindness,' which resulted in his losing the sight of one of his eyes. That made it dangerous to ride him in the

brush; he could not see his way on both sides and was easily frightened by a noise on his blind side. Nester was a beautiful sorrel with a blaze face and had been a marvelous 'cutting' horse. 'Nester can turn on a dime and give a nickel back,' Charlie often said when the horse was in his prime. His trouble was a swelling of the knees that at times seemed to be cured, but always came back. Both horses had been given their liberty on the range for past services and we hated to think of the possibility that they might fall into unkind hands.

After the check-up of the horses, Charlie went back to the work that he had been about to do on the day that we discovered the loss of our horses. As he drove Tom and Antonia to the field to hitch them to the seeder, I walked over with him. In the grass at the edge of the field, near the camp of Federico and Baltazar, I tripped over something, stooped and picked it up, and gave a joyous shout.

'Charlie Rak! See what I've found!'

'Holy smoke!' he cried. 'It's my old bridle! The thieves must have dropped it in the grass and couldn't find it again in the dark. I'm sure glad to see it again!'

The day after he finished the planting, Charlie made a trip to town to get the saddle that he had ordered from Sitzler, the saddler in Silver City. Naturally he inquired from the officers if they had any news of the thieves or of our horses.

'You are not likely ever to see your horses or your saddles again,' they told him, 'but those fellows won't steal any more.'

Federico and Baltazar, having sold our horses and saddles, where or to whom we shall never know, went to a lumbercamp in Chihuahua and asked for work. During their second night at the mill, they sneaked away, as they had from the mines at Dos Cabesas in Arizona, taking along all the

clothing they could carry which belonged to their fellow-workers. This time, following a hot trail, the *rurales* caught them, and with a summary justice, hanged the thieves then and there.

We wish all thieves would go first to Chihuahua.

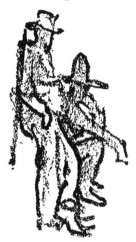

CHAPTER XXI

TEOFILO, THE JESTER

DURING the years that we have lived here, there has rarely been a week when two or three Mexicans have not come through our canyon on foot, a blanket or a *serape* tossed jauntily over one shoulder. These men have come up from Mexico to look for work in one of the wood-camps, scattered throughout these mountains, or are on their way to the mines at Dos Cabesas. Sometimes we see men who are returning to Mexico, resplendent in new hats and new shoes, a few dollars jingling in their pockets. In summer they sleep under the stars; in winter they build a fire in a little hut to which we make them welcome. Our own workers and all other Mexicans living in isolated places are glad to exchange a meal of *frijoles, tortillas* and coffee for the gossip their visitors bring. It is from these men that we recruit the casual labor that we need. Lately, though we have seen the footprints of men who have traveled the trail, none have come near our house and we have been in need of a man to help us.

Santiago Garcia walked over here from his camp in Tex Canyon one day recently. He apologized for bothering us; his *patrón* had not been to the camp with provisions and he and Nacho were without tobacco. Would we do him the favor of selling him a few cans? Santiago is pure Indian, so tall that he can look down on my husband who is himself over six feet tall. Santiago tells no one for what reason he left Tiburon Island and the shores of Kino Bay, to live a solitary life as a bachelor in the high mountains of a strange country. Within a few miles of this ranch he has been working in one or another of the wood-camps for twenty years.

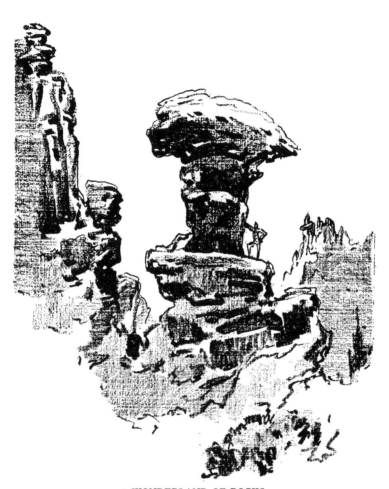

A WONDERLAND OF ROCKS

Men say that he is very old, but his long, narrow, black face and angular frame admit nothing. His keen eye and sinewy arms have made him an artist with the axe by which he earns his living, and for his long, lean, tireless legs, a six-mile jaunt over the mountains is only an evening's stroll.

'What has become of all the Mexicans?' asked Charlie, after he had produced the tobacco and Santiago had rolled a cigarette between his bony, black fingers. 'We used to see a great many of them and lately I haven't seen one.'

'They say that they are afraid to go near *El Rancho de Charlie*,' Santiago explained. 'They have all heard that two Mexicans stole your horses, your saddles and chaps, and they fear that you are now angry with all Mexicans. So they go past your ranch without stopping and, if they see you out riding, they hide behind the trees.'

'I have been here a long time,' replied Charlie, 'and many Mexicans have worked for me and very many more have passed through my ranch. Only two among them have ever stolen from me, so you may tell anyone you may see that they need not be afraid. I have only been angry with the thieves and they have been hanged so now I am angry with no one.'

'I shall tell them,' said Santiago, looking pleased and relieved, 'and if you should need a man to work here, I shall try to send you a good one.' He rose from the ground where he had been squatting with his back against a post. '*Muchísimas gracias! Adios!*' he said. Then his long, springy legs bore him out of sight as a deer bounds over a hill.

Always I have heard that animals, when pursued, are able to 'freeze' in an attitude so immobile that one may pass near them, even look toward them, without being conscious of their presence. Especially is this true if they have a protective coloration. I have seen deer stop abruptly, their outline blurred against a rocky hillside, merged with the gray

and brown of rock and earth. Rabbits, countless times, have
crouched, motionless, on bare ground, to watch our dogs
course past them. Wise old cows know the art and stand
rigidly in the timber, not a flick of the tail betraying their
whereabouts. I have heard that Indians have this art also,
and I realize now that one never knows when an Indian is
near unless he chooses to let one see him.

A few days ago, when Charlie was away and could not re-
turn until late, I believed myself to be entirely alone on the
ranch. Just after the sun dropped behind the high moun-
tain west of us, my chickens and turkeys came over to re-
mind me that they must be fed before they went to roost. I
went over to the grain shed for corn to feed them, and to my
astonishment, there sat a man, in plain view from the house,
whom I did not see until he rose when I came very near to
him.

'How long have you been sitting here?' I asked.

'A long time, *Señora*,' he laughed. 'I have seen you go
in and out of the house many times.'

I have never seen a blacker man. Powerfully built and
tall, he leaned forward from the waist, long arms swinging
before him, and he walked in a swift, shambling fashion
which combined with his posture to give him the appear-
ance of a great ape. His face, with low forehead and under-
shot jaw, was simian too; only the humorous gleam in his
small eyes was more human than gorilla.

'I am Teofilo Romero,' he said. 'Santiago Garcia tells me
that you need a man. Have you any work that I can do?'

'My husband can tell you that when he comes,' I replied.
For no reason at all, I liked the man instantly. 'Have you a
bed-roll?' I asked. 'A *mochila?*'

'This is all, *Señora*.' He showed me one small, thin blan-
ket, then swung it jauntily over his shoulder, *serape*-wise.

I told him that he could take down the roll of old bedding

which I keep suspended from the rafters of the garage for just such visitors, and that he might sleep in the *jacal* so abruptly vacated by Federico and Baltazar.

'Now come to the house,' I said, 'and split some kindling so that I can make a fire and give you some supper.'

Back of the kitchen were some blocks of dry juniper and a hatchet with which Teofilo set to splitting the kindling in such a quick and expert fashion that I commented upon it.

'This is nothing for me, *Señora*,' he replied. 'I once spent three months doing nothing but split kindling.'

'Were you working in a wood-yard?' I asked.

'No, *Señora*, I was in the penitentiary!'

He flourished the hatchet and looked at me to see how I took the news, and there was such an impish, quizzical gleam in his small, deep-set eyes, that I laughed aloud. When Charlie came home an hour later, he found Teofilo and me deeply engaged in the fascinating Mexican pastime of 'swapping lies.'

For instance, this Indian has now told me that he once had a very pretty, little, young wife; and that was a great mistake, because a wife is of no use to a Mexican who lives in the United States. On this side of the line someone always interferes with a husband when he is merely giving his wife a well-deserved beating for her own good. Teofilo says that he shot at his own wife one night, which did not matter in the least as he was too drunk to shoot straight. However, just for that, she had him put in jail and ran away with another man before he got out again. Now he has a much better wife who is living in Douglas. Would I like to have him bring her out here to the ranch? She is very clean and she could wash the clothes for me. I asked Charlie if he would bring the woman out, and he said that he would if Teofilo wanted her, as the man is a good worker and might be more willing to stay if he had his wife here.

When I told Teofilo this good news, he put his head on one side and wrinkled his shallow forehead as though he were pondering a weighty problem.

'Well, I may bring her,' he answered — 'or I may kill her! She is so very homely!'

Truth to tell, he has no wife at all!

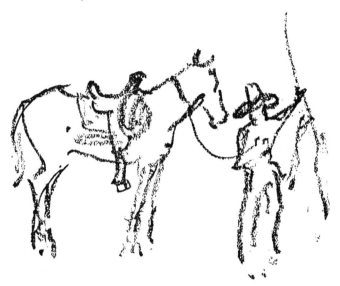

CHAPTER XXII

'OLE MISS POLECAT'

I AM ABASHED, humiliated! A feeble-minded, feckless hen-turkey has solved with ease a problem that has cost me much fruitless thought. She stole her nest and has been setting on the very top of a huge haymow. When I paid her an occasional visit, bearing gifts of corn and water, she scorned my offerings and repaid me with vicious hisses and stabs with her sharp beak. How in the world was I to get the little turkeys down to *terra firma* when they hatched out? I had no idea that I might safely leave the solution of this difficulty to the turkey-hen.

This afternoon, Teofilo ran over to the house to tell me, breathlessly, that the air was raining little turkeys, and I ran back with him to the haymow. Down on the ground, followed by several little, animated balls of feathers, mamma turkey was doing the original turkey-trot. At intervals she gazed upward, uttering weird cries which I interpreted to mean, 'Jump, baby! Jump! I think you will make it in about two jumps!'

Aloft, in her old nest, were several more 'yip-yiping' baby turkeys which had not as yet been able to get up the nerve to leap fifteen feet to join her on the ground. One by one, they did it finally, and lit on their tiny feet as expertly as any acrobat.

The mother turkey walked them about until dark and I walked after them, for I simply had to know where they would spend the night. Surely she wouldn't expect those baby turkeys to jump back to the top of the haymow! When she settled down on the ground at dusk and sheltered all the little turkeys under her wings, I feared that she had

chosen a poor place and that she and her babies might be prey of skunks before morning. Paying no attention to her warning hisses, I tried to urge her to move into the chicken-yard. Upon that, she spread her broad wings and launched herself straight at me and bit me on the ear, squawking, 'Take that! You meddlesome busybody!'

I am sorry for the skunk that tackles her.

In general I am not apt to be sorry for skunks and I have learned to be a fairly good shot from aiming at them. My proficiency was acquired more quickly than is usual because of Charlie's admonition that 'cartridges cost money' and one to a skunk is plenty. Hunting is an inexpensive pastime for our dogs, and they frequently come home with the expectation of being praised and petted for having done away with a skunk, only to be sternly ostracised and kept outside for hours afterward. Now they seem to have developed an odorless method.

One warm night the dogs were asleep in the house in their usual places and I had left the kitchen door wide open so that they might sally forth when they chose and not disturb our slumbers by scratching at the door on their return. We were suddenly awakened by the most unusual sound; a prodigious scratching of toenails on the bare floor, as though a gigantic centipede were traveling in circles. There was not a yelp nor a growl from the dogs; only this frantic scurry-scratching in the dining-room.

'Don't step on the floor with your bare feet!' I cautioned Charlie as he jumped up from his sleep. Instead, he stepped from his bed to a chair and leaned over to the chiffonier, where he found an electric flashlight and turned it in the direction of the open door to the next room.

'The dogs are killing a skunk in the dining-room!' he reported, aghast.

'Oh! My! We shall have to move out of the house!' I

wailed. But we had underestimated the skill of Robles and Foxy. Before the skunk had a chance to assail our nostrils, they had demolished it and, as Charlie picked up what was left of the beast and hurled it outside, he said, 'When that skunk came into this house, it was simply bent upon suicide.'

As a part of their duty, the dogs go with me at night to sniff around inside the chicken-house before I close it; there having been one tragic occasion when I locked up a skunk that was hidden inside. One evening last summer I went over at dusk to close the chicken-house and Robles happened to be off on some little rabbit enterprise of his own. Weeds had grown rankly in the chicken-yard, and in the dim light I caught a movement of two white-tipped tails, bobbing through the weeds as they do when 'Ole Miss Polecat switch down de road, a-steppin' an' a-mincin'.'

'Mr. Hampe! Mr. Hampe!' I shrieked. 'Come quick and bring a shotgun!'

He answered my shout and soon I heard him coming on the run.

'There are two skunks! In the weeds!' I pointed. 'There!'

'Gracious! There are three of them!' he exclaimed and whanged away with the shotgun.

Two white tails skipped around the corner of the chicken-house and out of range in that dim light. Gingerly we approached the third one — and found the white flower of a weed, neatly decapitated. Waving and bobbing in the light breeze, it had been our third skunk.

CHAPTER XXIII

AN INDIAN SHORT CUT

THE rough and rocky trail from here to the Spear E Ranch, steep, twisting, guttered by flood waters, impeded by overhanging limbs, was once a road. Long before our day, before the town of Douglas existed, wagons followed the trail that had formerly served the Chiricahua Apaches as they came and went between here and other strongholds in Mexico. It was a short cut from Stein's Pass in New Mexico to Sulphur Spring Valley and the Dragoons, and it may be one again when men have straightened out its curves and made a modern roadbed. In its present condition it has long ceased to be practicable even for horse-drawn vehicles, and cattle stumble in its boulder-strewn fords and pause, panting, at the top of its steep grades. For many years rust has accumulated on the frame of a motor car that rashly attempted to use the almost-obliterated road, when bootleggers, pursued by officers, toppled their car into a ravine and fled from it afoot.

Naturally, then, when we heard the sound of a laboring motor coming from that direction, we did as we have taught our dogs to do, looked into the sky for an airplane, fearing that an aviator, in trouble, was hunting a possible landing-place in this inhospitably rough and brushy canyon. We were wrong. Sputtering, droning, ceasing altogether at times and roaring at others from a wide-open exhaust, a motor car crept down the trail and we awaited it with an anticipation as keen and curious as that of our excited dogs.

In the lead of the procession that came toward us down an avenue of trees rode two youths, Roberto and Rosario Arviso, one on a sorrel, the other on a bay pony. Next appeared four burros, ears wagging, tails switching, pulling a

small wagon. The iron-shod wheels scraped and clattered on the rocks and wobbled in and out as they revolved, so that no two wheels were ever at the same angle, not even when the wagon came to rest. Bumping and swaying on the high seat were Antonio Valencia and his stolid, fat squaw, Josefa. In the back, lolling against a roll of bedding, was their son. Dogs of five different sizes and twice that many blood-strains walked beneath the wagon and cowered there for fear of Robles.

Last of all, with the noise of a steam calliope, limping on rims and patches, arrived one of those cars of ancient vintage which bear a myriad names, given in jest. We have adopted that with which the Mexicans have christened it, *Cucuracha*, the beetle. From under the torn top and between ragged, flapping curtains were thrust the faces of a woman and several small children and from behind the steering-wheel came a man who greeted us with many smiles and an outstretched hand. He was Malacio Arviso, a man who had worked for us at one time and had now returned in this astounding manner.

'How did we manage to come this way? Ah!' swaggered Malacio. 'It has been no trouble at all. We started from Horseshoe Canyon only six days ago and in two days we reached the water at the upper Spear E Ranch. From there on we proceeded a little slowly, it is true, six miles in four days. But it has not been difficult. First went the boys on horseback. Then came the burros and the wagon. When the burros were unable to pull the wagon up a steep hill, we unloaded it and everyone got out except Antonio, the driver. The boys helped to pull by ropes tied to their saddle-horns, while Antonio's son and I pushed from behind. Then we cleared away rocks and filled in holes, unloaded the car, hitched the burros to it, and in no time at all we were all at the top of the hill. If the women had not brought along so

much stuff that had to be loaded and unloaded, we should have done better than a mile and a half a day.'

With a persistence which would have taken them far if used in a worthier cause, they had reached here by direct route in six days, while they could have come around by the way of Douglas in a few hours. Neither time nor car was ours, however, so we complimented them upon their enterprise and made them free of the dumping-place where worn-out tire-casings were eagerly salvaged by the boys. Malacio then cranked his *cucuracha* and proceeded down to the river-bank where they intended to camp for the night. As the boys searched for old casings which they could put on over their own worse ones, I saw Charlie examining the two ponies and he looked after them with an appraising eye as they galloped away.

'Are you going to offer Malacio a job?' I asked.

'No,' he decided. 'The last time he worked here he left without warning when we were extra busy and you had to do his work until we could find a man. I don't want him again, even though he is a good worker as long as he lasts on the job.'

In the afternoon I went down to the camp by the river and renewed my acquaintance with Jesusita, Malacio's plump and pretty wife; saw her new babies and heard all the gossip of wood-camps and ranches. She said that her husband and sons had been working all the time, but that men were all crazy, wanting to move from one place to another, and she had to go where Malacio and the boys took her, though she would much rather stay in one place. Early in the morning they were planning to start again on their way to Turkey Creek where work was promised them. I told Charlie about it on my return and he said nothing, but I could see that something was on his mind. The next morning at breakfast time, I found out what it was.

'Those are good ponies of Malacio's,' he said. 'I wish I could have them.'

'Then go and get them, for goodness' sake!' I cried. 'Horses are no extravagance, for they help us to make our living. You have had to economize for so long that you have forgotten that you can buy the things you actually need.'

'You are right,' he agreed, a smile all over his face. 'I'll get into the car and follow those Indians down the road and see if they will sell the ponies.' He threw a saddle and bridle into the car and took Teofilo along to bring the horses back if the bargain was made.

Charlie and Malacio chaffered for an hour or so, and in the end, Malacio had a check in his pocket and Charlie had the ponies. The sorrel we have named *Calabasa*, the Squash, and the fat little bay, which is Charlie's present to me, we call *Sandia*, the Watermelon. As he came in, riding *Sandia* and leading *Calabasa*, Teofilo asked for a *pasear* for a few days. He said that he thought that there might be a letter from his wife awaiting him at the post office at Sunglow, near Turkey Creek, and he wished to go at once and get it. We knew by that time that he had no wife, but Charlie accepted the explanation entirely as though he believed it and gave Teofilo his leave of absence, knowing that he would go anyway. With a few dollars from his wages in his pocket, the happy Indian struck off down the road, leaning forward, arms swinging. At that pace he could hope to overtake Malacio's beetle and we felt sure that was his intention.

Three days later, he strode up to our door, laughing, refreshed by his vacation.

'Did you get your letter?' asked Charlie.

'No. That lazy woman has not written to me,' Teofilo confided. 'I got something that is better than a letter.' Reaching into the pocket of his tattered jumper, he brought forth a roll of bills and flourished it. 'See! It is the money

that you paid Malacio Arviso for those horses. Long ago I let him have money when he wanted to buy that car of his and he would never pay me back. This time I followed him to Turkey Creek, knowing that you had just paid him for the horses. We had a game of cards; Malacio Arviso should have known better than to play cards with me!'

Happy though he was at the moment of his return with his pockets full of money, Teofilo had little to say on the following day and still less on the third. There were no more of the little stories and jests that had delighted us and sweetened our labors. We knew very well what was the matter. The money which he had won from Malacio was weighing on Teofilo's spirits; he could not be cheerful again until he had spent it and we knew that he would soon seek an excuse to go.

'I have heard from my sisters,' he said, at the end of the third day of gloom. 'They are going to come up to Agua Prieta for a visit and wish me to come there to see them. I am very sorry to leave, but I cannot disappoint them.'

'Certainly I would not have you disappoint them,' replied Charlie, quite as though he thought there actually were sisters. 'I shall have to look for another man, but if you come back and I have any work, I shall give it to you.'

Instant cheerfulness spread over Teofilo's face as he added his wages to the money he already had, threw his blanket over his shoulder, and was ready for the journey.

'Don't throw all your money away, Teofilo,' I advised him, quite uselessly. 'It is very foolish to waste everything that you have earned in a month for a few days' pleasure, as so many Mexicans do.'

'You are quite right, Señora,' he agreed readily. 'No Mexican has any sense until he is over twenty-five years old.'

'And how old are you, Teofilo?'

'Ah! I am twenty-six!' With a laugh thrown back at me over his shoulder, he vanished among the trees.

CHAPTER XXIV

BEEF AND BEANS

WE HAVE had the first rain of the summer, an all-too-brief shower that fell at sundown, after threatening all day to halt the merrymaking and dampen the festive spirit of a barbecue which we had spent days in preparing. We wanted it to rain. Selfishly intent upon our own concerns, Charlie and I murmured to one another, 'A little rain right now will sprout the hayseed.' We closed our ears lest we hear from the others the words that are heresy in Arizona, 'I hope it won't rain.' Never do we say them and only think them once a year during the hours while our precious hay lies cut and drying in the field. Games may stop in mid-play, new hats may droop and cars stick in the mud — if only there is rain.

A fraternal order in Douglas decided upon a picnic this year for their summer festivity and asked Charlie if they might have it here, where shade and space for parking and room for baseball all offered themselves. We should have been willing in any case, but the chief feature of the affair to us was the opportunity to sell two beeves which were to be barbecued. In these times, when cattle are many and dollars few, selling those steers appealed to us very much, and Charlie told them that he would do all that he could to make the barbecue a success. Teofilo cleaned up the picnic grounds before he left us. Another Mexican dug the pit in which the beeves were to be roasted and helped to load the cordwood, well-seasoned oak, that was piled by the pit in readiness.

Two days before the barbecue arrived the man who had been engaged to do the actual cooking and he helped Charlie

to kill the steers which were already in the corral where they
had been fed for some time. After supper on the night of his
arrival, the barbecue cook, an old cowpuncher whose ways
and days harked back to the open range, fixed me with a
stern eye.

'I have to have my coffee at four o'clock every morning,
reglar!' he warned me.

I am afraid he is now telling that while here he had to
wait for his coffee until six o'clock every morning, 'reglar.'

I could have used all the hours of daylight in that busy
time had we actually breakfasted at four. Beans were
wanted at the barbecue. Incautiously I first offered to cook
them and afterward asked for how many people.

'Three hundred people, anyway. Maybe more. Be sure
to have plenty,' was the reply.

Feverishly I figured. 'If two pounds of beans last two of
us for two meals a day for three days, how many beans will
it take to feed three hundred — or more — people for one
meal on one day? Will they, or won't they, be fond of beans;
and how many people will remain for supper?' I have been
too long out of school. 'Shucks!' said I, and threw away
my labored calculations. 'I'll cook a washtub full and let it
go at that!'

In what were supposedly my spare moments, I picked
over beans and still more beans. It would never do to let a
tooth be broken on a rock at that party. Then I soaked the
beans, the red *frijoles*, though every Mexican will tell you
that they 'bleed' and lose their strength under such
Gringo treatment. How they swelled! Seven times I filled
my pressure cooker and steamed away until the pet-cock
screamed its shrill warning. The house was a beany bedlam.
And that was but the beginning. When the largest wash-
tub was filled with the tenderly cooked *frijoles*, I tackled the
flavoring that should induce the three hundred to eat

enough for six. Slabs of salt pork were cubed and tried out; onions were sliced and garlic chopped; tomatoes, canful after canful, added their savor; chilli and salt flowed into the conglomerate. Odors poured from the kitchen windows and rose to the skies. Charlie came in as I stirred the great mess in an iron pot. He took one look, one sniff.

'Wow! You've got everything in there but a bar of soap!' he exclaimed, and went out as quickly as he came.

It was a good thing that I am one who invariably takes time by the forelock. The beans were done by noon of the day before the barbecue; they lacked only the slow simmering in a huge, iron, rendering kettle, which was to be hung over coals near the barbecue fire. I was hot and tired when the job was finished and counted upon a little rest during the afternoon. I reckoned without the barbecue cook. After our noon dinner, he went down to the pit to build his fire and heat the rocks that were to cook the meat during the night. He was supposed to have brought with him all the tools of his trade and I did not expect him to come back to the house. However, I presently heard the harsh note of his elderly motor and I rose from the couch where I was taking twenty winks, as he drove into the yard.

'I don't see how I come to forget to bring it,' he began, apologetically, 'but I can't find any hatchet in my car. Can you lend me one?'

Willingly I did so and he drove, 'clatter-ty-banging,' back to his job. It seemed only a few moments when he came back a-humming. From that time until dark, whether I was in the midst of baking or bathing, up he bobbed with some request, prefaced always by 'I don't see how I come to forget.' Cups, wash-basin, towels, spoons, all disappeared from the kitchen and into his car. Chains and hooks had to be sought in barn and shop.

'Why can't the old reptile make a list and ask for every-

thing he wants at one time?' I scolded to myself. 'I know. It's because he "come to forget" to bring a pencil and paper!'

That was a hint to myself. I got out a pencil and paper and wrote down everything that he had borrowed and might come to forget to bring back to me. Just before going to bed, Charlie said: 'You've been sticking in the kitchen for two days. Come down to the barbecue pit with me in the car and see how the meat is getting along.' As we drove close to the pit, dark now and covered to keep in the heat, the cook came forward through the gloom.

'I'm sure glad you come down here,' he said, ''cause I don't like to leave the meat. I wish you folks would bring me down a lantern. I don't see how I come to forget it.'

I forgave him the next day. Everything should be forgiven a good cook, and the meat came out of the pit, well done, full of juice and savor. It was being carved, not in dainty slices, but in thick, substantial slabs, when I arrived at the barbecue grounds for the second time on the morning of the picnic. Very early we had been there to pour the beans and their seasonings into the great, iron, rendering pot that hung on a chain dropped from the long limb of an oak tree. The cook promised to keep a few live coals under the pot so that the *frijoles* would slowly simmer. By nine o'clock the vanguard of the town people arrived, bringing with them the bread, salad, pickles, and soda-pop to round out the menu. Family groups picked out parking places among the trees, near the open glade where games were to be played. Pillows were thrown on the grass; knives and forks, cakes and pies, were spread on cloths on the ground. Then each picnicker, plate in hand, hastened to the pit where the meat was being carved.

Meat, bread, and salad were on the tables near the pit. Coffee was poured from a gigantic pot, constantly replen-

ished from five-gallon oil-cans boiling over coals. Beans were ladled generously from the swinging iron kettle and I was gratified to see that many returned for a second supply of *frijoles.* I had seen and smelled and handled beans for days, yet they tasted good even to me, as we sat on the running-board of our car and ate our lunch. At our feet, snuggling closely, begging with his eyes for bits of meat, sat Robles. He and Foxy had been told to stay at home and he did not follow the car when we went down early in the morning. When I made my second trip on foot, he followed me at a safe distance for fear of being sent home. On reaching the picnic grounds, he saw the crowds of people, of cars, of dogs, gathered on that glade which he and the rabbits had had to themselves for so long, and he went wild with anxiety. I saw him frantically trying to smell my tracks among all the hundreds of others and called him to me. Once there, he remained glued to my side. Never had he imagined that there were so many people in the whole world. He showed no inclination toward going about to make the acquaintance of other dogs and when Charlie went and came among the other men, Robles' eyes followed his master, but he would not risk leaving the safety of my side to follow him.

Although I wanted to go home, I lingered on the picnic grounds in the hope that the ice, which cooled the root-beer and crisped the salad, might not entirely melt and that we might have any that was left. We are fond of ice-cream and only on cold, wintry days do we have ice with which to freeze it. Then we eat our frozen dessert as we sit in front of a blazing fire and the dogs eat theirs from saucers, placed in a row on the warm hearth. In the back of our car were grain sacks in which to wrap the ice and I was looking forward to the novel sensation of having ice-cream in the summer time.

Clouds hovered over us all day, dimming the brilliant

sunshine. From time to time a few heavy drops, splashing in the dust, sent the picnickers to their cars for shelter. By mid-afternoon, the games were over and one by one the cars departed. There was still plenty of food, and a few of those who love the forest lingered to have a second meal before the long return drive. Among these was one of Charlie's friends, who had brought to the barbecue his own young son and a boy companion.

'I hate to leave this place,' he said, looking around at the long shadows under the trees. 'I don't get out in the country very often.'

'Why not stay until morning?' I suggested. 'We have cots and blankets at the ranch and there are plenty of beans and beef.'

Before he could reply, his son, a bored, dissatisfied-looking boy of fifteen, put his veto on the suggestion.

'Don't stay, Dad,' he interjected. 'I'm tired of beef and beans!'

I was very silent on our short drive home, made just as the shower began. 'Tired of beef and beans!' Poor boy — with jaded appetite and scorn of simple pleasures. He will not know the joy of finding the first summer squash in the garden, of greeting the newborn calf in the barn. He can open a paper sack of bananas without a thrill and see a cake of ice without anticipation. While we, happy over little things, can gratefully say, 'Tomorrow we shall have beef and beans — and ice-cream.'

CHAPTER XXV

A NEW COWBOY

'I WOULDN'T have fired Teofilo,' said Charlie the day after the barbecue, 'but since he fired himself, I am going to try and get a cowboy this time.'

I groaned. Of all the men we have had working on the ranch at one time or another, Teofilo is the sole and only one who has admitted to knowing nothing whatever about cattle. All the others insisted that at some previous stage of their careers they had worked cattle and broken horses. They not only told these stories of vast herds and hundreds of wild ponies to us; they also told them to their fellow-workers as they drank coffee and swapped lies around the campfire. We have been taken in by these tales and disappointed so often that a man now has to prove to us that he is a cowboy by working cattle.

'Where are you going to look for a cowboy this time?' I asked.

'Town, I guess. I don't know of anyone around here.'

'What's the matter with that Yaqui who Steel Woods told you used to work cattle for Slaughters?'

'He won't stay put anywhere. Just about the time he learned enough about the range to be of any use, he'd quit and I would have to break in a new one at branding-time.' Charlie heaved the long sigh that hunting a new man and breaking him in calls forth; then started for the garage. 'I'll grease up the truck and go to town *mañana*,' he declared.

He stopped for the usual parting word as I opened the gate for him to drive away early the next morning.

'Look for me when you see me coming,' he said. 'I won't come home 'til I find a cowboy.'

'Don't bring home another Eugenio,' I warned him, mockingly.

'Don't pick up another Torres while I'm gone,' he retorted, and we were both grinning at the remembrances as he drove away.

Eugenio, his wife, his five children, a dog, a cat, and a truckful of household goods were driven away out here one day. Having taken the man's own word for his abilities, Charlie thought he had drawn a great prize. The morning after their arrival, we went over to the corral and saddled our horses to make a round-up of a small pasture. When Eugenio, a melancholy creature with drooping mustache and long hair, got on a gentle horse which I had lent him from my own mount, he put one hand on the horn and the other on the cantle. We call that 'sitting down on your own arm.' That was all we needed to know about Eugenio.

'Sunk!' hissed Charlie to me as we rode out into the pasture. We rode along slowly, scattering out to note the cattle as we went so that we should know where to pick them up on our way back. Up in the very farthest corner, as the cantankerous old creature naturally would be, was a lame, old cow, hiding in the heavy brush and betrayed by the bell which we had hung on her neck some days before. Besides an injured foot which had to be doctored, she had suffered the additional misfortune of ramming her head into a cactus while in search of plums and there was a festering thorn in her eye which must be taken out. Charlie was riding at some distance from us, so I gave the order to Eugenio to stay with that one cow and bring her home, since she was too lame to keep up with the rest of the cattle. When Charlie and I met, each driving a bunch of cattle which we threw together, I told him where I had left Eugenio with the crippled cow.

'He might as well be doing that as anything,' commented Charlie, morosely.

We drove our cattle to the corral and waited and waited for Eugenio and the lone animal he was driving.

'He and the cow are both asleep somewhere under a tree,' surmised Charlie when we became too impatient to hang around any longer and started out to search for them. Moping along at a snail's pace, half asleep in his saddle, we encountered the missing man a quarter of a mile from home.

'Where is the cow the *Señora* left you with?' shouted Charlie, as we approached the man.

'She ran away from me and I could not find her again,' explained Eugenio, placidly.

'Tinkle! Tinkle!' jingled a bell derisively, and up came the runaway cow, limping for the corral by herself on purpose to show up our new cowboy.

'Go and pack up, Eugenio,' ordered Charlie, when we arrived at the barn and unsaddled our horses. 'A man who can lose a crippled cow with a bell on is too much for me. I am going to take you back to town today.'

Torres was my own find. We had no regular man, and José Nuñez, who had come up from El Frida to help us temporarily, wanted to go home again. When Torres came along one day, looking for work and talking so wisely about cattle, I thought he was a wonder. Charlie was away and I desired greatly to have a fine new cowboy all ready for work when he came home. Especially I asked Torres if he could shoe horses.

'*Oh, seguro!* Sure!' he responded, throwing out his chest and gesturing with his hands.

At once I sent José Nuñez out to the pasture to fetch in some horses and I selected big, gentle Jerry, a work horse who has no nerves and seems actually to like being

shod. We bridled him and tied the reins to a length of log-chain in front of the blacksmith's shop and I told Torres to shoe him. I knew the moment he timidly approached the horse and picked up one of the great hoofs so awkwardly that he was no horseshoer. José Nuñez knew it, too, and gave me a delighted grin behind Torres's back.

'There are kegs full of horseshoes in the shop,' I advised the unhappy Torres. He went inside and I heard the clatter of iron. Presently he came out with four shoes; to give the devil his due, they were all alike, but far too small for Jerry, as I cruelly pointed out. I let the man get as far as holding a shoe to the horse's unrasped foot, a hammer in one hand and a nail in his mouth. Then I stopped him in mercy to the horse.

'That's plenty,' said I. 'I don't want that horse quicked by a man who doesn't know his business. Why did you tell me that you had shod horses?'

'I did not tell you that I had ever shod horses,' replied Torres with dignity. 'I only told you that I could do so.' And he went off down the big road without Charlie's ever seeing him — and small loss.

I was pleased with Alcario, the new man whom we now have, when I saw him jump down from the back of the truck and run to open the gate when he first arrived. On foot or on horseback, one must be able to move swiftly around cattle. Seated by Charlie was a pretty, slender, Indian girl, with a clean, black baby in her arms. I followed the truck over to their cabin and told the man to come to our house a little later and I would give them bread and beans for their supper.

'*Muchísimas gracias, Señora!*' said Alcario, with a show of white teeth, and his wife, Juana, echoed him. They seemed pleased with their quarters and Charlie and I were well satisfied with them as we left them arranging their belongings.

'I came near not taking the man,' Charlie told me as we drove to the garage. 'I saw him first on the street and he was very dirty and unshaven. Then I went to his house and his wife was so clean and tidy that I thought I'd take a chance on the man.'

He saw no reason to regret it the following morning. Alcario is a brisk, willing worker who can understand an order and carry it out quickly. He is a good horseman and light in weight, which makes it easier on the horses. While he is not a wonderful cowboy, he is used to working in a rough, brushy country; when he has learned our range, he should do well. I like his wife, Juana. Of course she lifted up her small hands and exclaimed about the dirt which had been left in her house by the last occupants. Even the most slovenly woman cannot see how her predecessor could possibly have been so 'pig-dirty.' I was glad that she seemed contented. Frequently, when we have found a satisfactory man, he has left because his wife does not want to live where there are no stores, no movies, and no neighbors. Juana told me that she was very glad to come out here and the farther from Douglas the ranch was the better she liked it. In town, she had been obliged to live in a house right next door to Alcario's mother and sister. They bossed her and told her how to bring up her baby and what to have for dinner and when she should wash her clothes. Every time she bought anything, they said she had paid too much for it and was throwing away her husband's money. She never wants to see them again.

'Why do they treat you that way?' I asked.

'Because they have lived a long time in Douglas and I was brought up on a ranch in Mexico, in a place where there are no schools, and I cannot read and write,' she explained.

'Then you shall learn to read and write,' I said, and her eyes grew big with astonishment. 'I shall teach you, and tomorrow we shall have the first lesson.' I left her laughing over the great joke that would be on her scornful mother-in-law.

CHAPTER XXVI

THE BLACK PUPPY

CHARLIE is mourning because our fruit blossoms were caught by late frosts this spring, except for a few apples. I pretend to mourn, too, but mine is mitigated woe. Of course I am sorry not to have peaches and cream this summer, and German prunes, purple and juicy, pears and apples, as they come in their turn. Especially I regret the seckel pears, so toothsome and so small that they are preserved skins and all. Then I think of last summer, of the hot, steamy, sticky days when life was for me just one canned thing after another; of the shelves upon shelves which are still loaded with glass jars of peaches, preserves, sweet pickles, jelly and jam, and I heave a secret sigh of relief because I have no fruit to cook, can, mash, and drip this year. The ill wind has blown me that much good.

At the old Hermitage Ranch, on either side of the adobe house, are magnificent crab-apple trees. Nearly always they blossom so early that they are caught by a frost while pink and white with delicate bloom. Last year they escaped being frozen and one day Charlie loaded the truck with barrels, boxes, and ladders; took along Santiago Garcia, whose long legs are well adapted to tree-climbing, and spent the day in those trees. Two whole barrels of tiny, tart crab-apples were landed at my door that night and the rest of them, box upon box full, were taken to town to be given to our friends. Kettles, pots, and dishpans of crab-apples were on my range for days. Juice dripped into tubs from bags hung under the trees in the yard. Colanders oozed pulp for apple-butter. If Mr. Heyne deserves his nick-

name of *Tio Manzana*, Uncle Apple, then I earned the name
of Aunt Apple before I reached the bottom of the last barrel,
washed all the dishes, scoured the pots, and ranged the
fruit jars on the shelves.

'Peaches are ripe — I'll go and get some today,' was
what I heard Charlie say before I had quite recovered from
the crab-apples. After days of peeling and preserving
peaches, I washed my kettles, my kitchen, and myself, just
in time to receive the plums which arrived by the washtubful.
A little rest in between times and pears were unloaded at
the back door, box piled upon box. Apples, thank good-
ness, keep without help from me.

This summer I have a more agreeable job, teaching
Juana to read. She arrives every day, choosing the time
when her baby is sleepy and willing to nap while the lesson
progresses. We began with the simple phonetic sounds to
which there are no exceptions in Spanish, once they are mas-
tered, no short vowels to puzzle the beginner. There are
no words like 'though' and 'plough' and 'tough' in that
language to drive both teacher and pupil mad. After I had
satisfied myself that Juana really wanted to learn and had
brains to do so, I bought a Spanish primer for her. On the
first page was a familiar acquaintance, the rat, politely re-
ferred to as '*El Señor Rata*.' He was still being pursued by
El Gato, the cat, who has never caught up with him during
all the years since I first learned to read. Only one thing is
missing; the Spanish cat has no mat.

I find that Juana knows no more of arithmetic than the
number of her own fingers; she cannot even add her toes to
them. She knows a silver dollar when she sees it, but can-
not tell the lesser coins apart.

'How did you do your shopping, Juana, when you lived
in town?' I asked.

'That was easy,' she replied. 'I gave my purse to the

shop-keeper and he took out what he needed and put in the change.'

Juana's tiny, prettily shaped hands, so nimble with the *tortillas* and expert with the needle, have adapted themselves quickly to the pen and pencil. She can copy neatly the letters that I have written for her and the numerals as well. With the latter she was fairly proficient up to eleven; above that she was lost. Twelve and twenty-one looked all the same to her. The difference between thirty-six and sixty-three was no more than that 'twixt Tweedledum and Tweedledee. After some days of futile explanations, I asked Alcario if he would try to help her a little with her arithmetic at night. Perhaps he would have better luck than I in making her understand.

'I have tried and tried, *Señora*,' he said, with a shrug, a sigh, and a shake of his head. 'I shall teach her no more, for she is so stupid with the figures that I am afraid I shall get mad some night and kill her.'

So we have agreed not to 'lisp in numbers,' for the numbers will not come.

When Alcario and Juana first came here, they begged so hard for one of Foxy's puppies that we finally gave them the black one, Negrito. I was sad to see the fat little tail-wagger go, although his new master went off with him so happily and promised to take very good care of him. We have kept the 'yaller' puppy, who moves with such rapidity on his over-sized paws that we have named him Scooter. Like his mother, he has one white, chalky eye and one brown one. He is altogether homely beyond description, yet Charlie has taken a great fancy to him. One day, wanting to praise the dog, he looked at the puppy a long time and all he was able to say was, 'Scooter has one real pretty eye.'

The day after Negrito was taken to Alcario's cabin, I went over there and found Foxy lying in the sun before the door

and the puppy nursing her greedily. Our faithful little mother dog has gone to give her child his breakfast. For playmate, Negrito has a small kitten named Blanco that Santiago Garcia gave to the baby girl.

Alcario has been doing very well with his work and is cheerful about it, whistling and telling stories, most of which begin somewhat in the manner of fairy tales, with 'One time in Mexico.' Juana seeks my sympathy for pains, terrible ones, that are one day in her head, the next day in her toe. She gets much enjoyment from describing her symptoms and shows great ingenuity in finding new ones. One of her other diversions is an occasional quarrel with Alcario; she described one at length to me one day.

'And what did you do then?' I asked.

'What can a poor Mexican girl do but pull in her head like a turtle?' she answered.

All the Mexican women on the ranch hand their children over to me as soon as they become sick, though they will not take a word of advice beforehand because I have no children of my own. Juana sent Alcario over to tell me that Maria Appolonia was sick. She had a fever, would not eat her beans nor drink her coffee. Quite sensible, I thought, for a 'yearlin'' child. The little girl, still wearing her daytime clothing, was in bed with all the quilts in the house piled on top of her; the doors and windows were closed and the July sun was beating down on the low roof. I knew too much to tell Juana to bathe the child, she would have thought me crazy, but I did induce her to undress the baby, take off some of the covers, and open the windows.

'Whatever you have been feeding her — don't,' I advised, then went home to cook oatmeal gruel to replace the diet of half-cooked beans. Juana fed her as I advised until the child was well, then went back to her own ways as I knew she would.

'Whin the divil was sick,
The divil a saint wud be.
Whin the divil got well —
The divil a saint was he!'

Negrito worries me. I wish I could do something for that poor puppy. He has no dish and almost no food. On the ground outside the cabin, beans are thrown in the dust, where he tries to salvage them and eat them together with the sticks and rocks that cling to them. He and the kitten forage together under the table for scraps of *tortillas*, but he hasn't the kitten's advantage of being able to leap to the top of the table to steal from the soiled plates. He is so pleased when Foxy comes to see him and tries to suck a little milk from her, but she has no more, the puppies are now too old. Sometimes the puppy follows her home and guiltily I feed him, knowing that will make him come all the more.

'Don't feed that puppy here, or he never will stay where he belongs,' says Charlie, although he is as sad as I over having given him away. I obey the letter of the law, but I feed Robles, Foxy, and Scooter with so lavish a hand that there is always something left in their dishes for a small, black muzzle and a little, red tongue when Negrito slips away from Juana and comes over here. He seems to crave pats and soft words as much as food and when Alcario takes a string around his neck and, scowling, drags him home, Negrito looks back at me so pitifully that my heart aches. They keep him tied up nearly all the time now and his whines and whimpers reach me to sadden my days and haunt my dreams. Foxy hears him and looks at me sadly, running a little way toward her child and then back to put a pleading paw on my knee. Poor little Negrito! If we only could bring him home again!

CHAPTER XXVII

JUANA IS EDUCATED

EACH morning the sun rises in a clear and cloudless sky. By ten o'clock there is one little cloud above Turtle Peak, beckoning to other feathery bits of mist which drift through the sky to rendezvous there. By midday the small, white clouds have merged into one; have swollen and turned into a shadowy mass from which lightning forks downward among pineclad peaks. The whole sky darkens and the mountains echo the reverberations of thunder. Plodding about on the parched, dusty earth, we turn our thoughts skyward, thirsting for rain. We watch the clouds silently, our need too deep, too keenly felt, for words. Silently we note the faint breeze that invariably springs up from the west, growing stronger with each passing hour until it has blown away the clouds and with them our hopes.

Little showers we have had, enough to sprout the seed in the hayfield and keep the stunted grass alive upon the range. Nothing really grows; plants barely exist. Only once this summer so far have we had the pouring, pelting storm of our desire. One morning we went far up into the mountains, driving a bunch of cattle to the upper pastures where the scant feed is a little more abundant. It was a hot day, the sort we welcome as a weather-breeder. Every step was uphill and the cows rebelled at being moved from their accustomed haunts. The calves grew warm and tired, lagging, bawling, exasperating us by their slowness and by the need of pausing occasionally to rest. We were hot and tired, too, but we had to forget ourselves and consider the cattle first, as always.

Blue Bell would have gone quite mad with having to

poke along behind such slowly moving cattle. It was fortunate that I had turned her out on the range to enjoy a vacation with her chosen friend, Chukie. In her stead, I was riding Eo. His full name is Eohippus. 'Says the little Eohippus, "You must never, never whip us."' Buying him was my first horse deal and is likely to be my last. It seems that I broke the chief and foremost rule of the horse trader. I let the owner know that I wanted the horse. I came home one day from a trip down the canyon in the car, all excitement, exclaiming as soon as I saw Charlie: 'Oh, I saw the most beautiful little horse today! He is a strawberry roan with a white spot in his forehead and he had such an intelligent face! He is the very cutest, fattest pony I ever saw. I petted him and he is awfully gentle.'

'Did anyone see you petting him?' asked Charlie, sternly.

'Oh, yes! A man was riding him.'

'Then I'll bet you boosted the price ten dollars with every pat,' he said disgustedly. 'I have been dickering with that fellow, to buy the horse for you, and now he'll hold me up because he knows you want the pony. Just for that, you can pay for him your own self.'

I did pay for him myself and I have never regretted a cent of it. Although he is short and squarely built and has feet which are too large for the rest of him, he can run when he chooses and he loves to work cattle. He objects very much when I take advantage of his good nature and put some woman on his back who is not used to riding. He would not misbehave and throw her off for the world. No, he has a subtler method. He simply trots, an up-and-down, bone-racking, buggy-trot, until his unfortunate rider is only too glad to get off and stay off. An equine diplomat is the little Eohippus.

The poet who wrote about 'dumb, driven cattle,' never

punched any reluctant cows and calves up a hill on a hot day. Ours were far from dumb and they well-nigh refused to be driven. When we finally arrived at the mouth of Bear Canyon, where we could leave the cattle on the salt-ground in the shade by the river, Charlie told Alcario that he might go directly home, while we would eat our lunches by the stream, rest ourselves and our horses, and come home later by a roundabout way. We wanted to see something of the range on our way back and we paid no attention to the weather. Clouds and thunder had become part of our daily lives and the west wind had blown the clouds away so constantly that we had ceased to hope for anything from a lowering, growling sky. The scanty forage on the ground, the dusty browse on the trees, occupied our thoughts as we rode silently along the mountain trails. We were only three miles from home when great drops splashed upon us and we realized that the overhanging clouds could send down rain if they chose. We looked back toward the mountains we had just left and saw only mist and the long, slanting lines that meant a drenching downpour on the heights above us.

'Say! This looks like something!' cried Charlie, hopefully. 'Come on, bean that fat scrub of yours and see if he can get out of a walk!'

Scrambling and sliding, we descended the trail and reached the floor of the canyon, and down the old wood road we came at a gallop. Hail overtook us, stripping the leaves from the trees, pelting us with stones the size of marbles. At the Hermitage, Charlie jumped from his horse, threw open the gate, and we, the horses and the dogs, took shelter together under a shed in the yard. The hail ceased and rain drummed on the rusty iron roof, dripped through a thousand holes, trickled in rivulets around our feet.

'Isn't it great!' laughed Charlie. 'I wish we had the phonograph here!'

It is a tradition of ours that we shall always play 'Turkey in the Straw,' which we have renamed 'Rucker in the Rain,' when the first big thunderstorm of summer gladdens us. Presently we heard a rush of waters and poked our heads out from under the roof to see the little creek that drains the Hermitage flat, bank-full, surging past in a muddy swirling flood.

'There must have been a cloudburst above us,' we gasped in surprise. Our return to the home ranch was cut off until the little creek rid itself of the flood-waters, a matter of only an hour or so, for it drained a very small watershed. We were too happy to care for that inconvenience. The rain ceased as suddenly as it had begun and we walked out into a washed, resplendent world in which every leaf was glistening. While we were sniffing the clean, refreshing air, there came a new note of Nature which sounded above the swish of the small stream plunging downward beside us.

'Cæsar's ghost! It is the big river coming down!'

We ran to the bank just in time to see the first of the turgid, rumbling flood, as the yellow waters took possession of the river bed and swept down the winding channel, cutting us off from our home for hours to come.

We unsaddled the horses and turned them loose to graze where they chose. Next, we opened the door of the dusty, dismantled adobe house, abandoned to mice and spiders since Grandmother Ortiz pronounced it haunted. Our saddles, thrown on the floor, were the only furniture; our saddle blankets the only bedding. Food was lacking altogether: we wished we might solve that problem by turning ourselves out to graze with the horses. With the setting of the sun a chill crept through the wet trees, into the long-closed house, and set us scurrying around in search of wet wood and bits of a dry box to start a blaze in the fireplace. Crumpled in a corner was a tattered newspaper and

we kept the first page of stale news for reading by the light of the fire. Stretched out beside us on the floor in front of the blaze, the dogs suddenly showed a surprising restlessness. They leaped from sound slumber to scratch as though they wanted to tear themselves to bits and they chewed their own tails viciously. This was not a mystery for long. We also began to wriggle, to squirm, to scratch. Fleas, left for months with none to prey upon, had come up from every dusty crack and crevice, hastening to the feast. I hope they enjoyed the night. We didn't.

At daybreak we walked down to the river, which was running swiftly still, muddy, grumbling and grinding among the rocks. The driftwood high along the banks, the leaves left by the receding waters, told how high the flood had reached during the night. We walked along the bank, down the river in the direction of home and breakfast, looking for a wide and shallow place where we might risk our footing among the rocks beneath the yellow waters. The dogs crossed the river while we were still looking for a ford; Robles ahead, stolidly swimming; three-legged Foxy bobbing downstream to our dismay until she won out on the opposite shore, gave herself a shake and a roll in the leaves, and made off after Robles. We presently came upon a sycamore tree, undermined by the flood, which had fallen across the stream and almost spanned it.

'Here is our bridge,' said Charlie. He scrambled across to test it, then came back to lend me a steadying hand. A few minutes' walk brought us to our house, and there, curled up against the closed kitchen door, emaciated, eyes glazed, lay the little black dog, Negrito. From his neck hung the frayed end of a chewed rope. When I saw him, I was afraid that he had crept home only to die.

'Never again!' roared Charlie. 'I don't care how mad that Indian is and he can leave tomorrow if he wants to. He is

not going to drag that puppy back to be starved and tied up!'

'Poor doggie! He can live here with us from now on — provided he lives at all,' I promised. The puppy had feebly lapped up a little warm milk and was lying on a sack on the back porch. His faithful mother, Foxy, lay beside him, her nose resting on his shoulder.

'If Alcario comes over here, don't say a word,' cautioned Charlie. 'It is quite likely that he will be glad to be rid of the dog. If he wants him back, let him speak first, then I'll have my say. He and Juana liked the puppy well enough when he was so small that half a *tortilla* was a meal for him. When he needed more to eat, it cost them a little flour and extra cooking. Just wait and see which way the cat jumps.'

The cat didn't jump at all. When Alcario did come to the house the next day, I happened to be holding a bowl of warm milk under Negrito's nose. Nothing was said and nothing done, except that Negrito stopped eating and hid behind me, trembling all over. When a little strength returned to the puppy, he never let me out of his sight; wherever I went about the place, he dragged his wabbly little legs behind me. To Juana's house was the one place that he would not go, and when I went there, he sat under a tree at a safe distance, waited for me to return, and fell in behind me with an air that said, 'I belong only to you.' Something, the toe of a boot, I fear, had disarranged the dog's little insides and they rumbled and creaked, 'clinky-clanky,' as he trotted along.

'That dog worries me,' said Charlie. 'I wish the miserable, sick, skinny thing would get well — or something.'

One morning we were awakened by the sound of a dog that was being actively and violently ill.

'That's the last of Negrito, I guess,' cried Charlie as he bounded out of bed, ran into the living-room where the dog

had been sleeping on a rug. He bundled both dog and rug out of doors and opened every door and window in the house. In a little while I was dressed and went out to see Negrito. I found him rather weak, but wagging a happy tail. He drank his milk, which had been the only thing he would take for many days previous. Later in the morning I found him nosing around in the dishes of the other dogs to see if they had left anything. From that day on he ate; my, how he ate! He grew fat; he bounded, barked, scampered, and yelped at the sight of a chipmunk on the woodpile. When we went for a ride, four dogs followed behind; when anyone came here, four barks heralded the approaching car.

'This is Dogville-on-the-Rucker,' said Charlie.

Like Alcario, Juana never mentioned Negrito, who hid when she came for her daily reading lesson. Through the primer we proceeded — The little girl broke her fan; the boys played ball; and the frog jumped into the pool. Juana had just finished reading the last page of her book when a strident motor horn set the dogs to barking and in rolled a *cucuracha*, in which were Alcario's mother and sister and two or three other people, come to pay a week-end visit. They looked with disfavor upon everything, the road, the house, the well from which water was fetched. They thought that the baby had not grown enough and that Alcario worked too hard and was not paid enough. Having tried their utmost to make both Alcario and Juana dissatisfied, they went away on Sunday afternoon, saying that they would never live a week in such an awful place. Only one satisfaction Juana had from their visit. She told them that she could now read, and, when they refused to believe it, she got out her primer and proved it to them.

Before I knew our Mexican families so well, I used to wonder how they managed to put up their many overnight

guests in a house of two rooms, without extra beds or even quilts. I know now how they do it, and it is very simple. They sit up all night and talk. About once an hour they drink coffee, which keeps them warm and wakeful. By morning they have exchanged gossip about every Mexican living on either side of the line within a radius of fifty miles. After their visitors had left, Alcario and Juana told us the Mexican news items, and one was startling. Esteban Gomez has been hanged in Mexico for killing his young wife and her boy lover. The hanging of Esteban was long overdue, it appears. Years ago, when he was called Rosario Velez and lived far down in the interior of Mexico, he killed two men. He fled across the border to this country, grew a beard, took a new name, married; thus he escaped punishment for many years. The story of Esteban and his end made me shiver for good cause.

Esteban came to us with good recommendation from the Slaughter Ranch, where he had been working for some time and where his wife had lately died. He was a good cowboy, skilled at gentling horses, and a fine axeman as well. He brought with him his brother-in-law, a boy of sixteen, and two little girls, the daughters of his dead wife by a former marriage. Catalina was eleven and Andrea nine years old at that time and already they could do all the cooking and washing. The boy was a natural-born cowpuncher and he soon became so useful that we did not need Esteban with the cattle, so gave him a contract to cut juniper posts for corrals and fences. After he had been working at that a little while, he had an illness and Charlie let him have a little money and all the provisions he needed while he was unable to work. That gave him the impression that Charlie was foolishly easy-going, and from being a good worker, he took to lying around his camp, working only when he felt just like it.

Charlie was not so easy as Esteban believed him to be. He rode around from one place to another where the man had been cutting posts and found out how little he had been doing.

'If that *pisano* comes here for more provisions at any time when I am not here,' directed Charlie, 'I do not want you to give him any until you have seen his posts and made sure that he has enough cut to pay for what he wants.'

The very next day, knowing that Charlie had gone to town, Esteban arrived at the house in the middle of the afternoon, when he should have been working, and demanded a supply of groceries.

'My husband has told me not to give you anything more unless you have cut posts to pay for it,' I told him. 'Have you been working today?'

'I have plenty of posts cut to pay for my food,' he replied, looking at me in an ugly, insolent manner through blazing eyes.

'Where are your posts?'

'About half a mile down the canyon.'

'All right. I will go down there with you and count them,' I announced.

We have had a great many Mexicans about us, both our own workers and those who were merely passing by, yet I have never feared a man among them, before that day nor since. I was alone in the house, alone on the ranch. There was no safety in backing down. I went into our bedroom and got Charlie's six-shooter, buckled on a big belt of cartridges and thrust the gun in the holster sagging on my right hip. Then I came outside and let Esteban note my preparedness.

'You go ahead of me,' I ordered, 'and I shall count your posts.'

The half-mile walk seemed awfully long to me. I was afraid that he might not have the posts cut. I had never shot that gun and never wanted to do so, but I had pulled back the trigger when the gun was not loaded and I knew that it was very hard to cock and that the old-fashioned weapon was too heavy for my wrist. I was relieved to find that Esteban had not lied to me; the posts were piled up, ready to be counted and chalked. Still marching him ahead of me like a one-man chain gang, we returned to the house and I weighed out his provisions and gave them to him. I believe that Charlie thought the danger had existed only in my imagination. At all events, Esteban had seen all he wanted of me. He began to work furiously, paid his bill, got some credit ahead, and left not long after.

The young brother-in-law left here with the rest, but he soon drifted away from the family. Esteban rented a piece of farming land down in the valley, acquired a team of work horses, and we occasionally saw him as we drove along the road past his farm. Catalina and Andrea were sent to school and when Catalina was sixteen, the teacher became suspicious that something was wrong and called in the juvenile probation officer. Catalina was going to have a child and Esteban admitted to being its father. The authorities meant well when they let him quiet the trouble by marrying her. When her baby was a few weeks old, Esteban took Catalina, the child, and the little sister Andrea to Mexico for a visit with some old friends of the girls' mother. He ran away and deserted them there in the home of these people who could not afford to feed them. Catalina was glad of the chance to go and live with a Mexican boy who offered a home to her baby and her sister as well.

Meanwhile, Esteban had come back to the United States and had found work with a road-building crew in the San Simon Valley where people did not yet know him. He was a

good worker and they trusted him with animals — until he disappeared one night with the best team of mules. Crossing the line during the night with the stolen animals, he went directly to the home of the people with whom he had abandoned his child-wife months before. When he found that she was living happily with another man, he killed them both. The *rurales* did not let him survive them more than a day. I can see his angry eyes now and I know how they looked to Catalina as he killed her.

After her guests' departure, I told Juana that I had bought a second reader for her and that with her next lesson we would begin reading in it. When she did not appear at the usual time, I went over to see why she had not come.

'My house is so dirty and my clothes have to be washed today,' she explained.

That sounded plausible. The next day she had a very bad headache; then came a pain in her toe; Maria Appolonia had a cold on the fourth day. I looked in Maria Appolonia's crib. There, tossed in for a plaything, was the little Spanish primer. The baby, much cleverer than *el gato*, the cat, had already chewed the first page and demolished *El Señor Rata*.

I realized then that I had wasted many golden summer hours in order that Juana might read ten lines to her mother-in-law. Lessons were never again mentioned by either of us.

CHAPTER XXVIII

PETS AND PESTS

OUR house has just been restored to order and we are recovering from a nerve-racking visit from a flock of bats. On warm summer evenings we have dodged them as they wheeled dizzily through the dusk or swooped downward upon us. We knew that by day they clung to the eaves of the dark, cool barn. At long range, on fragrant nights of summer, they seemed to be poetic creatures. Not so now!

> 'Come out into the garden, Maud,
> For the black bat, night, has flown.
> Come out into the garden, Maud,
> I am here at the gate alone.'

If I were Maud, Alfred Tennyson could wait alone in the garden indefinitely, unless I was perfectly sure that the bat had flown.

The house in which we are living was originally a flimsily built frame cottage, cold and draughty. When our big ranch-house burned and we took shelter in this one, winter was near at hand and we had to contrive a way of making ourselves comfortable as soon as possible. Mexican masons came and tore down the adobe walls of our burned home, brick by brick, brought the adobes over here in wheelbarrows and enclosed the frame cottage in a second wall of sundried mud bricks. The masons also built what they called a fireplace, which turned out to be nothing but a smokeplace, until Charlie tore it down and rebuilt it. By some oversight a crevice was left between the adobe wall and that of frame. Do not tell me that bats are blind when they found such a little hole as that and moved in with us.

For several days I was annoyed by the squeaks, scratches,

and rustling sounds that came from the wall beside the fireplace, beneath the wallboard with which the house is finished inside. It sounded as though a mouse congress were in full session there. I told Charlie about it and he 'pooh-poohed' me. The wretched creatures kept very silent while he was in the house and went to squeaking furiously as soon as he rode away. At last, one afternoon while he was taking forty winks on the couch after dinner, the flopping, rustling, and squealing began at a pitch that woke him up.

'Bats!' he exclaimed. 'Bats between the walls. We'll have them out of there mighty quick.'

Except for the bats, all was peaceful. Robles snoozed on the rug; Peter Cat dozed on a cushioned chair and I looked on with mild interest as Charlie prepared to evict the bats. First he removed the narrow strips of lumber that held the wallboard in place, carefully taking out the nails so that he could replace the boards later, unharmed. Beneath the strips, the wallboard was lightly tacked to the joists. Charlie grasped a sheet of wallboard with both hands and pulled. Off it came — and — Oh! Oh! The room was instantly full of bats!

Small wonder that the Inferno is always pictured as a place full of flying bats. Just a dozen of them, all by them-selves, could make an inferno of any spot. They flew, swooped, leaped, banged into the walls, fluttered under tables and chairs and 'batted around' our bewildered heads. Robles bit at a bat and it bit him. Whereupon he added his howls to the pandemonium. Charlie was laying about him with a poker, meanwhile yelling to me to fetch a broom. Peter Cat leaped for a table, back arched and tail bushed. Birds he knew, and mice, but this combination of the two was more than a cat could comprehend. Squeaks, howls, yowls, screams — that must have come from me — resounded unceasingly, all punctuated by the whack,

whack, of the poker whenever a bat came within Charlie's reach.

As soon as my wits would permit, I bolted shamelessly for the outer door and, since I neglected to close it, most of the bats followed me out and disappeared magically. After Charlie had found a broom for himself and had dispatched the bats that remained in the house, he came outside, mopping his brow, to reproach me for having fled from the field of battle without having struck even one blow.

'Whatever was the matter with you?' he asked. 'You are not usually such a coward.'

'It was because all I could think of was the schoolboy's definition of a bat,' I confessed. '"A dirty little mouse with injy-rubber wings — that bites like the devil."'

Since I have become a rancher, I find that there are a good many things in nature which properly constructed people rave over and I merely rave at. 'Feathered songsters,' dear to the poetically inclined, are called by harshly descriptive names when I enter my vegetable garden to find that birds have been down the whole line of my newly sprouted string beans and have nipped off the top of every plant. We are not duke and duchess, therefore, we cannot wear strawberry leaves and we raise strawberry plants tenderly for the fruit alone. The birds visit our strawberry bed daily and gobble each berry as it reddens. Each night we hang our fresh meat on hooks under the roof of the open porch, where the cool air may blow around it. Before we take it back to the storeroom in the early morning and wrap it in canvas, the blue jays alight on the meat and peck it to shreds. There are some who assert that the blue jays fly down to the lower regions every Friday and report to the Devil all that has occurred in the world during the week. If that is the case, they are careful to breakfast on our meat before they leave here.

Of course we have a tender spot in our hearts for the
'birdie-boarders.' Snowbirds they are called in these parts,
tiny, brownish things, flocking wherever they find the seed
of weeds, pecking diligently at the grain which is dribbled
by the horses on the ground beside the mangers. Every
year we first notice these birds when our winter snows be-
gin. Crumbs from a shaken tablecloth, bits of bread
dropped by the dogs, attract them to our door-yard. When
we go outside, they flit up into the trees that encircle the
house and, from their perch, spy out the land for morsels of
food. Unmolested by the dogs, they grew bolder and looked
into the dogs' dishes. I was afraid that Peter Cat might
slip up on them there, so one day I crumbled a piece of
cornbread and placed it on a little dish on the sill outside of
the kitchen window. I had only time to go inside the house
when the first bird flew down to the dish and ate raven-
ously. All during the winter now, there is a dish of food on
the window-sill, and the birds come in such numbers that
the dish has to be replenished more than once before night.
When Charlie goes out into the kitchen on wintry mornings
to build a fire in the stove, he often finds a birdie-boarder
on the window-sill, feathers fluffed out, head pulled in, sit-
ting pitifully humped-up beside the empty crumb dish, a
mute reminder that it is breakfast-time for birds. Before
building the fire, Charlie crumbs a generous piece of the
dogs' cornbread between his hands and fills the birds' dish.
Sometimes they empty it before we have finished our own
breakfast. They are not gregarious creatures; at least, not
at the table. One at a time they peck at the crumbs; when a
second bird alights near the dish, the first one flies away and
there seem to be flocks of them in the nearest tree, awaiting
their turns. Year after year, they come when the snows
cover the ground and long icicles drip from the eaves. We
like to think that they are the same birds each time, bring-
ing their children to the feast we provide.

Chipmunks, chichimocos, pretty, little, striped rascals they are. I would like them very well if only they would not get into the chickens' grain and scatter it far and wide as they search for their choicest delicacy, sunflower seeds. Chipmunks annoy the dogs, too, by hiding under a pile of old boards back of the garage and squeaking in a manner most tantalizing. Robles is wearing out his teeth, moving those boards around. Move one board and the chipmunk whisks under another, squeaking, 'You can't catch me!'

Rabbits creep into the vegetable garden through the smallest of holes and leave devastation in their wake. Squirrels dart into the chicken-house whenever the hens cackle, grab the fresh eggs in their mouths and scoot back to their den under the blacksmith's shop. Ignoring the windfall apples that cover the ground, to which they would be entirely welcome, the dainty squirrels climb our trees and bite holes in the red cheeks of our choicest apples. This afternoon I went down to the orchard, carrying a box for a seat, a book for amusement, and a small shotgun with which I hoped to bag a few squirrels. Unfortunately, all four dogs went, too, and chased each squirrel that came in sight. When Robles was a puppy, he incautiously thrust his inquisitive nose into a hollow tree and the squirrel that had taken refuge there bit Robles on the nose. He declared an undying feud against them from that hour.

As I sat in the shady orchard, the river gurgling past, a slim, blond stranger, with a rifle slung to his saddle, rode along the road just outside the orchard fence and stopped to talk. Although he was dressed like a cowboy and was well-mounted on a flea-bitten gray horse, there was something about his way of sitting in the saddle which hinted that he was not a cowboy. He soon told me that he was a deputy game warden, riding around through the country in pursuit of his duties.

'Just what do you do?' I inquired.

'Oh, I don't know as I am doin' very much,' he admitted, 'but I just ride around, a kinder pertectin' of the game.'

After he rode on, I settled back on my box and leaned against a tree, book in my hand, shotgun across my lap. I was not doing very much either, only kinder pertectin' of the apples.

Presently I had another visitor who also arrived on horseback; Alcario, home from his day's work on the range. I was glad to see him come in, for he had gone out alone in the morning on his own little pony, Jalisco, after an astonishing exhibition of equine fireworks. If only that pony were gentle, how I should like to own him! He is a 'buttermilk' horse, yellow, with cream-colored mane and tail; beautifully formed, with neat little feet. He is lovely to behold until you catch the mean look in his wicked, rolling eyes, in which the whites are ever showing and 'agin the Guver'mint' blazes hotly. Alcario accepted the pony from a Mexican boy in payment of a bad debt and occasionally he insists upon riding the pitching, side-winding creature, because it is his own. If we owned the horse, Alcario would feel abused at being required to ride such a mean, dangerous animal. It would not be so bad if Jalisco pitched only early in the morning before starting out for the day. He does pitch then, to be sure; he also pitches at noon, in the middle of the afternoon, at any time at all when the pitching notion strikes him. The edge of a bluff or the bottom of the river suits him just as well as the smooth corral for his vicious performance. So far, Alcario has not been thrown by him, or, at least, if he has been, he does not acknowledge it. Jalisco was on his good behavior when he trotted up to the orchard fence. Alcario left him, 'tied to the ground' by the dropped reins, and climbed over the wire to get an apple.

'That is a very good little shotgun you have there,' he commented. 'I borrowed it the other day and shot the hawk that has been bothering your chickens. The hawk was up in that old, dead cottonwood tree and I hit him easily. I once had a little rifle, a twenty-two, which shot very straight, but had to be reloaded after each shot, like this little gun. I paid dearly for my rifle, as I can tell you.

'One time in Mexico, I was working in a wood-camp, packing wood on burros. I was earning fifty cents in Mexican money each day and my board besides. That was a great deal for a young boy and I saved nearly all of it. Little by little, I bought with my savings the things I wanted most, a good, big burro and a saddle. I plaited a bridle for myself from rawhide. I was very proud when I was able to saddle up my own burro and ride to town in style. I also bought a good pair of shoes which I wore only when I rode my burro, for I did not want to wear them out by walking in them.

'Near where we were cutting wood there was a very good adobe house that had once been owned by an American rancher. No one was living in it, so, when the season of heavy rains began, we moved from our camp into that good house. In it was a big stove with an oven, like the one you have in your kitchen; I had never seen one before.

'One very rainy day a strange man came into our camp on foot. He said that he had just been robbed of a fine horse and saddle and he was tired, wet, and hungry. We asked him to make himself at home with us and, after he had eaten a big dinner, this strange Mexican took off his wet shoes and put them in the oven to dry, then filled the stove full of wood. By and by he opened the oven and his shoes were baked, hard, hard. They had shriveled until they were small enough for a child. How angry he was! He remained with us for two days while it was raining and we

could not work. I liked him very much because he listened
to everything I said with such respect, saying, "Sure! Sure!
How right you are!" I was only a boy and it pleased me to
have a man treat me as though I were grown and worth his
attention. When the sun came out on the third day, he
called me to one side and said, confidentially, 'As you
know, my fine horse and silver-mounted saddle have been
stolen and I must now go to town to see about that and also
to attend to other business of great importance which will
bring in much money. Lend me your burro and saddle. I
shall return this evening and shall bring you cigarettes and
many other presents!"

'He spoke so nicely that I caught my burro and saddled
it up for him. Just as he was about to ride away, he looked
down at his bare feet.

'"I am going to transact my business with merchants
and other rich people," he said, "and I shall feel ashamed
to have them see me without shoes. Lend me that beautiful
pair of yours for the day and I shall buy a pair just like
them for myself before I return."

'I went to the box where I kept my shoes wrapped in a
clean flour-sack, and off he rode with everything I owned in
the whole world except my old shirt and overalls. After he
had gone, I went out to see if I could hit a rabbit with the
little twenty-two rifle which he had left behind. It was a
good gun and I became a very good shot with it, even killing
deer and wild turkey. I had plenty of time to practice
shooting, for I never saw that man again, nor my fine burro,
nor my saddle, nor my shoes. The gun had to be reloaded
after each shot, but that did not matter. If I had ever seen
that mean coyote of a fellow again, one shot at him would
have been all I needed.'

Alcario tossed away an apple core, climbed the fence and
picked up the bridle reins. After a day of scrambling up

and down steep trails, Jalisco was standing with head down, half asleep. Alcario swung carelessly into the saddle for a jog to the corral. There was a flash from a mean, rolling eye, and Jalisco, pitching, twisting, leaping, disappeared in a cloud of dust.

CHAPTER XXIX

HAYING

THROUGHOUT this disappointing rainy season, so-called, we have been visiting our hayfield after each abortive shower, poking sticks into the ground to see how deeply the water had penetrated, measuring the hay against ourselves in the hope that it might have grown an inch or so since our last inspection. It did jump several inches as the result of the storm which kept us from home all night, otherwise it would hardly have been worth the cutting. A little rain fell one afternoon while Charlie was away at the Spear E Ranch for a few days, and toward evening I walked over to the field, followed by all four dogs and Peter Cat. Peter has seen very little of other cats and fights them on sight, even chasing Alcario's kitten, Blanco, when it ventures to the barn. Having grown up among dogs, Peter seems to believe that he is one also. When the dogs bark at a car or a stray animal in the yard, Peter rushes forth with them and yowls, 'Meow! Meow! Meow!' fiercely, under the mistaken impression that he is barking. He helps the dogs when they are hunting chipmunks and pack-rats and they agreeably let him have whatever they catch.

My companions chased a cotton-tail rabbit into its hole under the roots of a wild walnut tree and I left them there, the dogs digging and yelping; Peter Cat meowing encouragement from an overhanging limb. As I approached the field, the hay did not look just as it should. I crawled between the fence-wires to have a closer view. Heavens! On each stalk, climbing up and down, were small, dark worms. They had two legs under their chins, another pair at their tails and they progressed by smacking down the front pair, looping their slender bodies and setting the rear pair close

to the front ones. Measuring worms, I believe is the name for the brutes. Well, they had taken the measure of our hay crop and had harvested the best part of it, the tender, green leaves.

Aghast — for it was a disaster of magnitude to us — I waited until dark when I knew that the men would be in from their day's work and then called up the Spear E Ranch, asking to speak to Charlie on the telephone. To my surprise and irritation, he seemed not at all excited when I told him of our latest misfortune. He said that they were very busy over there on a round-up, branding and vaccinating calves and he was going to stay there and help Mr. Krentz. He would come home and see about the hay in a few days. From my explosive Texas husband, this placid attitude was incomprehensible. I had expected him to start for home at daybreak and have the mowing machine in the field by noon. In a few heated words I expressed my fervent wish that I were a large, husky man instead of a small wearer-of-petticoats, and hung up the telephone, highly incensed.

In the middle of the forenoon, three days later, I heard the dogs barking at the sound of an approaching horse and yelping for joy when they were able to see the rider. Charlie had just come home on Eagle, passing through the lane which runs beside the field. When I went over to greet him, his face was set in harsh, angry lines and his eyes were blazing.

'Our hay is nearly all eaten up by worms!' he shouted. 'I saw it from the lane and got over the fence to look at it. There's nothing left but the stalks!'

'You are not telling me any news,' I replied, heatedly. 'I told you all that over the telephone three days ago. Why didn't you get excited then?'

'Because I didn't believe it was possible for little bits of

worms to eat up a whole field of hay! That's why. Where's
Alcario? I want to send him for the team so I can cut what
is left before the worms eat that up too!'

The scanty remnant of a crop has now been harvested
and the haying is over for another year. Last evening I put
a record on the phonograph, and when two voices mingled
in the strains of 'Oh, that we two were maying,' I laughed
aloud.

'What's the joke?' asked Charlie.

'To me it sounds like this,' and I parodied the song with
'Oh, that we two were haying.'

'Cut it out!' cried Charlie. 'We two have done enough
haying!'

He meant it, too, although this spring he had a piece of
rich, level, bottom-land cleared for farming. 'We can't
have too much hay,' he declared when he announced his
intention of adding to his cultivated land. Perhaps he ex-
pected me to argue about it, but I agreed with him. We
can't have too much hay — though we have both had
enough of haying to last us. One good-sized field had al-
ready been cleared and planted since we came here to live.
Its acres adjoined those of the old field and have the same
heavy, alluvial soil. It would cost too much to pipe water
to the land from the river, though it would flow by gravity,
therefore we do dry-farming with all its risks and anxieties.
We are ever asking querulously why it seldom rains when
the seed should be sprouted and rarely fails to rain when
the hay has been cut and is lying in windrows. For a cattle-
man who needs to be riding and watching his range, it is
very hard to find the time for farming, even if he raises only
hay, as in our case. When it is time for the fall plowing, the
ground is apt to be too dry — unless it is too wet. If the
soil happens to be in just the right state to roll over and fall
away cleanly from a shining plowshare, we are sure to be in

the midst of gathering steers or some other essential task that postpones the plowing until the ground dries out again or is flooded by rains. If the plowing is done in the fall or early spring, the first warm days bring up weeds. Harmless little flecks of green against the black soil they seem to be, harbingers of spring. Let them alone and they are harbingers of hard work. They must be harrowed and harrowed again until they curl up and die and new ones cease to sprout. Again it is hard to find the time for this essential harrowing. Spring is full of multiple jobs for the cattleman. If the harrowing is not done at the proper time and the weeds grow too tall and rank to be killed by disk or tooth-harrow, Charlie one day returns from an inspection of his fields and says disgustedly, 'There's no way out of it. I've got to plow that ground all over again to kill the weeds.'

Plowing discourages me, although I have never done any of it myself. It is only when I take a bucket of fresh water to the thirsty plowmen, or call them to dinner when they have failed to hear the bell at noon, that I go over to the field. Comparing the puny line of the first furrow with the immensity of the field and watching the men on their plodding, toilsome rounds, I am reminded of the saying, 'Little by little, like a cat eating a grindstone.' It is marvelous to know that some day Charlie will come in, flop down on the leather-covered couch, dusty, weary, saying, 'Whew! We are through plowing — and am I not glad of it!'

Poor as we are, we always have an extra man to help with that work, for Charlie cannot spare the time from riding to do the plowing alone. I urge him to have two men and do none of it himself, but he won't do that; he will not trust other men with his teams unless he is there to see how they are handled, to adjust the harness, to sponge a collar-chafed animal with salted water. We have two good teams, one of mules and one of horses, and an extra horse to use in an emergency.

'If you must do half of the work, why not buy a riding plow?' I ask.

'That would be too hard on my horses,' he replies.

So, to spare the team, he walks after the plow, round upon weary round.

One afternoon last fall, when the men had come in to unharness after a day's plowing, I went over to the barn and found Charlie examining one of the horses with great concern.

'I am afraid Jumbo has been sweenied,' he said.

A work collar had been buckled too tightly, pressing on the shoulder; the skin was clamped down on a muscle which had already begun to atrophy and shrink, leaving a slight hollow where there should have been a bulge. Charlie came over to the house and at once telephoned to 'Grandpa Winkler,' an old neighbor who has spent a lifetime with horses, and asked him what to do for sweeny.

'Slit the skin over the sunken place on the shoulder and slip a dime in under the skin,' was the remedy suggested.

Charlie accepted it with faith. I was frankly skeptical. It sounded to me more like a voodoo charm than an authentic medical treatment. My own suggestion that if a dime would work a cure, a quarter might do it sooner, was ill-received. It added injury to insult that the only dime in the house was found in my own lean purse. This I squared promptly by taking two nickels from Charlie's pocket. I am glad that I did not bet those nickels on the result of the treatment. Voodoo won and Jumbo is again pulling a plow. Perhaps he would rather be sweenied.

Knowing what hay-raising means from the first furrow turned by the plowshare to the last truss of hay thrust into the barn by the pitchfork, I do not wonder that cattlemen are loath to add that labor to their year's round. Even when they do plow, plant, and pitch hay, they inwardly

adhere to the old-fashioned cowman's pious belief that
'The Lord made the earth this side up and it's wrong to
turn it over.'

We used to have a small farm wagon, surmounted by a
hay-rack, drawn by Tom and Antonia, skittish, eye-rolling
mules. We could not afford help and after the hay had been
cut and raked, I helped form it into neat cocks. Then the
morning arrived when I shouldered a pitchfork and fol-
lowed the wagon in which Charlie was standing up to drive
— jiggle, jiggle, jolt, across the rocky creek-bed — through
the gate and into the hayfield. As long as I could reach high
enough, I pitched hay into the wagon. When the load was
partly on, I was boosted up and waited with pitchfork in
hand to catch and spread the forkfuls that Charlie heaved
up to me. Wind-borne, an occasional truss of hay flew
overboard and lit on the mules; the load lurched as they
jumped and started off with the wagon. Even if I was not
thrown to my knees by the sudden jolt, I flung myself flat
on the hay, arms thrust deeply into it, scratched nose bur-
ied among the stalks, with each jounce expecting to be
catapulted to the ground. My only hope was that I might
have the luck to alight on a haycock. Anticipated dozens of
times, the spill never really happened. Always the long
reins lay stretched on the ground, and no sooner had the
mules started than Charlie dropped his pitchfork and
grabbed for the trailing lines. He tugged and 'whoa'd!' at
the mules. The wagon dragged heavily behind them and
always they stopped before any real damage was done.
Scared and wabbly at the knees, I rose, took up my pitch-
fork, and began to work once more, hoping with each fork-
ful that Charlie would look over the load with an appraising
eye and say the welcome words, 'That's enough of a load
for this trip.'

Time after time I had heard Charlie cuss the truck for

not starting when it was cranked. Now we both cussed the mules for being self-starters. When I mentioned that difference to Charlie, he said, 'That gives me an idea! Next year I'll build a hay-rack on the truck.' He did that and it worked well, except on an occasional year when the ground was softened by heavy rains and we bogged down. Then back to the mules and my acrobatics when they ran away.

Since I was not tall enough to pitch from the wagon, on arriving at the barn my job was to receive the hay as Charlie thrust it in and to spread it out over the haymow. With each load, I mounted nearer to the eaves where the dusty air was suffocating. Somewhere I have read that 'horses sweat, men perspire — but ladies only glow.' Well, I was working like a horse and shared his privileges.

For several years we planted milo-maize hay, until we learned what was better suited to our needs and planted Sudan grass. Milo-maize hay requires a long time to dry and a shower is very apt to catch it during the process. 'Make hay while the sun shines?' Of course. Anyone would do that without being told — only, just when is it going to shine? One year we actually wore out our hay by handling it, by cocking it when it was dry, spreading it out when a shower dampened it, cocking it again. All that the poor cows and horses got for our labors were the stalks that they do not like and eat only in default of anything else. The leaves, wet, dried again, forked over and over, crumbled into brown flakes and blew away.

'There,' said Charlie, when we finally landed this sorry remnant of hay in the barn. 'We must not be too slow about putting up hay. That teaches us a lesson.'

Trying always to profit by our mistakes, the next year we watched our hay carefully, testing the stalks for moisture, and on the first day that Charlie decided that it was dry enough to be put in the barn, we began to load it in. No

shower fell to interfere and we thought we had mastered the hay problem very cleverly. A week after the haying was over, the hay wagon put away, and the mules turned out to graze on the range, I went into the barn, and on opening the door which leads to the haymow, I was appalled to see smoke arising from the hay like mist from a marsh. The whole mass gave forth a steamy, fetid heat. Terrified, as I always am by the thought of fire, I slammed the heavy door and barred it, as though I could imprison flames. Running to the stable end of the barn, I dragged sets of harness from their hooks and lugged them outside, dumping them in the corral; scurried back for saddles, bridles, chaps, and pack-outfits. One saddle was gone; Charlie was riding somewhere on the range and I did not know how soon he would be back. I had now done all I could. Nothing remained, I thought, but to watch the first red flame burst through the barn roof and to try to protect the house with buckets of water if the wind veered that way.

It was hours before Charlie rode in; meanwhile nothing more happened. Had I dreamed of that smoking haymow? I returned to the barn and took a second hasty look. The smoke was there, more than before, rising to escape through crevices under the eaves. Excitedly I told Charlie about it when he appeared at the gate. One look was enough for him.

'That hay is sweating! We may have spontaneous combustion if we don't get it out of the barn right away!' It was too much of a job for us alone. He mounted again and galloped away to the camp where several big boys were taking a vacation. Two husky lads were willing to come and help us and soon all of that hay, which we had so laboriously stored, came hurtling out into the corral, propelled by four busy pitchforks.

'There,' said Charlie. 'We must not be too quick about putting up hay. That teaches us a lesson.'

We were enrolled in the School of Hard Knocks.

CHAPTER XXX

SCOOTER ADOPTS A BABY

To EACH man who works for us we give a small account book and in it is written the amount and price of the supplies he draws from our storeroom and the purchases we make for him. At the end of each month he brings to us his book, *la cartera*; its items are checked with our own accounts; the sum of his purchases is deducted from his wage for the month and an entry is made in his book. Thus he always knows exactly how much pay he has to his credit and there are no arguments when the final day of settlement arrives. The last time Alcario's account was made up, it showed a total balance in his favor of one hundred dollars and thirty-two cents. When Charlie had made the entry, Alcario accepted his book with a smirk. Thereafter he swaggered about the corrals with a hundred-dollar air; his whistle was arrogant; his whole attitude devil-may-care. Juana caught this spirit from him. She opened her door and threw her empty tin cans into the yard, hoping that I would mention this breach of our rules. When I gave her a faded dress of my own, her *'Gracias'* was languid and perfunctory, and by the next day she had scornfully tossed that garment into the yard beside the tin cans, well knowing that I should see it.

Alcario continued to do his work well, however, and we resolved to let him be the one to give the signal for their departure. We are familiar with the usual methods: the demand for a raise in pay which they know they will not get; the sick child; the pretended offense at some word of ours. Alcario was too ingenious for these and gave us something original.

'I want you to bring in the horses from the range to-morrow,' said Charlie to Alcario at the end of a day's work. 'I want to shoe some of them and keep them up to ride during the branding.'

Alcario stopped whistling and pulled his face down into a semblance of grief.

'I shall be very sorry to leave here,' he said, 'but I shall have to go soon. Juana is very anxious to go to see her father and mother who live near Cananea in Old Mexico. They want to see our baby and we have promised them that we shall go down to visit them this fall. I would like to have a month off for a vacation.'

'Very well,' replied Charlie. 'You can have it, and since you will not be here through the branding, it is better that you go tomorrow so that I can get a man who will help me with the calves.' That took the wind out of Alcario's sails, for he no doubt expected that Charlie would beg him to stay here.

In the morning Charlie drove the truck to the door of their cabin, told Alcario to pack in it the things they wanted to take, and be ready to go in an hour. I went over to bid them good-bye. Alcario was whistling, laughing, and swaggering about, clean-shaven and wearing new overalls and jumper. Juana had on her blue dress and black lace *rebozo*; Maria Appolonia was resplendent in a starched white dress with bows of pink ribbon pinned on the shoulders. I looked into the house. The two rooms had been denuded of every garment and furnishing belonging to Alcario's family; there remained only the stove, bedstead, and tables, which are our own. I cast a look around and raised my eyebrows for Charlie's benefit. He nodded in mute response. 'Going for good,' was our silent comment.

Had they forgotten Blanco, or were they intentionally leaving behind the half-grown cat? Humped-up on the

sunny window-sill in the kitchen, keeping out of the way during the bustle of packing and loading, the kitten watched the dismantling of the only home he knew. Almost I spoke to Juana; on second thought I held my peace. Mice and rats riot in barn and field; gophers dig in the garden; we shall never miss a saucerful of milk; so what is a cat more or less? Juana climbed into the seat beside Charlie and took Maria Appolonia in her lap. Alcario ran ahead to open the gates, waving me a glad farewell. I waved back as gladly, happier for their going. I see them through the eyes of my little black dog.

Charlie did not look about in town for a man this time. Working in the wood-camp in Tex Canyon was Dolores, a very good cowboy, who is unfortunately afflicted with the *wanderlust*. For some time he had been itching to leave the axe for the saddle and we knew that he would be glad to come here. Presently he would itch to desert the saddle for the axe, but the branding would be over by then and we could get along without any man until weaning time. Charlie rode over to Tex to see him and Dolores delightedly promised to settle up with his *patrón* for the cords of wood he had cut and come to us on the following day.

They landed here at noon. Dolores was mounted on an old, bay horse, and his wife, Clara, rode another, equally ancient and bony, their small baby before her in the saddle. Except for a few soiled quilts, a sackful of clothing and another of cooking pots, the horses were all they owned in the world. They were retained so that Dolores might easily mobilize his family when he made his frequent moves. Back of each rickety saddle were tied a sack and some bedding. Dangling from Clara's saddle, at the end of a bit of hair rope, was her most civilized appurtenance, an old-fashioned iron flat-iron. We provided them with a supply of groceries and a few minutes served to establish the household.

Charlie and Dolores now ride off together each morning and I go only when a third person is needed to help handle the cattle. Dolores is a good *vaquero* and he knows these mountains well. He is a short, very black Yaqui Indian. His nickname — nearly all Mexicans are nicknamed — is the *Yaquicito*, the little Yaqui. I have always before associated the name of Dolores with beautiful *señoritas*, leaning from balconies with roses in their hair. Singularly inappropriate is the name in this case, and the thick, wiry, black hair of our Dolores has not seen a comb in some time.

While the men are away riding, Clara and I attend to our domestic duties. She uses only one room of her house, spreading her bed-roll on the kitchen floor at night, hanging the quilts on the fence or the bushes by day. She makes no use of the stove. To cook on it she would have to chop wood and stand up to attend to her pots and pans. Wearing the full skirt and short Mother Hubbard sack of Indian tradition, she squats near the door, within reach of a small fire which is built between stones on the mud floor of her kitchen. By the hour she sits there, feeding with small twigs the tiny blaze in her primitive fireplace. In one lard bucket, coffee is always boiling; in another are beans forever bubbling. To cook her *tortillas*, of which she makes a tall stack once a day, she puts a piece of sheet-iron across the stones that encompass her fire. I am somewhat envious of her leisure, until I remember that she has no way to spend it.

Baby Rita requires a minimum of attention from her mother, having been adopted by our young dog, Scooter. Each morning, as soon as the baby has been placed on a piece of rawhide in the shade of a tree, Scooter takes up his duties. First of all, he painstakingly gives Rita a good bath with his rough tongue, not neglecting her eyes and ears. Her one garment, a sleeveless shirt, does not interfere with

this process in the least. When the refreshing bath is over, she settles down for a nap, and Scooter shares her bed of rawhide, napping with one eye open for cats, chickens, or horses, allowing nothing to come near her.

This morning I heard Rita crying, a rare sound. She kept it up for so long that I became worried for fear that something might have happened to the mother. Scooter, nursemaid extraordinary, had taken a day off to follow Charlie out on the range with the other dogs. I ran over toward Dolores's house and through the open door I could see Clara calmly squatting by her fire as usual. The baby's screams came from some trees at a little distance. Under a big juniper tree I found the tiny girl, on her back, arms and legs waving as she shrieked with fright. Around her in a circle were gathered the horses, sniffing curiously at her to find out what sort of a creature she was. Scooter had never allowed them to come that close to her before.

CHAPTER XXXI

TEMPERAMENTAL TOBE

MORE undesirable aliens, wearing fine coats of gray fur, have been smuggling themselves across the line from Mexico by night. Government trappers are working close to the line to stop these lobo-immigrants, but occasionally they slip past the trap-lines and make a bee-line for our mountains. Then out come our traps and the everlasting rounds begin. We finally succeeded in catching the impudent wolf that invaded the sanctuary of our home pasture and tore one of our milk-pen calves with his long fangs. Luckily, the pretty, fat, little heifer got away and the wound in her thigh healed quickly. Even after accounting for that wolf, we still found fresh tracks and kept our traps set all through September without result. October first is the first day of the deer-hunting season and when hunters are rambling everywhere, there is little use in trying to trap for wolves; so on the last day of September we rode out with the intention of taking up all the traps.

Robles wanted so much to follow us when we started out that Charlie said he might go. He trotted along behind the horses very obediently and when we came to a set, I stayed at a little distance with him until Charlie took up the trap. There was little danger of catching our own dog. Everything worked smoothly. Trap after trap was sprung; taken up, stake, drag and all, and hidden in the brush where it would be handy when we went to trapping again. Robles behaved perfectly and trotted along behind us as we ascended Ocotillo Hill and topped out on Lobo Mesa. We caught a flicker of movement at a distance when we neared

that playground of wolves. Charlie loped on ahead; I loitered behind, keeping our dog with me.

'It's a wolf!' shouted Charlie. 'And I'm going to take his picture before I shoot him.' Through the trees, I saw Charlie dismount and untie the camera which was fastened to his saddle by leather strings. The same wind that bore Charlie's voice clearly to my ears had a message for Robles' nose. He lifted his head, pricked up his ears, sniffed and darted away.

'Robles! Robles! Come back here!' I shouted. No use, he had winded the wolf. Straight to the source of that wind-borne scent sped the dog. Charlie was standing with his back to us, aiming his camera at a lone wolf. Up dashed Robles and attacked that lobo. All Charlie could see in the camera was a bouncing, revolving ball of fur. One snapshot he took, then dropped the camera, jerked his six-shooter from his waistband and took to the fray. I came up on the run, shrieking at the top of my lungs, 'Don't let the wolf kill Robles!'

Charlie grabbed Robles by the tail and heaved back. The instant that he had the combatants apart, he aimed at the wolf, and was lucky enough to kill him with the first shot. I felt Robles all over; there was not a scratch on him; the trapped wolf had not been able to get the dog by the throat.

Charlie was riding his big, black Leppy horse, who does not mind what is put on his back. Burdened by the wolf, Charlie rode on ahead of me down Coal-Pit Canyon. I stayed at a discreet distance behind this time so that, in the event of our finding a second wolf, Charlie might have time to shoot it before Robles could smell it. Where the trail from Coal-Pit crosses the river and enters the Main Canyon of Rucker Basin, there is a camp-ground much favored by hunting parties. When we reached there, a hunter who

knew us, hailed Charlie. 'Hi!' he cried. 'This afternoon a man shot a wolf that was in a trap away up in the canyon.' Two wolves in one day! Hooray! Charlie threw down the dead wolf which he carried on his saddle and loped up the trail, eager to find the other one. Robles and I remained with the hunters, who, pleased with the excitement and novelty, gathered around the lobo to have a good look at a beast which they had never seen before. We were kept waiting a long time. The hunters arranged their camp, built a fire, and started cooking their supper. Dusk had turned into night before we heard the clip-clop of shod hoofs on the rocks and Charlie was back with the second wolf. How to get home with both of the lobos was the next question. I was mounted on old Tobe, a mule, the smoothest-riding saddle animal on the ranch, but temperamental to a high degree. He is given to shying and bolting from even imaginary terrors. We hated to think what he might do if he smelled fresh blood on a wolf-hide and felt a wolf's legs dangling against his own shoulders. Charlie unsaddled his horse and my mules, then put my saddle on tall, calm Leppy. I couldn't begin to get my toe up to the stirrup, but I was boosted into the saddle. When I was all set, Charlie threw one of the dead wolves across my lap and Leppy never budged nor turned a hair.

Next, Charlie put his own big saddle on my small mule and mounted. A hunter picked up the other wolf and came toward the mule. Tobe bucked, shied, whirled around and around, his eyes bulging, his long ears pointed and close together; indignant snuff-snuffings came from his distended nostrils. Charlie's patience was soon exhausted.

'The next time I come close enough, throw the wolf across my lap,' he told the hunter Around whirled Tobe, the hunter heaved the wolf. Charlie grabbed it and pulled it across the saddle in front of him and Tobe bolted

down the road like Tam O'Shanter's ghost-ridden mare. Tobe is not used to carrying much weight. After he had run for some distance, burdened with a big man, a heavy saddle, and a husky wolf, he slowed down and let me catch up. We had a road to follow all the way home and only one thing to bother us, until Tobe got his breath again and had time to think of some more meanness.

Between us and the home ranch there was a gate which must be opened. Neither of us could dismount. I was pinned down to my saddle by the weight of the wolf across my lap and even if I could throw off the wolf and dismount, neither the wolf nor I could get up on that tall horse again without help. If Charlie got off to open the gate, there was no hunter about this time to give a helping hand with the wolf. I did some deep thinking on that subject as we proceeded homeward at a swift running-walk. I had not thought of a way to solve the gate difficulty when we reached it, but my resourceful husband knew what he was going to do.

Fortunately for us, the gate was a sturdy, free-swinging one of heavy boards, not one of those abominable wire contraptions, a 'Texas gate.' It opened outward and was fastened by a heavy iron hook. Maneuvering Tobe skillfully, Charlie managed to get near enough to the gate to lean forward and release the hook. Tobe danced away, whirled around a time or two, and was brought within reach of the gate a second time. Charlie took his foot from the stirrup and gave the gate a resounding kick. It flew open and we were free of obstacles for the rest of the way home. Leppy now took the lead with his long stride and presently I heard a commotion behind me, turned and went back up the road at a gallop, the wolf flopping perilously before me.

In a cactus roosted Charlie's wolf. Rolling near the same thorny cholla was Tobe, all four feet waving in the air,

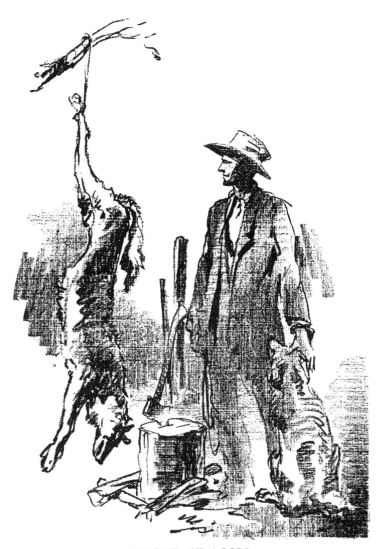

CHARLIE AND A LOBO

and from under the mule came words. Charlie was on the ground, under Tobe.

'Are you hurt? Can't you get up?' I cried.

'I am holding this damn mule down until I get my foot out of the stirrup,' raged Charlie, wriggling and kicking himself loose, holding small Tobe down with a strong grip on the saddle-horn. When his feet were free of the stirrups, and he knew that Tobe could not drag him, Charlie released Tobe and the mule scrambled to his feet, ran a few steps, and then stood waiting for orders, trembling. I learned then that out of pure cussedness Tobe had shied at a boulder which he had seen a thousand times and, when Charlie made him pass it, the mule jumped, swapped ends with himself, backed into the cactus, and fell down, all in the small space of a few seconds. Except for a few scratches and thorns, no one was hurt. Charlie extricated the wolf from the cactus and the mule meekly let him throw the lobo on the saddle and mount behind it. For that night, Tobe was through.

The next day a hunter told Charlie that he had come suddenly upon a lobo, sunning himself in a sheltered spot away up on a ridge between Rucker and John Long Canyon and he had shot the beast. Charlie immediately went up to get the wolf, but he did not ride old Tobe on that trip. Everyone around here will be happy to know that there are three wolves less in the world; everyone, that is, except Brother Anderson. He is now trapping along the border and he won't like it a bit when he hears that three lobos went safely around his traps and reached the Chiricahuas. He wants to catch 'those big old loafers' himself.

CHAPTER XXXII

STRAY CATTLE

WHENEVER neighboring ranchers, whose ranges adjoin ours, are rounding-up to brand, to vaccinate, or to gather cattle which they wish to sell, they are almost certain to find animals which wear our brand, and they let us know that they are working, so that we may fetch home our own cattle. Our fence-encircled cows have descended from those that roamed at will over a vast open range and they are filled with an inherited urge to travel in search of fresh pasturage as the seasons change and valley or mountain promises better forage. Stout fences, well-built and constantly watched, surround our entire range, but accidents happen to the best-regulated fences. Gates are left open by careless hunters or wood-haulers; trees, to which the wires have been stapled, are uprooted by the wind and take the fence down with them as they crash. As soon as a wire is broken or loosened, cattle thrust questing heads through the opening in search of tempting tufts of grass on the far side and press through until they have made a hole through which other cattle soon follow them. Our cows exemplify the old adage, 'The grazing is always better over the hill.'

Once in a while we find a broken fence, on both sides of which the ground has been torn up, brush broken, and stones overturned. We know then that two range bulls, bellowing from afar a boastful challenge and its fierce acceptance, have met, to find a fence between them, and have demolished it in their lust for battle. I was once privileged to witness such a combat. It took place when first we came to the ranch and I felt a tremendous sense of responsibility every time Charlie was off riding the range. It seemed to

me in those days that no sooner had he ridden out of sight than some emergency arose with which I, in my ignorance, must cope. I feel the sense of responsibility still, but what seemed emergencies then are commonplaces now.

On one of those earlier days, I was digging in the flower garden in front of Old Fort Rucker, when I heard a great bellowing from the river bottom, out on the range. There were many bulls about and the sound was familiar enough. What brought me to attention was the answering bellow from our home pasture where we had interned a huge, black Galloway bull, which we had named the 'Black Crook.' Of all the splendid Galloway sires that had been on our range, only this one remained. We were intending to breed the red, white-faced Herefords from that time on and wanted to sell the sole black bull. Now he was evidently coming down the pasture on the run, eager to meet an ancient enemy. Trumpeting, he surged into the water-lot, head down and going strong. Guided by the bellowing of the bull outside, he hit the fence. 'Crack! Smash!' Good-bye fence and good-bye bull!

Charlie wanted that bull — I had let him get away. With that in mind, I jumped through the broken fence, followed the sound of another crash as a second fence gave way, and arrived on the scene as the antagonists met on the river-bank. Appallingly they fought, tearing up the ground, meeting one another head on with an impact that jarred the earth. Nearer and nearer to the high bank of the river the red bull forced the black one, until at last he found the advantage he had been seeking. Thrusting his bloody head under that of the black one, he hunched his powerful shoulders and lifted. Over the river-bank toppled the black bull, to crash heavily on the boulders below.

'Ah! Ha-a-a-a!' bellowed the red victor.

The black bull managed to pick himself up and bolted

away blindly, as the loser always does. Still with my responsibility in mind, I pursued him vainly, waving my little, blue, gardening sun-bonnet, imploring him to return, until he quickened the pace and disappeared among the trees. — The Black Crook!

Tom Hudson telephoned us a few days ago to say that he and some other neighbors were going to be rounding-up his cattle and that he knew some of our strays were over in John Long.

'We'll get 'em together and you can come over after 'em,' said he. 'Two of 'em are those old, wild Necklace cows. Snakes! Snakes! Both of 'em!'

For once Charlie agreed that the description fitted. Usually he disputes Mr. Hudson's claim that our cattle are wild, and so do I, remembering that once, when we were showing our neighbor some young registered bulls, so tame that they allowed me to pat them on the neck, Mr. Hudson would not admit that even they were gentle.

'Turn them out in these mountains,' he asserted, 'and in a month they will be snakes! Snakes!'

We know the Necklace cows all too well. In fact, it was Charlie who adorned them with the jewelry that gave them the name. Finding that these two cows would run like deer every time a man approached them on horseback, he managed one day to get them corraled, then into the chute, snorting and fighting though they were. Whittling long pieces of green oak until they were shaped somewhat like baseball bats, he bored a hole in the smaller end of each one and fastened it to the neck of each of these wild cows by a strong necklace of steel chain. The cows shook their heads with rage when they felt the weight of their jewelry and heard it rattle. If these cows were snakes, as Mr. Hudson insisted, they were now 'rattlers.' Charlie turned them out on the range again, and as they ran, the oak pendants

swung against the cows' knees, impeding them, cramping their style. For all of that, they managed to get over the ground surprisingly fast. Starting the two cows, one red, one black, down a long, steep hillside and betting which would be first at the bottom, was a game of *rouge et noir.* Take your choice.

Dolores left us some time since to go back to wood-chopping; consequently I have been working very steadily outside and my house plainly shows that I have been licking and promising far too long. For that reason, I begged off from accompanying Charlie on the morning when he went over to John Long to get the Necklaces. I was not really needed, for there would be plenty of men to work the cattle and doubtless they would prefer doing it without me. Also some of the men would be coming in our direction with their own strays and would help Charlie to put ours in a small pasture from which we could get them at another time. At daybreak Charlie rode away and I plunged into the arrears of housekeeping jobs, feeling sure that he would not return much before dark.

After I had washed the breakfast dishes, 'punched down the light bread,' stoked up the wood-burning range so that I might have a hot oven and plenty of hot water, I sat down to churn while the white clothes were soaking in a tub in the yard. As time for reading is a luxury we seldom enjoy, I propped a newspaper in front of me so that I might be enlightened as I churned. Perhaps I am what the Russians term a 'peasant intellectual.'

This is what I read. It seems that something is always taking the work out of life. The writer of 'Helpful Hints to Housewives' informed me that one may now remain at the bridge party until the last, lingering moment, since a clock-like contraption on the electric range keeps the home fires burning and turns out a dinner fit for the gods, all by

its unaided lone. Better not let the men know that! I want the credit myself when I give my husband a good dinner.

Farther along in the same column, I read, 'The days of bread-making, churning, and standing over the wash-board are long past.' The churn dasher thumped an echo to my sentiments. 'Oh yeah? Oh yeah?'

Fragrant bread and yellow butter were ready to go into partnership and clothes were hanging on the line when Charlie arrived, hours earlier than I had expected him. I perceived that something had gone wrong, but, wife-like, did not ask him what it was before he had dinner.

'Get into your riding-clothes,' he said, as soon as we finished eating. 'Leave your dishes and come along.'

As quickly as possible I dressed and went over to the barn where already he had saddled my mare, Blue Bell, and was saddling a mule, Antonia, as well.

'Why are you saddling Antonia?' I asked, for Art, a big, blue roan, was ready for Charlie to mount.

'We are going to take José Leon with us,' replied Charlie. 'I stopped at the wood-camp on my way home and told him to be waiting for us to pick him up there.'

We mounted. Charlie led Antonia, and on the way down the road he told me of the morning's events. Having made the long ride, Charlie arrived in John Long Canyon to find that the men who were rounding-up had already brought the cattle to the corrals. Mr. Hudson next rode into the herd and cut out from it all the cattle that did not wear his own brand. Several other men were there just as Charlie was, to get their own strays, and Charlie threw Red Necklace, Black Necklace, and their calves into the bunch of cattle that were coming this way. When they came to the place where their roads parted, the Necklaces and their calves were skillfully cut out of the bunch and two of the men volunteered to help Charlie with his cattle, which had to

be put into a small pasture through a gate about a mile up a long, steep draw. One of these volunteers was younger than the rest of the men. He had a big felt hat; a good horse, which he did not know how to ride; a belief in his own prowess as a cowboy which was not shared by the older men. When cattle should be checked, he pushed them, whistling, slapping his chaps. When cattle were scattering, running every which way, he was happy. That gave him an excuse for running his horse into a lather, then to set him up on his haunches; all the while yelling and making a nuisance of himself generally. Charlie could not very well tell him that his assistance was not wanted and the cattle would do better without him. The cows had only a mile to go and, considering what sort of outlaws they were, they had been behaving unnaturally well.

At the top of the draw which they were ascending was a gate, not of Charlie's contriving. It did not belong to us, otherwise he would have torn it out by the roots long before and built a proper one there. It was too narrow, for one thing, and badly located in an unbroken stretch of fence-line, without a wing. The Necklaces were setting themselves a pace over-fast for hill-climbing and were somewhat winded on reaching the top of the draw. Seeing that they were willing to stop to get their breaths and cool off. Charlie took the opportunity to make a wide circle around the cows and open the gate. He had it open and was remounting to return to the cattle when he saw that the impatient young cowboy, unwilling to wait for Charlie's return, had started up those two snaky cows and their equally wild calves and all were headed for the gate on the run. There was still just a hope that the cows would go through the gate. Beyond it the land sloped sharply downward and running lickety-split downhill was their favorite sport. Possibly they would all have done so had the cow-

boy, wilder than the cows, been willing to let well enough alone. Red Necklace and her calf bolted through and plunged headlong down the hill. Black Necklace had also darted through the gate when the cowboy burst forth in a high, blood-curdling yell, 'Yip! Yippy! Yippy!' It was too much for Black Necklace's calf. Wheeling from the gate through which his mother had already passed, he turned tail and fled, the cowboy spurring after him in noisy, vain pursuit. Wrathful, beneath his smiles and words of thanks, Charlie bid his companions good-bye, closed the gate, and came home to dinner.

Now we were on the way back to the little pasture, three miles from home, pressing José into service. A woodchopper and a cowboy have very little in common, but Charlie hoped that the cattle, seeing José on a mule, might not detect the difference. At the wood-camp José mounted Antonia and we proceeded, looking about us, as we rode, for some gentle cattle which we sorely needed as a decoy for the wild ones. Luckily we found some, close to the trail and quite willing to come with us. We drove them into the little pasture where, if they had not found a weak spot in the fence, we hoped to find the Necklaces.

So far up on the hill that they were silhouetted against the sky, we saw them, two cows and two calves. Once over his fright and left to his own devices, Black Necklace's calf had found a hole in the fence and managed to join his mother in the pasture. That lessened our difficulties considerably. Outlining a plan of campaign, Charlie deployed his slender forces. I was ordered to stay in the glade at the bottom of the hill, guarding the gentle cattle which we had brought along. José climbed up on a hillside and stayed there in full view to turn the cattle downward if they headed his way. Then Charlie turned his horse in the direction of the watchful Necklaces. Circling around,

he rode closer and closer to them. When he was nearer to them than they liked, they started to run away and, since they were alone in a strange place, they instinctively headed for the bunch of gentle cattle below.

When I saw them running downhill in my direction, I feared that they might bolt past me and had they done so, I should have had an equal chance of stopping a river at full flood. To my relief, they stopped as soon as they reached the quiet cattle; then turned to watch Charlie as he unhurriedly descended the hill. Without haste or noise, we three riders surrounded the cattle and started them homeward. With foresight, Charlie had left all gates open as we came and on our return the cattle went along unchecked by barriers. All the way home, without any trouble, although we were apprehensive at times, we fetched the Necklaces and their calves.

Tom Hudson had told Charlie that he did not expect him to get home with them, so after supper Charlie called him up on the telephone to say, 'Hello, Tom. I got home with those Necklace cows all right. With a woman riding a mare and a wood-chopper riding a mule, we brought them all the way without any trouble and they are in our home pasture.'

'Huh,' grunted Tom. 'You think you have 'em in your home pasture, but I'll bet they get out before morning. Those two cows are snakes! Snakes!'

No sooner had we brought home from John Long Canyon the cows that had strayed to the north than we were asked to make a trip to the Spear E Ranch, south of us, where some of our strays had also been found. Charlie answered the telephone when Frank Krentz called us and, after their conversation, told me the plan they had agreed upon. Charlie was to go to the Spear E Ranch the following afternoon and spend the night there. The next morning, bright

and early, he would start toward home with our strays, Mr. Krentz helping him. I was to start from here at peep o' day, ride toward the Spear E Ranch, and meet the men as far down the trail as possible. Then Mr. Krentz could return to his headquarters ranch and we could bring our cattle the rest of the way home by ourselves. That sounded like a perfectly feasible, fool-proof plan.

The next morning Charlie wrangled horses, chose Art, a big blue roan, for his own mount and Blue Bell for mine, turned the other horses back into the home pasture and went away right after our noon dinner. He had only eleven miles to go, but he wanted to take it slowly and look at the cattle he met on the way. He left my mare alone in the corral, with the door open to the stable where there was a mangerful of hay. There she could spend the night and be ready for me; the early morning hours being too precious for me to spend them in hunting horses. I did not mind being left here alone; there was plenty to do and I had four dogs for company. Blue Bell did mind it. She had nothing to do and to her the only society worth having is that of another horse. No sooner had the sound of Art's hoofs died away than she was out in the corral, nickering, stamping her feet, running to the gate. If I appeared outside, she ran toward me, begging to be let out of her prison. Chukie, her particular chum, came down from the pasture in search of her and stood by the gate, adding his shrill protests to her own. I felt sorry for her and said it with oats. She ate them with good appetite, then nickered some more. After that I turned a deaf ear to her outcries.

The days had grown short and I did not trust myself to waken early. To call me at five, I had my charming alarm-clock, bought in one of San Francisco's Chinatown bazaars; it will tinkle the Chinese music, 'Golden Lilies,'

for fifteen minutes if I wind it tightly. I went to bed with mind at ease, depending on that faithful timepiece. I had no need of it. Half an hour before it would have called me, a splash, as though someone had thrown a pailful of water against my window, aroused me. Rain! Pelting! Dashed by gusts against the house. I jumped up, closed my window, and climbed back into bed. When the 'Golden Lilies' tinkled sweetly, I did not get up. At half-past five I thought I could safely call up the Spear E Ranch without rousting them out of bed on a rainy morning. There was no answer when I rang the telephone bell, loudly and long. I tried again. Surely they would not be able to sleep through that clamor, and they are early risers, too. It was all too apparent that the miserable old telephone had broken down somewhere, as it frequently does at vital moments. There was no possible way of telling Charlie that I would not start as we had agreed.

There is one peculiar excellence about our ranch. The mountains which surround it seemingly exert an influence upon the wind currents and they in turn draw down into our basin the low-lying clouds with their precious burden of moisture. Often we have a shower that confines itself, as by intention, within the borders of our range. 'A private rain on the Raks' we say, when we have a little rain that is not shared by our neighbors. I could not see the sky beyond the mountains that encircle us. It was entirely possible that what seemed to be a real storm was only the largess of a few clouds directly over us. If that happened to be true and I remained at home, I should be shamed in my own eyes and Charlie, who had depended upon a woman to help him punch cows, would share my disgrace. Before the day was over, I expected to hear from him one or another of two remarks, 'Don't you know enough to go in when it rains?' Or, 'Are you sugar or salt — that you are

afraid you may melt if a few drops of water fall on you?'
Of the two, I much preferred to hear the former.

While thinking of these things, I kindled the kitchen
fire and put on the coffee; after which I dressed hastily,
all except my boots which I did not want to soak, and ran
over to the corral to feed Blue Bell. Chukie had evidently
gone off to join the other horses and no longer answered
her occasional neigh. I put oats before her and scampered
back to eat my own breakfast, pull on my boots, and be
back by the time she had finished eating. Blue Bell was
glad to be bridled; she preferred any amount of work to
solitary confinement. I wiped off her wet back with a
grain sack; she was another who didn't have sense enough
to stay in when it rained. I saddled her, led her through
the gate into the lane, and mounted.

Both the mare and I felt happier when we had put behind
us the corrals, the buildings, the outlying fields, and en-
tered the trail that would take us to the divide and into
Tex Canyon. Blue Bell would have preferred going in
some other direction, knowing that this one usually means
a long journey. She is not lazy, though, and her plump,
prettily curved body shows that she is well fed. 'Fat is
the purtiest color there is' — for horses and cattle. The
dogs are delighted to go anywhere at any time. The moist
ground held exciting scent of wild creatures. When they
found a very fresh trail and tore off up a hill to my right,
'Ki-yi! Bow-wow!' I did not call them back. They would
return to where they had left me, nose out my horse's
trail and follow me.

The wind had died down, the rain was now but a drizzle.
I wore a large felt hat, a canvas jumper, chaps. It would
take a heavy downpour to drench me. That it had rained
heavily in the night and early morning was evidenced by
the water running in every little creek and wash, where

yesterday had been only rocks and dry leaves. We turned the corner where Cottonwood Canyon lay to the left of the trail, past which we had fought and out-maneuvered unwilling cattle often and often. As we ascended the trail which climbed steeply from there on, I found the place where the telephone line was broken, snapped by a falling tree. It was good fortune to find the break so quickly and so near home.

We reached the top of the divide and looked into a great valley, the San Simon, toward which we would travel through Tex Canyon. No. This was no little, private rainstorm which we were having. Near-by, on the divide, it was drizzling and over the valley the clouds were heavily banked. It had rained harder in Tex Canyon than in Rucker, judging from the water flowing in the creek, through which Blue Bell sturdily splashed. As we went on down the canyon, small washes added their flow to the main stream, which grew larger and larger. If narrow, the crossings would have been dangerous to a horse's footing, so we carefully crossed and recrossed where the stream was spread out and shallow.

Presently, emerging from a narrow, wooded trail, we came upon a warm cove in the hills in which nestled a house, now uninhabited, a field, and an orchard. Under great cottonwood trees, leaned the log cabin of 'Tex,' the pioneer from whom the Canyon took its name. Awry, battered by the winds, the mud chinking between the logs had long since fallen away. We were six miles from home. Soon I might expect to hear the movements of cattle, the voices of the men who were driving them. Around any clump of trees, I might come upon them. They were gentle cattle, I knew, otherwise I could not have taken the risk of scaring them by meeting suddenly, head on. Only in one place was there a chance of missing men and

cattle; that was a short distance through the creek bottom where another trail paralleled the one I had chosen. When I reached the place where the two trails again united, I looked at the ground for sign. Only the hoof-marks of one or two cows had been imprinted since the rain; there were none of horses. On I went. Surely the men should have met me by now. The cheek of telling *me* to get an early start!

Since they had failed to meet me as far up the trail as I thought they should, I quickened my pace. I should show them how prompt and energetic a woman can be. We climbed out of the creek bottom onto a smooth, level mesa. From her rapid running-walk, Blue Bell changed to a trot of her own accord. Perhaps she wanted to show Charlie's horse what a mare can do. Suddenly, the footing which had been soft, yet gravelly, changed to a slick, reddish clay. Blue Bell, taken by surprise, floundered, slid, pawed for a foothold, strove desperately to keep her balance. Charlie has often warned me never to let myself be caught beneath a falling horse. I helped the mare with the reins until I knew her efforts could not succeed, then kicked my feet back, out of the stirrups, dropped the reins, and dove over her head as far as I could. When the world was made, a rock had been left in just the right place for me to hit it with my eye.

Blue Bell picked herself up and stood near-by, smeared with red mud, trembling. I got to my knees, then to my feet, waggled all my arms and legs. They seemed to work. My eye was going to be a 'shiner' — already it hurt me to close the lid. Slowly the vision cleared; the blow had been on the socket and not the eyeball. Blue Bell let me catch her and mount, although I led her beyond that treacherous, red, slippery clay before I got on her again. Down, down the canyon we went and a cold wind whipped

around us as the country grew more open. It struck upon
the wet mud which had dampened us; soon nothing was
warm about me but my wrath which I was nursing as we
put mile after mile behind us. There were several gates
to be opened and I felt myself growing stiffer from my fall
each time that I dismounted. After opening the last gate,
I could see the Spear E ranch-house, smoke ascending from
two chimneys. Blue Bell chose that time to develop a
slight limp and I added her injuries to my own. Up to
the house I came, riding so near that I could see into the
windows of the sitting-room. There, in two rocking-chairs,
slippered feet resting on the nickel rail of the stove, sat
Mr. Krentz and Charlie!

I said not a word. I sat my horse like an equestrian
statue of Nemesis. There seemed to be nothing to say.
The familiar 'Hi, there!' was too jocular, too friendly for
my mood. To throw a rock through the window would
have suited me, but to get one I should have to dismount
and I had made up my mind to let them know coldly that
I had come, then ride away with as much dignity as Blue
Bell's limp would permit.

The men happened to look out of the window. What con-
sternation! They rushed outside. Mr. Krentz, all host,
wanted me to come in at once and get warm. I should eat.
I should rest. My mare should be taken to the barn and
filled up with oats.

'No, thank you,' I replied stiffly. 'I am going home
now!'

'Don't you know enough to stay in when it rains?' asked
Charlie, knowing that the best defense is an attack.

'You told me to come and I am here,' I retorted, vir-
tuously hinting that I am a wife and must obey.

'Oh, come on in,' cajoled the hospitable Mr. Krentz.
'You are hungry and cold. Have dinner. Then we'll

wrangle horses and Charlie can go back with you. He can get the cattle another time.'

I had ridden eleven sloppy, rainy miles. They had not even wrangled horses! My feeling of superiority mollified me. I was hungry.

'Have you any beef?' I inquired.

'Oh, yes! Roast, steak, anything you want.'

I dismounted.

'What I want,' I said, 'is a raw piece to put on my eye.'

Then I was petted and doctored. Blue Bell was tenderly examined; her lameness seemed only from a bruised muscle and she was led off to be rubbed down and fed. Big bones were given to all the dogs. I took my turn by the stove with my feet on the rail and presently we were called to dinner. The Krentz family live in town while school is in session; this was for the time a bachelor establishment. Two cowboys had cooked the meal, steak, potatoes with onions, biscuits, and coffee. One of these men rose and waited on the table when more food was required. He was a tall, thin Texan, with spurs at his heels. Not the silent, sober, business-like ones that Charlie wears fastened to his boots by leathers. This cowboy had the sort that I mean to wear when I can get them; shiny silver-mounted ones, with rowels that made a lovely sound.

'Jingle, jingle, jingle, "Will you have a piece of steak?"'
Jingle, jingle, jingle, "A biscuit will you take?"'

It was their music that soothed my savage breast.

CHAPTER XXXIII

MISTLETOE

ROBLES is a victim of nervous prostration. He is lying out in the yard in the sun, not a tail-wag left in him. The other dogs dash off after rabbits and he does not even lift his weary head to watch which way they go. Excitement has left him in need of a rest cure.

Yesterday afternoon we started off for the chicken ranch where we knew we could buy some pure-bred Rhode Island Red cocks. I do not like chickens and can barely endure them when they are the best of their breed. Just before leaving home we bade three of the dogs good-bye.

'Good-bye, Foxy! Good-bye, Scooter! Good-bye, Negrito!'

The three dogs crouched in a mournful group at our feet when they were so addressed, ears drooping, eyes downcast. Robles was afraid that we might also say good-bye to him, so he hastened toward the garage at a trot, careful not to look back. He is the only dog that we allow to ride in the car, and when we call, 'Chooka hound!' he jumps into the back seat and laughs and slobbers in joyous anticipation.

There was no reason why Robles should not have the pleasure of this ride, and he enjoyed it particularly when we turned to the left just before reaching the schoolhouse and entered a road which we seldom use. To the adventurous, who do not mind waiting hours for a creek to subside and have no objection to shoveling themselves out of a hole, this road offers a route to Douglas which is seventeen miles shorter than the one through Sulphur Spring Valley. Charlie's own experiences and those of our neighbors have given a profound respect for the old saying, 'The longest

way around is the shortest way home.' It is as much of a
novelty to me to use this road as it is for Robles. He hung
his head out at one side; I leaned out of the other to see all
that we could. Charlie saw nothing from start to finish
but the ruts, rocks, twisting climbs, and bumpy descents,
from which his alert eyes dared not stray. We had not the
least intention of going farther than the chicken ranch
when we left home, but it was a longer distance than we
had thought and when we crawled all the way down Leslie
Canyon and located the place, it proved to be in the foot-
hills which rise from the eastern side of Sulphur Spring
Valley. From the great plain spread out beneath us rose,
billowing, the smoke from the smelters in Douglas.

'Let's go on into town and get our mail,' suggested
Charlie. 'It is two weeks since we have had even a news-
paper and we can get the Moores' mail too and go home
through the valley instead of driving back through that
hell's hip pocket.' I agreed with much pleasure, and when
we had the roosters stowed away in a crate, we drove on
toward Douglas.

Robles grew tired of standing up to be jolted and jounced
and settled himself cozily in the corner of the back seat,
lazily looking at the cows and hills which he had seen all
of his life. At the edge of town, houses and automobiles
in unprecedented numbers attracted his attention. He sat
up straight and leaned forward to get a better view of the
town which he was seeing for the first time. By the time
we reached the center of Douglas, he was talking to himself
in grunts and whines of astonishment. Charlie got out at
the post office while I remained in the car with Robles to
keep him from jumping out of the open car. Young Carl
Cole, who had been a visitor on the ranch, came up to
speak to us and our dog was delighted to recognize a friend
among all these strange human beings. 'Wow! Wow-ow-

ow!' he yelped, wagging with delight. We drove down the main street of Douglas and parked on a busy corner while Charlie dashed off to do an errand. Robles jumped over into the front seat with me and sat there talking to me with such whines and exclamatory yelps that people stopped to marvel and to laugh. Charlie took my place while I did my own small shopping and we started for home after less than an hour in town. As we came to the outskirts of Douglas, we saw a train pulling out of the railway station.

'Robles has never seen a train,' said Charlie. 'Let's stop and let him get out and have a good look at it.'

Robles watched the long freight train roar past, 'clickety-clack, clickety-clack,' followed it with his eyes until it passed out of sight around a curve. Then he climbed into the car, heaved a sigh of satiety and settled down in the back seat to sleep all of the way home. He slept all of last night and has been snoring away all day. We wonder what he will say to the other dogs when he finally wakes up.

During our very brief stay in town, I did all my Christmas shopping, which consisted wholly of tissue paper, seals, and string. This year I can see Christmas drawing nearer without a qualm. When I was last in California, Mildred taught me how to make hooked rugs and Theodore made a hook and gave it to me. To one as impecunious as I, it is delightful to be able to make Christmas presents by combining old barley sacks and worn-out silk stockings. I am becoming a nuisance to my friends by reason of letters importuning them to send me their cast-off hose. There is a fine graft to it which I am keeping dark. My town-dwelling friends discard their silken hosiery for just a trifling run or two. The cows do not notice such small defects and I amble around the corrals on silk-clad feet. I feel so much more at home in cotton ones with a patch on the heel that I am reminded of the story of one of our jovial

neighbors. He once told us that as a boy he was so hardened to going barefooted that when he had his first pair of shoes he had to put some gravel into them before they felt comfortable.

In addition to the hooked rugs, made during evenings spent beside the blazing hearth-fire, I shall send away the Christmas gifts which I annually pluck from the trees. In the early part of December I begin prowling around in the forest, looking for the trees which promise the most beautiful clusters of mistletoe. Imitating its host, the parasitic plant bears a resemblance to the tree it grows upon. On the oak tree it offers a profusion of white, waxen berries and small, curled leaves. On the sycamore, the mistletoe clusters have loosely sprawling foliage and berries of a deep cream color; while the pink berries of the juniper mistletoe grow on tight clumps of green that resemble needles more than leaves.

Just before Christmas each year, I place my boxes in a row and line them with tissue paper. Then we go out into the woods to gather the mistletoe and the gray-green berries of the juniper as well. As the car bumps over its annual route up the pasture to a sheltered glade where the greens grow profusely, the eight-feet-long pruning-knife, which we call the 'long-legged snicker,' jounces on the fenders. When we reach up into a tree with it and nip off the high-growing mistletoe, 'snick, snick!' the Christmas presents fall on the ground. It is like shaking a breadfruit tree.

In only one year we knew a scarcity of waxen berries, when the mistletoe suffered from unusually heavy autumnal frosts. Our touring car was out of commission for some reason; Charlie was away and I do not drive the truck. Taking the long-legged snicker on my shoulder, I trudged the length of the home pasture and up to the sunny hillside

which offered the only mistletoe growing near-by that had escaped the frost. When I had cut cluster after cluster, I made them up into large bunches which I tied together with strong twine. These bunches I tied in pairs so that I might carry two at a time without losing any of my cargo; one pair at a time I carried down the hill toward home. When I grew so tired with the weight that I could carry it no farther, I deposited my green and waxen burden on the ground and went back for more, resting myself by relaying the heavy mistletoe. Very gratefully I picked up the last two bunches and walked down the rocky hill on my final trip. I still had to pick up the greens, which I had left in a pile about halfway home, but the walking would be smoother and easier. As I approached the spot in the pasture where I had deposited my greens, I caught sight of a familiar bulky, black cow, all too near my pile of mistletoe. I ran. I shouted with all the breath I could spare — quite futilely.

Mrs. Trouble, her big hoofs planted in the midst of broken greens and trampled berries, had eaten up the Christmas cheer.

CHAPTER XXXIV

'HOME, HOME ON THE RANGE'

'EAT, sleep, and ride a pony,' that is an old description of the cowboy's life. I can hardly believe that it ever was a true one, certainly it is a long way from telling the whole story now. It is no longer enough that a cowman be able to throw a rope, tie a calf, and brand it neatly with a running-iron. It takes even more skill to round-up a buyer and tie him with a contract. In hard times it is more difficult to sell one's cattle for a fair price than it was to raise them. Formerly there was a certain price for cattle by the head during any given year; now competition, unknown to our business in earlier times, has put in its appearance. When there is not a demand for all the cattle that are for sale, naturally the best are selected by the buyers and the finest cattle bring the best prices and find the surest sale. With decreased demand the buyers have become very 'choosey.' They are no longer content with the customary 'ten per cent cut.' Instead of that, they want to go into a herd and pick out only the very best animals, rejecting this one because of a little too much white on his back, another because of a red spot or two on a face that should be all white. Our own difficulties are increased by our having a number of black steers, Galloways. Buyers will not even look in their direction, although the black cattle are frequently heavier and of better conformation than our red ones.

A particularly captious buyer came to 'cut' Grandpa Winkler's cattle. Going into the herd, he rejected this one and that, and these 'cut-backs' were thrown into an ad-

joining corral, until nothing remained but the very cream of the herd. He had 'topped out the bunch,' as we say. Grandpa Winkler looked on, saying nothing, but becoming more angry with each rejected steer.

'Are you all through?' he asked the buyer.

'Yes, I'll take these that I have picked,' replied the 'sharpshooter.'

'Well, I can show you how to do a better job of cutting than that!' shouted the old man. Then to his son he yelled, 'Dolf! Throw all the gates open!'

Dolf gladly obeyed and the steers rushed together, out of the gates and back to the range.

Within the past few years a custom has grown up of selling cattle by the pound, live weight, and there are scales in the railroad shipping yards. Naturally, when we are to be paid by the pound, we do not want to sell our cattle when they are thin. It is for that reason that we now have on our hands a bunch of steers which we should have preferred to sell last fall. The feed was far from good last summer; the steers did not fatten properly and we withdrew them from sale in the fall to try our luck in the coming spring. We are now afraid that we made a mistake. The fall and winter have been nothing to brag about and neither are our steers. We have been worried over what to do with them, for we can see that we shall need all of the grass we have on our range for our cows and calves. Now we have had the good fortune to find pasturage for our steers on the Spear E Ranch in the San Simon Valley. The Spear E has not had any too much rain either, but its range is at a much lower altitude than our own and consequently warmer; they will have an abundance of weeds. Cattlemen do not save grass 'for a rainy day'; they save it for a dry one. Weeds cannot be saved at all. As soon as the hot weather comes, the weeds will curl up and blow

away, so our steers will not rob the Spear E cattle by grazing on their range while the weeds are green.

Until this luck came our way, Charlie and I had been moving our steers about from one place to another, keeping them on the best feed we could find. Mr. Heyne came to our rescue again and let us have his pasture, where they thrived until they ate all the grass in it. The day before we were to drive the steers over to the Spear E Ranch and turn them loose there, we had to bring them up from Mr. Heyne's place, a little over a mile through thick brush. We have had no cowboy since Dolores left and Charlie asked Tom Hudson if he would help us bring the steers home.

'Sure, I'll help you,' he agreed. 'They will all be snakes! Snakes!'

He met us early in the morning in Mr. Heyne's pasture and we soon had the steers rounded-up and we counted them to make sure that we had overlooked none in the brush. Then Charlie rode ahead, opened the gate, and took the lead to turn the steers in the right direction when we went out of the pasture, up a lane and on to the range. I had dreaded the trip through the timber with those precious steers and felt my responsibility more keenly than I needed to do with Charlie and Mr. Hudson there, both well-mounted and highly skilled in handling cattle. There was no telling how the cattle might behave. They might plod along as amiably as oxen; they might feel frisky and keep us on the run. Loose horses might gallop past and startle them; an automobile, coming along the road where it parallels the trail, could easily set the whole bunch to running or scattering in a panic. At best, there are in every herd of cattle, as in every group of human beings, speedy creatures to be checked, slow ones to be prodded, 'leaders and drags,' we call them.

At our right, all the way home, we had the river; now a mere trickle winding through a broad waste of rocks. There we could easily head off any of our steers that chose to make a break for liberty on that side of the trail. At our left were trees and oak thickets, pierced by many a path made by cattle coming down to the river for water. Charlie rode on that side, abreast of the leaders, checking them when they were too far in advance. Tom Hudson followed Charlie, paralleling the main bunch of steers. I rode humbly in the rear, keeping the drags in motion and always with a watchful eye toward the river. My little Eohippus knows his duty in that place perfectly. He seems to poke along in a very unconcerned fashion, but let any animal stop to drink or nibble a tuft of grass, and he is right at its tail. He is not a horse to hurry himself unnecessarily; though he tucks his short legs under himself and shows a surprising speed when it is a question of heading a runaway steer.

Everything went along smoothly until we had to pass only one more place where there was much danger of losing any of our cattle in the brush. At that point we had to make a sharp turn to the left to climb a steep bank, and cattle that are well acquainted with that locality frequently bide their time until they get right at the foot of the bank, knowing that it offers their best chance for escape. Sure enough, the leaders broke into a run when they reached the bank and Charlie dashed off to head them. Tom Hudson joined him, trying to force the steers back into the trail. Hastily I routed some of my drags from a pool in the river where they were stubbornly determined to linger at that critical moment. Then, anxious to catch up, I took a short cut through the trees, leaned far to one side to duck under a low limb — and over I went, saddle and all. I grabbed at Eo's mane for the instant which enabled me to kick

my feet out of the stirrups and then I landed, slam-bang, in a pile of rocks, leaving my saddle swinging under the pony's belly. Any other horse in the world would have started for Cheyenne when he felt that saddle dangling, hitting at his legs. Eo only stopped still and looked at me with disgust.

'This is a pretty time for you to fall off, when we should be riding like the devil!' his look said.

While I was recovering and picking myself up, he reached up for a mouthful of oak leaves and chewed them nonchalantly. His attitude hinted that he was not responsible. I had saddled him, hadn't I? He was to blame, all the same. Always when he is being saddled, he puffs himself up with a deep breath so that he will not be cinched too tightly. Usually I slip up to him just before mounting and jerk the latigo strap up a hole or so. That day I had forgotten to do it. I rose from the rocks, unbuckled the cinches, picked up the saddle and blanket. As I resaddled at top speed, I could hear the men shouting and the loose rocks sliding as cattle and horses scattered them.

'Mary! Where are you?' yelled Charlie.

'Coming!' I shouted, as I mounted again and Eo ran his fastest, anxious to be back on the job. We were too late to be of any use. My feeling of self-importance shrank when I found that the steers had been brought back to the trail without my help and in a few minutes we were up the hill and safe in the corral with all of them.

'What became of you while we were having hell with those steers?' asked Charlie.

'Taking a nap on a pile of rocks,' I replied. 'My saddle turned and spilled me.'

'Well, you came near spilling the beans by not being there,' warned Charlie. 'You'd better see that you are cinched up tomorrow.'

'Sure need all hands with those steers,' commented Tom Hudson, happily. 'I told you they were snakes! Snakes!'

I went over to the house to cook dinner, and after eating, Mr. Hudson went back to John Long. He has a ranch and cattle of his own and we could not ask him to give us any more of his time. Of course we had to have someone to help us take the steers to the Spear E Ranch and another neighbor lent us a cowboy for the day. I was delighted when Charlie told me that we were to have Jim Frost, for of all the cowboys I have ever seen, he looks the most like the ones on the magazine covers. He is tall and thin, with scanty, white hair and stringy, white mustache. Always he is dressed in blue overalls and jumper, 'Levi's,' and high-heeled boots. He evidently believes that his bowed legs were made only to bestride a horse and one rarely sees him afoot. Even then there is more than likely to be a pony waiting near-by, reins dragging, 'tied to the ground.'

I had faith that with a cowboy like that to help us, Charlie could ride on one side of the cattle and Jim on the other and I need only keep the drags in motion.

'I am going to sleep like a top tonight,' I told Charlie. 'I need not drive those cattle all night in my dreams.'

During the night an unexpected shower woke us and we were sorry when the brief downpour ended in a pattering and a desultory drip, drip, from a tree that overhangs the roof. A good, steady, soaking rain was what we needed and never mind what plans it interfered with nor whose plans they were. When we arose, long before daylight, the sky was overcast and had all the earmarks of a coming storm. None the less, we hurried through breakfast and morning chores and were saddled up when Jim Frost arrived. Although we disliked doing so, we had put the steers in the home pasture where they could fill themselves on our very best grass. The December days are so short that we could

not spend time in grazing our cattle on the way and we know how hard it is to drive hungry beasts along a trail lined with browse and grass.

The home pasture consists of a wide mesa, open in the center and edged with trees, and a heavily wooded gulch where the mesa slopes toward the river. As we entered the pasture our paths divided. Charlie took the mesa, driving ahead of him every animal he found. Jim Frost and I took the gulch, he on one side and I on the other, so that we could not fail to find all of our steers. As Jim had never been in the pasture before, I told him to take the side that is bounded by a fence and that it would lead him to the place where Charlie and I would meet him. The gulch widens, narrows, and widens again. At the place where our trails almost touched, Jim called out to me, 'This place is awful brushy! I don't see how you ever find cattle here!'

'Oh, dear!' thought I. 'What are we in for now!'

I had heard before that there are two kinds of cowboys, those who are 'brush hands' and those who have worked cattle only in open country. If Jim thought that this pasture was brushy, what in the world would he do when he hit the 'deep, tangled wildwood' that we were soon to drive through. How glad I was that I had not known all this the night before. I should not have slept a wink!

Driving everything before us, Jim and I reached the corner of the pasture where the river cuts across it and makes a watering-place. Charlie's cattle were soon seen coming down the slope from the mesa, he following them on his white horse, Eagle. As the cattle drank, Charlie counted them, and we were glad enough to know that we had found all of the steers and need waste no time hunting for missing ones. Besides the steers, we had picked up some cows and bulls which we must cut out of our herd before leaving the pasture. It is brushy by the river, and so, when

every animal was watered, we drove the cattle up to the mesa where there is ample room. When the United States Cavalry occupied Old Fort Rucker, they cleared a parade ground in what is now our pasture and the oblong rifle butts are still outlined there by mounds of rock. Here we stopped the cattle; Jim and I held them and Charlie cut out the cows and bulls. We were ready to go.

Jim was asked to go ahead and open the gate, and that gave me the chance I had been looking for. I loped over to Charlie and said in a low tone, ' Jim thinks this pasture is awful brushy and says he can't see the cattle.'

'Good Lord! He isn't a brush hand! Well, Mary, you'll have to take the Cottonwood side.'

For the first half-mile the trail followed a fence and that gave the steers a chance to line out, one behind another. I was interested to see that the same ones that had been among the leaders the day before were there again and the drags were the same animals that I had prodded on the way from Mr. Heyne's pasture. In the middle of the line were the rank and file that would be troublesome or well-behaved according to the example set them by the leaders. When we left the fence, Charlie took the lead and turned the steers sharply to the right, downhill, on an old road which leads to a gate. I took one side and Charlie the other, leaving the place behind the cattle to Jim. We could not see the gate until we were right upon it, so Charlie took the lead there, the cattle following him, opened the gate, and went on through to take a stand on the right to turn the cattle to the left this time and into a broad trail cut through the trees. It is a ticklish spot. Jim and I had to stay inside. until we saw the last steer through the gate, then, asking him to close it, I scooted for the left side of the moving herd and Charlie and I soon had them 'laned' be-

tween us. Jim stayed in the trail behind the cattle. So far
so good.

I was now on the Cottonwood side, I had not for an
instant forgotten that. I pulled my hat down tightly on
my head as I rode along the little saddle trail which paral-
lels the broad one on which the cattle were traveling. As
well as the trees would permit, I kept my eyes on the
steers and when I saw them dip down into a draw, I knew
it was time for me to make a quick sprint for the mouth of
Cottonwood Canyon. Right here the main trail for Tex
Canyon swerves abruptly to the right, crosses a creek, and
climbs a hill. 'All to once and nothing fust.' Just at this
point also there opens the mouth of a very tempting, wide
canyon. Again the allegory of the straight and narrow
path and the broad road that leads to destruction. Enter-
ing a trail that has been cut at that strategic spot, I got
around the cattle as fast as Eohippus could take me and
planted myself in the middle of the entrance to Cotton-
wood Canyon.

'Oh, it's you again, is it?' I saw that in the eyes of the
steers as they reluctantly abandoned their intention of
scampering into Cottonwood and turned into the Tex
trail instead. Again I fell into my place on the left flank,
disgusted with myself for having worried so much over what
had proved to be a simple performance. We were now
climbing a steep glade on what had once been a wagon
road. Everything was going well and I looked about for
our dogs, not having given them a thought since leaving
home. Robles and Foxy understand that they must follow
and never, never get in the way. If we have no cattle with
us, we let them hunt and ramble as they please. Scooter
and Negrito may learn their manners in time; now they
must be watched and called back to heel. I looked back
and found Robles and Foxy trotting behind me, models of

deportment. Their sons, oh, where were they? I did not dare call or whistle for fear of exciting the steers. When the young dogs returned, I intended to scold them for breaking the rules of the drive. We came to a place which was a trifle less brushy and I could see the leaders stepping out as though they were really going somewhere. As I looked, a rabbit streaked across the trail, almost under the leader's nose. After the rabbit, Scooter; then Negrito! 'Ki-yi! Ki-yi!' An instant later all were demoralized.

'Stay with the bunch, Jim!' yelled Charlie and dashed off to the right. I took to the left and each rode in a wide semicircle to surround the runaways. Up and down, into ravines and out again; on hillsides, treacherous with rolling rocks, we ran, until we had headed off the steers. Then we turned them back toward the big bunch of cattle that had seen neither rabbits nor dogs and were waiting peacefully while Jim rode around them, and talked to them in the reassuring tones that cattle understand. Each steer we met, we turned toward the herd, our horses in a lather from dodging and climbing. When we could find no more, Charlie gave the low whistle that started the drive anew. He took his old place on the right of the draw which we were ascending. Jim and I resumed our places. Soon we came to a place where the cattle were obliged to pass between two trees. I saw Charlie sitting on his horse in view of that spot, sawing the air with his arm. He was counting the steers to see if we had lost any during the recent fracas. When he started on again, he looked in my direction and, in response to a motion toward the steers, he sawed the air twice. That meant that we had lost two steers. Of course they were on our own range and would be found another day, but we wanted the satisfaction of arriving at the Spear E with our bunch intact.

Shortly after I had learned of the missing animals, we

heard a bawling back of us and a little to the left. I waved my hand in that direction and Charlie nodded his head, giving me permission to leave my place. There were now steep hills on both sides of the trail and we risked nothing by my temporary absence. As fast as I dared ride down the steep, rock-strewn trail, I went back until I was below the bawling cattle. Circling around, I came upon our two missing steers. They had enjoyed running away. Now the fun was over, for they were in a strange part of the range and alone, bawling in hope of an answer from other cattle. Willingly the truants ran for the herd when I started them in the right direction.

Two miles farther along, we reached the fence on the top of the ridge which marks the boundary between the Spear E range and our own. When the cattle were through the gate, we let them spread out as they chose in an open space, to rest a few minutes and catch their breath after a stiff climb. We dismounted and took off our saddles, brushed off the horses' backs and shook from the saddle blankets any sticks or leaves that had thrust themselves under the saddles as we raced through the brush. Every tree and bush was wet from the shower that had fallen during the night and we stamped our wet, half-frozen feet to warm them. We mounted again, strung the cattle out in a line and made good time down the trail. As we descended Tex Canyon, we came into open, rolling hills, where the wind had full sweep at us. It was about noon then. The sky had an added chill. I was not a bit sorry when Charlie turned to me and said, 'Jim and I can take the steers on from here. You had better start back.' With my dogs behind me, willingly I turned my face homeward.

At the mouth of Tex Canyon is the headquarters ranch-house of the Spear E Ranch, with corrals, watering-places, and pastures. Charlie and Jim arrived there to find the

house deserted, the men having temporarily moved their bachelor camp to another house on a distant part of the range. Charlie and Jim corralled the steers and watered them; then went into the house, which was unlocked, as is the custom of our country. They built a fire in the kitchen stove, put coffee on to boil, and unwrapped the lunches which I had given them to tie on their saddles, not knowing where they might be at dinner-time. Charlie seldom drinks coffee, but he was cold and he was going to drive the steers out on the open flats that we call the 'baldies.' When he was warm and fed, he rang me up on the telephone, knowing that I must have reached home, and told me that he was warm outside from the fire and all jazzed up inside from drinking coffee strong enough to float a horseshoe. The world looked much brighter to him now, in spite of the fact that the sky was all set and ready to drench them with rain, bury them with snow, or blow them clear off the map.

It was long after dark when I heard from him again. Afraid of being snowed in, Jim had left for his home by a shorter route through Bruner Canyon. Charlie had returned to the Spear E Ranch to spend the night. He told me that they had not gone more than a mile after lunch when there began a blinding snowstorm, accompanied by a howling north wind. Right then both the mountain-bred cattle and their mountain-bred owner wished they were off those 'baldies' and back in a deep canyon, among tall timber. In a storm, cattle are like the American buffalo — they turn their faces toward it. When the storm came on, the steers were headed south, toward Old Mexico. Before the men fairly realized what had happened, the cattle about-faced and headed northward, toward the mountains from which they had just come. There are not enough cowboys in the whole countryside to have kept the cattle pointed

southward in that storm. There was nothing to do but turn the steers loose, first bunching them with some native cattle which they had passed shortly before the storm hit them. Those cattle were also headed northward and Charlie had some trouble in overtaking and stopping them. He was riding Eagle, a willing horse, eager to give his best, but he is not used to prairie-dog holes and there were many old ones on those flats, covered with grass and hard to see; Charlie did not dare to let his horse travel at full speed. When the native cattle were finally stopped and the steers caught up, the two bunches were soon 'milling' together.

Before telephoning to me, Charlie had vainly hunted for an axe, then had taken a sledgehammer as a substitute with which to break up a good supply of wood. In the pantry were three Irish potatoes, some flour and baking powder. He could hold out until morning on that much chuck and then head for home.

'I'm all fixed,' he told me. 'An old Navajo blanket over a rocking-chair, a good fire and a lamp. I am going to rest my feet on the oven door and read a magazine that I found in the woodbox. Good-night!'

On winter mornings, after he has lighted a fire in the kitchen range, Charlie carries to the living-room his basket of finely split juniper kindling and slivers of pitch-pine. Kneeling on the hearth, he places his fuel with the skill learned at many a branding-fire and when the logs blaze gloriously, he shouts to me, 'Get up, lazy bones, and see what a beautiful fire I have built!'

There was no one to call me on the morning after the drive to the Spear E Ranch with the cattle, and the house was cold and cheerless when I finally got up and went into the kitchen to start a fire. I had hoped that the rising sun would shine on a dazzling, white landscape and that the

trees would be weighted down with snow. In our need of moisture, it was dispiriting to see the familiar, brown earth and a sky from which rain was half-heartedly drizzling. When the kitchen fire was burning well and the coffee percolator was saying, 'Clup! Clup!' I picked up my basket of kindling and went into the living-room. It was New Year's Eve. The little Christmas tree on the center of the mantel, sparkling with tinsel and bright ornaments, had gladdened us for a week past. On either side of the small tree were toy animals, tiny dolls, red candles. We would feel sorry when the time came to put them away for another year.

As well as I could, I built a fire on the hearth, 'a squaw fire,' Charlie would have called it, and when it was blazing finely, the long flames licking up the throat of the chimney, I returned to the kitchen to prepare my breakfast. I was buttering toast when I heard a roaring sound, unlike anything I had ever known before. It was not in the house, I thought. As I listened, there came to my nostrils a whiff of smoke. Dashing down my toast, I rushed to the living-room and was horrified to hear the roaring of a chimney ablaze, burning out. And not that sound alone terrified me. From the crevices between the sections of wallboard above the mantel, smoke poured into the room. Momentarily I expected the whole wall to burst into flames.

I ran to the mantel, grasped the small Christmas tree by its trunk, tore it away from its fastenings, and hurled it, ornaments tinkling, to the other end of the room. A poker, frantically wielded, splintered the wooden strips and I jerked away the sheets of wallboard that masked the chimney. Smoke puffed out at me from holes between the massive adobe bricks, and always the burning chimney roared, 'Haste! Haste!'

Leaving the house for a moment, I ran outside to look up

at the chimney from which flame shot straight into the sky. From many places on the outside of the wall, flame spurted from chinks from which the mud plaster had fallen. Near the house is a clump of young juniper trees and there I rushed to fetch the ladder that should be leaning against them. It was not there! How in the world was I to reach the most vulnerable spot where the wooden rafters touched the adobe chimney, and douse them with buckets of water? I must find out where that ladder was and I must get help from the neighbors. I rang the three short and one long telephone rings that would call Charlie if he had not already left the Spear E Ranch. He answered instantly.

'Where's the big ladder?' I shouted, without preamble.

'I don't know. Isn't it by the juniper trees at the side of the house? What's the matter?' he answered.

'The fireplace chimney is burning out and I think the house will go too!' I shrieked. 'I could throw water on the roof if I only had that ladder!'

'Oh! Oh!' he cried. 'I remember now. We left it down at Alfred's — a mile away! Get the neighbors! Get Winklers! Get anybody you can!'

I hung up, and while the chimney puffed smoke at me and roared unceasingly, I rang and rang that telephone, this call and that, trying to get someone to answer; all the while watching the wall for flames that I believed must surely spurt out from the smoke wreaths. No one answered my repeated rings until at last Charlie called me. Eleven miles away, unable to help and quite frantic, he shouted, 'Get the neighbors! Keep on trying!'

'Hang the neighbors!' yelled I. 'I am going to save what I can before the house goes. Don't call me again. I won't answer!' I slammed up the receiver and looked about me for the first armful of household goods and gods to be carried out.

Twice in my life I have seen all that I had go up in smoke and a bright moonlight on a barn roof, or steam rising from wet boards when the sun strikes them, will cause my heart to lose a beat. Always I have thought that I could not live through another fire and come out fully sane. Yet now I was coolly ignoring the roar of the chimney, turning my back to the smoke spurting from the wall, as I selected the best of our possessions and took them outside. There, too, I was balked, for the drizzle had become thicker and anything put on the ground would be ruined by water. I found out then that only little angers confuse the mind and flush the cheek. Rage is cold, is calm, a steadying force. Every circumstance had conspired to thwart me: Charlie's absence; the neighbors who didn't answer the telephone; the ladder that had been left a mile away from its proper place. Now the rain was trying to injure the few things I might otherwise save. Coolly and in an icy fury, I threw open the door of the adobe storeroom, which is detached from the house and has a cement roof. To that shelter went our clothing, our bits of silver, bedding, everything I could select of the best and most useful. The telephone rang and rang, running through the whole gamut of neighborhood signal bells. I would not answer it again. Time was too precious. It ceased to clamor presently and I knew that Charlie must have left the Spear E ranch-house to saddle up his horse and run for home. Well, I hoped he would still have a home!

After a while, did I imagine it, or was the roaring of the chimney a little less passionate? I ran outside and looked up. Flame still shot up into the sky, but surely it was now not so high by a foot. Between armfuls carried to the storeroom, I ran again and again to look at the chimney, cherishing my first hope that the house might not take fire. Down, down, sank the flames; lazier and lazier were the puffs of smoke between the adobe bricks. As I paused to

take the first long breath of the morning, a car drove up at
racing speed. Summoned on the telephone by Charlie's fran-
tic calls, the Meadows had arrived.

Smoke, dismantled walls, ravished shelves, greeted them;
a floor bestrewn with broken Christmas ornaments and
tracked with mud; beds from which mattresses and blankets
had been torn. Pridefully I surveyed the horrific mess. It
was our own dear home — and we had it still.

The shower that had interfered with my salvage opera-
tions blew away and the sun came out. I was sitting with
our neighbors in the dismantled room when we heard the
clatter of shod hoofs on the rocks and Charlie galloped to
the door and leaped from his lathered horse. Under his tan
a pallor and strain showed in every line of his face.

On reaching the divide between Tex Canyon and Rucker,
he had seen a wreath of mist hanging over the forest near
our house. It had marked the end of the storm, but he,
believing it to be the smoke of our burning house, had
come down from the ridge at a reckless, headlong pace, and
did not know until he reached the door that he still had a
home.

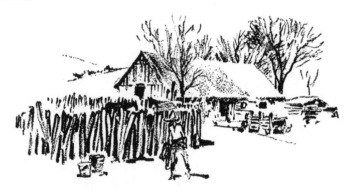

CHAPTER XXXV

TRIPS TO TOWN

'MARY, you're getting to be a regular old nester!'

We are having our semi-annual argument over a trip to town. Charlie wants me to go. I want to go — although I will not acknowledge it, or the real reason why I refuse to leave home.

'If you don't go somewhere pretty soon, you will forget how to talk to other women,' he continues. 'By and by, all you will be able to do is to "moo" when they speak to you!'

It is time to end the argument and I do so with the words that Eve first used; 'I haven't a thing to wear.'

Like Adam, he finds no reply other than a grunt of disgust and goes forth to earn his bread by the sweat of his brow.

Clothes really concern me but little; I have too many other things to think about. Kind friends and relatives, both east and west, consider wherewithal I shall be clothed much more than I do and from time to time send me garments by parcel post. When a blouse from the Atlantic looks well with a skirt from the Pacific, I know how the old woman felt when she was asked, on Thanksgiving Day, what she had for which to be grateful.

'I have two teeth, and thank God, they hit!' she replied.

On the glad occasions when our friends come out to the ranch to visit us, they wear their picnicking clothes. Seldom do we see clothes of ceremony. I diligently read the fashion notes and learn that sleeves are long; have crept up to the elbow; have vanished altogether. Yet somehow, by the time I have snatched an hour in which to remodel my own garments, sleeves have reappeared and bulge or flow

about the wrists. I am always one or two laps behind with hems that fluctuate between knee and ankle. Once I did manage to make over a dress and wear it to town before it became obsolete. It must have created a sensation there, audibly expressed by a good friend who is famous for her *faux pas*. She looked at me with amazement and said, 'What a difference clothes make!'

Sometime, when it rains and if it rains; if steers sell for a good price; if we do not have to use the money for five miles of fence or a new barn; I am going to buy a whole new outfit from head to toe, assemble an ensemble, and put it on. Then I shall not recognize myself in those fine feathers and shall anxiously say,

'If this be I, as I do think it be,
I've a little dog at home and he'll know me.'

Hats are sometimes found in the boxes which my friends send to me. I hold them up on my hand and twirl them on the tips of my fingers to admire them from all sides, knowing all too well that I shall never admire them upon my head. It is not that I am over-critical of headgear. I should be charmed to wear them — if only they would stretch themselves to fit this large head of mine. I used to say that my knot of hair caused all the grief. Now I am shorn of that and still hats perch like peanut shells above my short, gray locks. Once a hat came that I could actually wear. I put it on and proudly showed it to my husband.

'Now you will have no excuse for not going to town,' said he.

We were going down to see the Moores that afternoon for a brief outing and I decided to give my new hat a trial trip. Charlie went out to the garage to get the car and discovered that a tire was flat.

'Will you let the milk cows into the corral while I am

changing this blamed tire?' he requested, and I went over to do it. Among the cows was Mrs. Trouble and it was one of her off days. I wanted her to go one way and she was determined to go the other. Mindful of my best shoes, I did not want to pursue her through rocks and litter. She dodged me. With familiar gesture, I snatched off my hat and slammed her with it. Only when I heard my new straw adornment smack resoundingly upon her flank did I realize that it was not the old, gray felt of my daily wear. Oh, well! I did not want to go to town, anyway!

Even when we have help, it is rarely possible for us to leave the ranch together to be gone overnight. Too many things can happen, and do happen, to make us comfortable about turning our backs upon our responsibilities. So when I go off on a little trip to Douglas to be gone two or three days, I bake bread, cook a roast of beef and a pot of *frijoles*, in order that baching may not be too burdensome for Charlie during my absence. Then, fearsomely, I point the nose of my car down the canyon. I am not the usual sort of timid driver. I am not afraid of the rough road, of the river crossings, nor of the traffic; though of the latter I see little on my fifty-six-mile drive. Once I made the whole trip without meeting a car. What I do fear is the uncanny way in which our very ancient automobile knows when I am alone in it. Let Charlie be with me and the engine purrs, the lights glow, the tires stand up. Let me be alone and the spark plugs refuse to fire, bulbs burn out, and if there is one rusty nail on the Cochise County roads, my tires will pick it up. The day before I leave home on one of my rare peregrinations, Charlie devotes hours to greasing, oiling, and refurbishing our elderly vehicle. It has to serve; we have no money for a new one. On the morning of my departure, he takes me to the garage and points out all of his preparations.

'You have plenty of gas and oil, only you had better fill up again before you start for home,' he warns me. 'There is your spare, and under here — see this? — is the key to the spare. I hope you will not have to use it.' (So do I!) 'Here is the tire wrench. Here are pliers in this side pocket. The jack is under the back seat. Now. Go ahead, and I hope you have a good time and come home when you get good and ready.' We set no hard-and-fast date for my return and I am always back before he expects me.

Once I did get almost all the way to town without a hint of trouble. Then, on entering the outskirts of Pirtleville, ridges of dried mud bounced the car high in air. Immediately I heard a curious scraping sound from the rear. 'Something broke when I bounced!' was my fear; although the car was still traveling well, I stopped the car and got out to look at the back. Hanging from underneath the car, dragging on the ground, was a tire-chain. Wherever did that come from? I climbed in and lifted the cushion of the rear seat. Underneath, where there should have been a kit of tools, gaped a hole. I had jounced out the nails that held the bottom in place. Only the chain, caught on a nail, betrayed the loss of all my tools. Leaving the car, I walked back up the road, picking up a hammer here, a jack there, the other chain. When I could find no more, I threw them into the car and went on my way. 'Now why did that have to happen when I am alone?' I grumbled. 'This old car does things to me out of pure cussedness!'

On my last trip, six months ago, I had a very good time indeed. My friends gave me as many tastes of town pleasures as could be crowded into two days and I started for home at peace with the world, expecting to arrive well before dark. Through Pirtleville I cruised without picking up a nail. The dirt road was smoother than I had ever before seen it and I rolled along at the best speed of my car, thirty

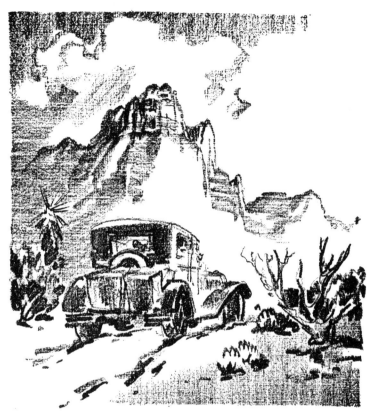

GOING TO TOWN

miles an hour. I passed the garage at McNeal without even looking that way. I needed no garages, thank you! I turned a corner, bumped over to the other side of the railroad track, and entered the rutted Mormon Highway. Few houses are along that road and presently I saw no dwellings except at a long distance. The car had maliciously bided its time.

'Whooosh!' went a tire.

No one was coming. No one was going, on that little-used road. I wasted no time in wistful waiting for a man to come along. I had an obsolete linen duster in the back of the car and I pulled it on over my town-going finery. I exchanged my shiny shoes for a scuffed pair which were in the side pocket for such an emergency. Then I found the key to the spare, jacked up a wheel, and pulled, puffed, and hammered until my tire was changed. Now I no longer had a spare. That was the cankering thought at the back of my mind as I went on again, heading ever toward the mountains, farther and farther from human habitations and the chance of meeting a car. After many miles, I topped a rise and there in the distance I saw the houses, barns, and water-towers of Frank Moore's ranch, three miles away as the crow flies, five by the winding road. There were friends; there was a telephone by which I could talk to my own home! My spirits soared and I began to sing. Emboldened by the privacy of thousands of acres, inhabited only by un-critical cows, I exerted the full capacity of my lungs.

'Kathleen mavourneen! the gray dawn is breaking...'

'Bing!' The steering-wheel was all but torn from my grasp and I stopped the car in the mesquite bushes. 'A blowout! And no spare tire!'

I was in for it now. I had to take the casing off the rim of the one that had been punctured earlier, patch the tube, stick it back on the rim; then pump it up and get it on the

wheel. I could still see the big buildings of the Moores' Ranch. Alas! They could not see me, a little black speck among the mesquite bushes. It was a hot day, far too hot to wear a linen duster over my dress all the time that strenuous job would take me. I peeled off my dress and hung it on the fender where I could grab it quickly in the happy event of an arrival. Then I set to work. I extracted the punctured tube finally. Next I found the patch, the glue to stick it on with — but there was no clamp to hold it tightly while the glue was hardening. I pasted the patch on the hole, then laid the tube on the running-board and stood on the patch — a highly exasperated, impatient clamp I was, too. I was putting the tube in the casing, meanwhile thinking of all those toilsome strokes which I must make with the pump, when I heard a welcome sound. I jumped for my dress and slid it over my head.

Hooray! It was Mr. Moore, also coming home from town. How quickly tires go together for a man. On his shiny car was that boon of boons, a tire-pump attached to the engine. My troubles were over. But I haven't forgotten them. I want no more troubles like them.

'Haven't you made up your mind to go to town yet?' insists Charlie.

'No,' I still reply. 'I told you, I haven't a thing to wear.'

CHAPTER XXXVI

VALLEY CATTLE

ALTHOUGH we greatly dislike the idea, we shall have to sell the big young Galloway cows that form part of our herd. They are black; and black cattle are out of style in these parts. Cattlemen hereabouts are all raising Herefords; all cows must wear red, with white trimmings, otherwise the captious buyers will not accept their calves. From experience we know the cost in time and pains of breeding up a depleted herd. Nevertheless, we shall have to sell the black mother cows and raise red ones to replace them.

This big Rucker Basin was divided into two ranches when we came here to Old Camp Rucker and we had not been here many months before we decided that, if we were to have a real ranch which we could fence and control as we pleased, we would have to buy out the man who owned the other place. He wanted to sell it, for he did not like the situation any more than we did, but he thought that we should be willing to pay more for it than the place was worth, therefore put a price upon it that was away beyond what we, or anyone else, would pay. Surprised because we did not jump at it, he offered his ranch to others, lowering the price each time that he did so. When it reached the sum which we were willing to pay, we bought it through a third person, for fear the price would soar if we were known to be the purchasers.

Our former neighbor did not want to sell his cattle. Instead, he gathered them and drove them to another ranch some distance away. That was a source of satisfaction to us because we wanted to improve the quality of our herd and had some very good cattle to begin with. When our ranch and

grazing privileges extended over the entire Rucker Basin we needed more cattle to replace those our former neighbor had driven away. Raising cows from little calves and waiting for them to have calves of their own is a slow process. We wanted to buy some good, grown cattle. That was easy to say and hard to do. Cattlemen were prosperous at that time. The seasons had been good, prices likewise, and no one wanted to part with good young mother cows. We did find one small bunch of cattle which were for sale and bought them. They were raised in these mountains, so there was no difficulty in locating them on our range. Then someone told Charlie of another small bunch of cattle down in Sulphur Spring Valley and he went down there to see them. He was not enthused. Still, he needed cows if he was to have enough calves the following spring, and these were cows — of a sort. He bought them and drove home. The next day with another man to help him, he went back to the valley on horseback and on the evening of the third day of absence, he drove those cattle into our home corral.

I went over to see them. I knew very little about a cow, but I could not think of a word that was complimentary to say about those animals and looked at them in silence.

'The old woman who sold them cried when we drove them away,' volunteered Charlie.

'Then I think I had better cry now that you have driven them here,' I replied.

'I know that they are not much to look at,' admitted Charlie. 'As sorry a bunch of cows as I ever saw. But we must have more cattle and can't get any good ones. When these cows have each given us one or two calves, we'll sell them and be rid of them.'

The next day the new cattle were driven out on to the range and were left on the best feed we had on the whole ranch. There was the river running through the middle of

the grazing we had allotted to them. A block of salt was left near the trail, where they could not help finding it. All the comforts of home — but it was not home. Those cows were not in their first flush of youth, to put it mildly. They had been used to eating grass and weeds which grew on ground as level as a floor. When they were thirsty, they had been accustomed to the warm, muddy water of a dirt tank into which they could walk and stir up the mud. When they were tired or wanted to chew their cud, they had found shelter from the sun in a clump of mesquites. Now everything was new to them. Strange forage must be searched out in strange places. They did not know that the leaves of trees and bushes were good to eat; to thrust noses into icy river-water was not tempting to them. They tried to get back into the valley, hanging around the gates, from which we repeatedly drove them back to the mountains. Up on the hillsides was an abundance of grass and browse, but they showed about as much desire to scramble up and down our mountain trails as one could expect from an eighty-year-old woman who had spent her entire life on a prairie. No one had told them that mountain air is bracing, and with each breath they drew, their backbones took on an added slump and their horn-weighted heads sank lower and lower.

Long before we had to feed any of our own cattle, we were obliged to bring these cows in and feed them; otherwise they would have starved in the midst of plenty and the calves, for whose sake we had bought the cows, would never have been born. Each day as he poured cottonseed cake into the troughs and forked our precious hay into the manger for them, Charlie would say, 'Never buy old valley-raised cows and try to locate them in the mountains. That has taught us a lesson.'

One of the most exasperating of these wretched beasts was a cow we called Old Flaca — *flaca* meaning thin, in

Spanish. No amount of feed added a pound to that animal. All day long she munched, munched. She was the first cow at the feeding-trough in the morning, the last to leave the hay-manger at night. Yet Flaca she was and Flaca she remained.

At night we left the gate of the feeding-corral open so that the cattle could go down into the water-lot to drink from the pool, into which spring water flowed, and sleep under the trees. One morning we went out to feed the cattle and found that Old Flaca had not come up with the rest of them.

'Perhaps she has had her calf,' suggested Charlie, hopefully.

Down into the water-lot we went and by the pool we found her. Stumbling over a rock as she went to drink, she had fallen at some time during the night and lay sprawled there, supine, her nose so near the water that she had missed drowning only by a few inches. I took her by the head, Charlie grasped her by the tail; together we heaved with all our might. Flaca gave us neither aid nor encouragement. When we were exhausted and let go, she flopped back in a heap. Charlie is resourceful. 'I'll have her out of there,' he declared. He got the truck and rumbled off to the wood-camp and came back with two husky, Mexican wood-choppers. Hauling and tugging, the three men got Old Flaca up on the bank to where the truck could be backed up to her. Stout planks were inclined from the ground to the rear of the truck; a pulley was made fast inside, then was hooked to ropes around that cow. Inch by inch, like men raising a heavy mainsail, they hauled on the pulley and inch by inch Old Flaca came up the boards and landed in the truck. The men did not sing as they hauled. Perhaps there is no chanty adapted to the cow business.

Arrived at the barn, the truck was backed to the door

and Flaca was shoved down the plank-slide and into the stable. Overhead are great beams and around one a log-chain was swung to hold the pulley. Then the pulley was hooked to a harness of broad webbing around that cow. Again the men hauled on the rope and Flaca was brought to her feet. During all of this she had not once tried to help herself. She merely chewed her cud and let others worry. Her belated breakfast was set before her and she ate with her customary good appetite. It now developed that one of her front feet had become cramped as she lay by the pool and it would not straighten out. Undaunted, Charlie took one of his own old shoes, cut off the sole and laced the upper part around her ankle.

And there she swung for days, and ate, and drank the water we fetched to her. Each night when we let her down on the ground, she would not even pull her feet under her as proper cows do when they are lying down. We had to double up her legs and shove them under her. Then we dragged up a bale of hay and put it behind her back so that she could not fall over on her side during the night. She occupied more time than it would take to care for fifty better cows.

Then came the glad morning when we went over to the barn and found that she had managed to do one single, solitary thing unaided. In the night she had given birth to a heifer calf. It was not destined to win any prizes at that, but it was alive and husky and a calf of any kind was welcome. Another surprise was the fact that Flaca had milk for it. We pulled her to her feet with better grace then. Perhaps she would help herself now, give her time.

When the calf was a few days old we had to go off on an all-day ride to a distant part of the range. Flaca was left swinging in her harness, suspended from the beam as usual. As usual, she was eating hay. When we came home and un-

saddled, we went in to see her and there she hung still —
with what a difference! Somehow, twisting herself in her
harness, she had managed to slip it out of place. Head down,
hind legs in air, she hung: dead as dead could be.

Charlie jerked the pulley and let her down in a mournful
heap. Then he picked up in his arms her bawling, hungry
calf, saying, as he started to the door: 'I am going to raise
this calf in these mountains. I am going to give her Wilhel-
mina for a foster mother. Then we'll settle that argument
once and for all: which is stronger, heredity or environ-
ment?'

Now among these valley cows was one bright and shining
light. She was not much to look at, but 'pretty is as pretty
does.' She was brownish in color, with white feet mottled
with brown. Across her white face were dark, irregular
patches. Her horns were set at a rakish angle. Finding that
she fought the other valley cows and that they were too
spineless to defend themselves, we tipped her horns and
that did not add to her appearance. We wanted a name for
that homely cow and I called her Gertrude, simply because
we happened not to know anyone by that name. The old
woman who sold the cattle to Charlie had told him that
Gertrude was a good milk cow and we found that she lived
up to her reputation. Somewhere in her very mixed an-
cestry there must have been a strain of Jersey blood. It did
not show in her appearance, but it did show in the rich
cream. The calf that she gave us that first spring had a
curious brown bar across his white nose. We named him for
it, Zanzibar.

Zanzibar was about a month old when the summer thun-
der-storms began and lightning flickered over the peaks.
One afternoon when the storm center seemed to be right
overhead, I begged Charlie not to go out riding again as he
had intended doing.

'All right,' he agreed. 'I hear Gertrude bawling at the gate. I'll let her in and milk her.'

He took the milk bucket and went off toward the barn. Presently I heard a terrific clap of thunder, so close that I knew the bolt must have struck something very near-by. Frightened for Charlie, I ran out of the house and toward the barn. Before I had covered half the distance, I met him coming along the path, milk bucket in hand, a queer, dazed look on his face. 'Thunderstruck' describes it exactly.

'I've been struck by lightning, Mary!' he said. Still moving like a sleep-walker, he came into the house, sat down and unlaced his shoes. 'It came out at the soles of my feet.'

We looked at the bare soles, but they bore no mark. Gradually he recovered from the shock and regained his normal spirits and when the storm had passed over we went back to the corral. In the trunk of the big cottonwood tree beneath which he had been milking Gertrude was a deep furrow where the lightning had struck and plowed downward through the thick bark. To the tree was stapled the heavy wire which held the corral posts in place. The lightning had followed that wire, saving Charlie, who received only a small part of the bolt.

'Something like a heavy stone seemed to fall into the milk bucket,' he told me. 'I cannot have imagined it, for the milk splashed out on the ground. Gertrude must have thought that I struck her, for she turned to look at me reproachfully — and her eyes were green.'

Showers had brought up weeds in the river bottom and the next morning we turned Gertrude out to graze there as usual, keeping her calf in a little pasture near the house so the cow would not fail to come home every night. As a rule she was in at least an hour before dark, mooing at the gate. That night she did not come, and Zanzibar bawled unceas-

ingly, 'Umm-baw! Umm-baw-ah-ah!' In the morning he
was still bawling and we rode out to look for that cow. Up
and down in the river bottom we searched where we had
often seen her grazing. Her calf was young and her big bag
of milk would soon be a source of discomfort to her. When
she failed to come in the second night, we knew that some-
thing must have happened to her.

'Poor old Gertrude!' mourned Charlie. 'I wonder if a
wolf has killed her, or if the lightning that she escaped once
has struck her this time?'

'Umm-baw-ah-ah!' wailed Zanzibar. We had to induce
one of the other cows to divide her milk and give half to her
own calf and half to him. He sucked her greedily, then
turned from his foster mother and lifted up his voice again
in an inconsolable 'Umm-baw-ah-ah!'

I wailed too. 'Poor old Gertrude!' No Gertrude meant
no milk, no cream, no butter. 'The only decent cow in that
whole valley outfit — and she has to go and get herself
struck by lightning!'

Four days passed by and I was working in my vegetable
garden when I heard by the gate a curious sound. It was the
faint ghost of a 'moo.' I went to see what it was and there,
a pale ghost of a cow, wabbly and weak, was poor old Ger-
trude. Pounds she had lost in four days; her hair was matted
and smeared with earth and leaves, showing that she had
lain in the mud. Staggering, she came in when I opened the
gate and again she breathed that ghostly 'Moo!'

Faint as it was, her calf heard it and came at a gallop.

'Umm-baw-ah-ah!' yelled Zanzibar.

CHAPTER XXXVII

THE BULL FIGHT

WE HAVE gathered up our bulls this dry year, have brought them in from the range and are feeding them for a short time. Some cattlemen believe it is a good idea, others do not. However, we shall try it this time. The bulls, all polled Herefords, have been bought at different times and from different herds. Some are old and will be sold this year. Others are young and newly come. Although they are as nearly alike in appearance as it has been possible to select them, in order to give uniformity to our herd, slight differences can be noted and, as these have enabled us to distinguish certain animals, we have given them names. When we came here, there were three bulls, the inseparables, Tom, Dick, and Harry, since sold. There was Benjamin who disappeared; not even his bones were found. Daniel was struck by lightning. We still have the Biblical trio, Abraham, Isaac, and Jacob. There are Mr. Shakespeare's boys also, Romeo, Cæsar, and Othello, who is darker in color than the rest, and many others.

There is one among the bulls who went unnamed for a long time. He is an aristocrat in bovine circles, carrying himself as though he were aware that his grandfather cost a thousand dollars. Charlie and Mr. Ray, a short, massively built man, had been working in the corral all one afternoon, branding. The cattle had grown tired of it, as tired as were the men, and some of the cows were angry — 'snuffy,' we say. As many of the cows as possible were therefore turned into another corral where they could wait peacefully for their freedom at the end of the day's work. Among those that still remained where the men were roping, tying,

and branding, was this bull of high degree. Our bulls are well accustomed to having men near them and no one gave this one a thought. The last calf to be branded that afternoon was a big one that had been hiding somewhere in the mountains during the previous branding-time. He was suspicious and irritated. He watched the branding of the smaller calves, heard the swish of the rope, saw them fall, and smelled the acrid smoke that rose from their singed hair. 'None of that for me!' he snuffed.

The horses were now taken to the stable and the men planned to handle this large calf on foot, working in a small corral which had a big, snubbing-post in the center. The best way to down this big calf was for one of the men to rope him by the head, then take a turn, a 'dally,' around the big post. The other man would then rope the calf by both hind legs, stretch him out, and he could easily be thrown.

Mr. Ray made a loop and threw it over the calf's head and was just going to make a turn of the rope around the post, when Charlie yelled, 'Look out for the bull!'

There was the forgotten bull, coming for Mr. Ray on the run, head down. The post was right at hand and the man jumped behind it. 'Bang!' went the bull's head against the post. He backed off and glared around to see who else he could take after and spied Charlie. There was no time to run for a gate and the corral posts offered no foothold. Charlie leaped behind Mr. Ray and grasped the man's thick waist with both hands. Mr. Ray clung to the post and again they maneuvered so that the bull's head collided with it instead of with them. Most animals would have given up after two such head-on collisions with solid wood. This bull had been slow to anger and he was not to be cooled off quickly. Time after time he attacked the men from a new angle. Each time they capered about that post,

two deep, Charlie's long legs extended to make the outside circle. Between onslaughts, the bull retired to shake his head, snort, paw the ground; then he tried it again.

Safe, on the other side of a heavy lumber gate, I was enjoying it hilariously. Something finally distracted the bull's attention momentarily and Charlie took the chance of running for the gate. The bull saw and pursued him, an instant too late. Charlie was up and over, out of reach. The bull wheeled about to look for his other enemy. Mr. Ray had reached the gate at the opposite end of the corral, had opened it and sped through. The show was over.

'Charlie!' I called out, 'I have found a name for that bull. We'll call him Oscar, because he is so "Wilde."'

Busy about my household tasks, yesterday morning, an uproar startled me.

'A-rruu-ah-rouu-ah-ruu-ruu! A-row-a-row!'

A row, indeed! I dropped the dustpan and broom in the middle of the floor; the screen door banged behind me, and I sprinted toward that bellowing. No time for out-of-the-way gates; to lie down and roll under fences was quicker. Across a wash, ducking under low limbs, I raced toward the pasture. It would be terrible if it should all be over before I got there! I was on my way to a bull-fight. A real bull-fight, between the bulls themselves. For prize, the supremacy of the herd. Breathless, disheveled, I reached my ringside seat, a fallen log, and leaned back against the tree that should be my protection if the battle raged too near. The arena was the parade ground of Old Fort Rucker. The ring, a living one, of bulls, all moving in a circle around and around the two combatants, watching their every move, bellowing continuously. In the center, heads down, forehead pressed to forehead, legs spread and braced, were the two oldest, heaviest bulls in Rucker Basin. I knew beforehand which ones they would be, Joseph and Red Boy. For

a week past they had challenged each other, working up their courage for the battle that was to make one of them the king of the herd.

'Ah-uuee! Ah-uuee!' That had been Red Boy's defiant note.

Joseph, coming from the pasture each day to be fed, head down, body swaying insolently, rumbled, 'I'm-a-bad-old-bulllll! I'm-a-bad-old-bulllll!'

Now the proving time had come, and the lesser bulls, having foreseen that a fight was inevitable, watched the outcome with the keenest excitement.

There were no horns; there would be no gore, except for the ensanguined foreheads from which hair and skin were torn by the force of the impact with which they came together after an instant's withdrawal. In height, weight, and courage the two were equal. The ground was torn beneath them as their hoofs dug into the sod for firmer footing. At last Joseph found the advantage both had been seeking. He thrust his massive head between Red Boy's front legs, lifted with all the power of his tremendous shoulders, and toppled him to the ground. A fall ends the battle by bull-fighting code. Red Boy, again on his feet, rushed blindly away and was lost to sight among the trees.

I rose from my seat — then sank back on my log to look with amazement at the scene. The ring of bulls had broken up into pairs, and where a single combat had raged, there were now a dozen under way. Incredibly well matched they were; each pair of antagonists seemingly had chosen one another as equals in weight and skill. And they were 'Irish bulls' — fighting the preliminaries after the main bout!

Later in the day we made a leisurely ride through the river bottom, a mile above and a mile below our home ranch, looking for thin cows that might need to be brought

home and fed. The thinner cows are, the less they feel able to travel far from water in search of feed. For that reason, weak cattle hang about the river or near the springs, where the grass has long since been grazed off. We found none that were thin enough to worry us and were returning home to do the evening chores, when we found a dead cow, lying close by the trail which follows the fence of the home pasture. We recognized the cow instantly because of her peculiarly shaped horns from which she took her name, Crumpy. She had not been dead more than a day, and we felt sure that poverty had not been the cause of her death for we had seen her quite recently and she was then in good shape and was about to have a calf. We could tell that her calf had been born; all around her were scores of tiny hoofprints, made by a very young calf. Her baby must have been hanging about the dead mother, lonely and hungry. The brush is thick where we found the cow, so we dismounted, left our horses and circled about on foot, thinking that the baby calf might be curled up in sleep near-by. When the sun dropped behind the mountains, we still had not found the calf. There was a possibility that it had followed some range cows and would return with them when they came back for water. There was nothing to do but come back early the next morning and hunt again.

We mounted our horses and rode to the near-by gate to the home pasture where the bulls were having their prolonged stag party. Each afternoon we drive them to the round corral where they eat, drink, and are merry. When the bulls saw us coming, they knew perfectly well that we had come to fetch them. Some started for the corral without waiting for us to ride up to them; others watched us approach, then lowered their heads, switched their tails, and frisked off with elephantine playfulness. We counted them; one was missing, Red Boy. Searching

among the trees, we found him lying down near the water; still feeling his defeat in the morning's battle, he was unwilling to rejoin the other bulls. He did not take the trouble to get up when he saw us and, when we rode up beside him, we found that his great bulk hid a small companion. By his side, snuggled up to his shaggy hide for warmth's sake, lay a baby calf. Her nose was caked and dry, showing that she had not sucked recently. Crumpy's calf, beyond a doubt, had crept through the fence in search of bovine companionship.

Red Boy rose majestically and ambled off toward the corral. Little Crumpy toddled after him. 'It is a wise child that knows its own father.'

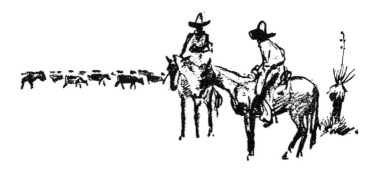

CHAPTER XXXVIII

DROUGHT

DROUGHT! Throughout last summer the thought of it haunted us when the dry west wind ruled the sky and half-hearted showers feebly pattered on the roof. When the fall rains disappointed us, we whispered the word with a dread that dominated our thoughts more and more as the winter months passed by in succession, bringing with them only little flurries of snow. Now we speak the word aloud — and we speak of little else. The terrors of drought, its stark realities, and its labors overwhelm our little corner of the world.

Long ago our cattle consumed the scant growth of grass which last summer's slight rainfall provided, and they entered the winter in a condition far short of that which they show after a summer of lush and abundant feed. Down in the valleys and on the foothills, where there is little shelter from cold winds, the cattle are thinner than our own. Our cattle find warmth and shelter in the canyons and all winter there has been browse on the mountain-sides. Now spring has come, dry, hot, totally lacking in the verdure and new life that we associate with that season of tender bud and sprouting weed. Dry and brown, the leaves of the live-oak trees and low-growing shrubs still cling to the parent stem; for no sap flows and no bud swells to push the old leaf from its twig. Sun-baked leaves of former years are heaped on the floor of the forest; a gust of hot wind sets them whirling through dust-laden air. They blow about my door-yard and swirl in through an open door. Dry leaves cling to the wood that I fetch in for the kitchen fire; the dogs lie down on a bed of leaves

and come inside to shake them on my floor. Yet the leaf that flutters down into the pan of milk that I am carrying to the storeroom is showing a wind-blown vagrancy that is natural, while the brown, shriveled wraiths of foliage that still cling to the trees are hideous, grotesque.

Fearing a dry spring, we weaned our calves somewhat earlier than usual, for the cows were in none too good condition and the sooner they were rid of their big calves the better for themselves and for the calves that were to be born. The yearling steers were taken over to the Spear E Ranch where the big steers were already on pasture and our one piece of good fortune this year is that the steers have all been sold recently. On our range now are the mother cows, most of which have already had a calf this spring or will soon have one; the bulls and the young heifers.

Before the newborn calves began to arrive in any numbers, we were riding and watching our cows in order to bring in to the home pasture and corral any that needed to be fed. To postpone feeding them in the early part of the season and allow the cows to become thin and weak was a course that had proved its folly in former years. The cows suffered, their calves were stunted, and we had to feed them longer and more lavishly than if we had begun sooner. Each year we feed some of our cattle in the spring; old cows; heifers with their first calves. This year as usual, one or two at a time, we brought in cows to be fed on cottonseed cake and hay from the small stack that had been left to us by the measuring worms. After a while we realized that for every cow that we had brought in because she needed to be fed, there were three others on the range that needed it just as much. The young heifers, the bulls, and the cows that are not going to have calves this spring must rustle for themselves. If we are to save our mother cows and baby calves, we must feed them all.

As soon as we began bringing in cows and calves, we had to have a man to help us and Charlie drove down to Sulphur Spring Valley to see if he could get José Nuñez. José is a gay bachelor in his thirties, spare, wiry, with strongly Mongolian features; as neat, pernickety, and fussy-particular as the dourest spinster. Although he is very fond of dancing and of spending his time and money upon the *señoritas*, I believe that he has never married because he fears that no woman will cook and clean house as well as he can do it for himself. When I once asked him why he did not marry, he laughed and said, 'What have I got against the poor girls that I should marry one and starve her to death?'

José always comes here for a while quite willingly, knowing that there is no chance to spend money and he can save up for a grand good time on his return to El Frida. This spring he came with real pleasure. Charlie told him that his job would be the feeding of cattle and there is nothing else that he likes to do half so well. There is no need to wonder if a cow, calf, dog, or horse is getting enough to eat if José is around. On the contrary, we have to watch him to see that he does not break us by feeding them twice as much as they need.

With José Nuñez wielding the pitchfork night and morning, our small haystack dwindled alarmingly. What in the world could we feed the cattle upon when it was exhausted? All over our part of the country, men were meeting the same problem. Those who had soapweed on their ranges were burning the old leaves from its treelike stalk, putting it through a chopper and feeding it to their cattle. Others, fortunate in having plenty of old galleta grass, turned their cattle out to eat that coarse, unpalatable feed, supplementing it with protein in the form of cottonseed cake. We have neither soapweed nor old grass. Hay costs nearly

thirty dollars a ton in Douglas and must be hauled fifty-six miles on a truck that holds only a ton of baled hay. To that cost would be added the day of Charlie's time which is so much needed on the ranch. After much consideration, Charlie decided to hire more men and have them cut the large heads of the mescal plant which grows abundantly on the steep hillsides; chop up the tender, white heads into small pieces; mix them with cottonseed cake and feed them to the cows.

From the wood-camp at Turkey Creek, we drafted the fat and chuckle-headed Lorenzo and his shrewish wife, Barbarita. Cutting the mescal is an axeman's job. A long crowbar is thrust under the pineapple-shaped head to topple it over; then the long, saw-edged, thorn-tipped leaves must be chopped away. Lorenzo brought with him two younger men, Pancho and Manuel, who were to chop mescal with him and load the heads on the burros, by which they were to be packed down from the steep hills where they grew to the nearest place to which a truck could be driven.

Our burros are not pleased at all to find that they have a steady job. We have three of them, the mouse-colored Madroña, Chicha, and the black one, Dinky. We use them when we take the fifty-pound blocks of salt to the salting places which are miles from the nearest road. They carry posts and wire for fence-building, cement and tools for work on watering-places. They are accustomed to being packed only a few days out of each year; the rest of the time they roam the range at liberty. Chicha is the mother of Dinky and she has a new child this year, a very spritely little *burrita*, named Miss Oreja De Bray. She comes when I call her by it, 'Oreja! O-ray'ha!' She does not dream that her pretty Spanish name is merely 'Ear' in English.

As the three heavily laden burros mince sedately along, followed by the capering Miss De Bray, who is too young and flighty to work, they are haughtily regarded by Mr. Hampe's pet burros, Mazie and Susie, who feel themselves superior because they have never done a day's work in all their lives. Mazie is known to be nineteen years old and her mother's exact age is lost in the mists of antiquity. They have nothing whatever to do with the burden-bearers and have not even been in their vicinity until now, when they find that we feed Madroña, Chicha, and Dinky at the end of their day's toil. Since learning that, Mazie and Susie come to the gate every afternoon and set up such an infernal clamor with their braying that we let them in and feed them as the price of peace. They still choose to eat at the opposite end of the trough from the working burros.

In the beginning, we had the mescal heads chopped up by hand, but that took up too much of José's time. Charlie then bought a mechanical ensilage chopper, which is driven by means of a wide belt of webbing attached to the engine of the wood-saw. An ear-splitting noise from engine and chopper combines with bawling of cattle and braying of burros to destroy our woodland peace.

For ourselves we take little heed of the morrow, of what we shall eat and what we shall drink. Feed and water for our cattle are our constant preoccupations. Charlie expressed our attitude recently when he returned from a morning spent in cleaning up watering-places and looking over our barren range. Mr. Hampe was visiting us and brought in to show us a beautiful spray of purple heather, picked on the hills near Hanover by his sister who lives in Germany. She had tied it daintily with a matching purple satin ribbon and it lay in Mr. Hampe's hand on a background of white tissue paper.

'That's beautiful!' exclaimed Charlie. 'Will cows eat it?'

CHAPTER XXXIX

FEEDING CATTLE

FEEDING cattle involves a great deal of hard work and expense, to both of which we are resigned. What money we have is the product of our cows and we should not begrudge them some of it to keep them alive. Our problem of what to feed them was apparently solved by the use of mescal, supplemented by cottonseed cake. Our Mexican workers know their jobs and go about them with a will. It seems to be only a case of working hard and waiting for rain. So far we have had nothing to remind us of rain save our own great need of it. The sky is clear; the wind blows from every direction except the southerly one from which we may look for moisture. As yet that does not worry us. The normal rainy season is not due for six weeks and we refuse to borrow trouble while we have so much on hand.

After we had been feeding mescal for a week, we noticed that some of the smaller calves were moping along after their mothers when the cattle were brought in to be fed. On closer inspection, we noted that the eyes of the calves were sunken and sick-looking.

'What can be the matter with those calves?' asked Charlie, puzzled and worried.

The calves were not being fed and were depending altogether upon their mothers' milk. The following day there were more moping, sick-looking calves, and those that had been sick on the first day were now wabbly and weak. We had been accustomed to feeding cottonseed cake for years, so could not blame that for the condition of the calves. It must be that the mescal was having a

bad effect upon the milk, for the mother cows themselves
looked perfectly well and ate with gusto.

Telling José to feed the cows from our remaining hay,
of which there was only enough for a few days, Charlie
went to town in the morning for a load of grain. That gave
him a chance to consult with other cattlemen whom he
found in Douglas on similar errands. By good fortune,
Jim Hunsaker was in town from his ranch in Leslie Canyon,
and he at once told Charlie what was the matter with our
calves.

'You'll have to cook your mescal, Charlie,' he advised.
'Roast it in a pit, then grind it up and feed it to your
cows. If you will do that, it won't make your calves sick.'

Charlie came home much happier than when he went
away. He had been afraid that he would have to find a
substitute for the mescal and he was so glad that he need
not do so that he did not mind the extra work we were now
obliged to undertake.

'We'll need another man,' he told me. 'José, Lorenzo,
and the two boys are working every moment now and the
roasting of the mescal will take a man's entire time.'

Shortly after breakfast the following morning, I heard
a car chug-chugging up the hill and finding the going heavy.
The laboring motor sounded like sheets of corrugated iron
blowing from a barn roof. Nevertheless, it had completed
the ascent by the time I reached the gate and out of the
rusty, rickety, rambling wreck of a *cucuracha*, stepped
Teofilo Romero.

'*Buenos dias, Señora!*' he cried as I approached. 'May
I have your permission to leave this fine automobile some-
where under the trees so that the sun will not spoil the
paint?'

'Certainly, Teofilo,' I replied.

'If you wish to take a ride, you may borrow it,' he con-

tinued. 'It is a wonderful car. It flies along like a bird. It will climb a tree if you wish.'

'It will sing, also,' I contributed. 'I heard its voice as it came up the hill.'

Teofilo parked his bird behind a clump of young juniper trees where it was well out of sight; then came over to my kitchen for a cup of coffee.

'My car is an owl and remains hidden in the trees all day,' he explained. 'That is because this year I have not been able to buy it a license, so it flies only at night.'

While eating his breakfast, Teofilo told me that he was on his way to a ranch over in the San Simon Valley where there was an old car which would not go at all. From it he thought he could get some parts to use for repairs on his own machine, which was of the same ancient model. Being somewhat in a hurry, he was going to make the trip from here on foot. At that moment Charlie came into the kitchen.

'You're just the Indian I wanted to see,' he said to Teofilo. 'I want you to stay here and roast mescal heads for me in a pit, so I can feed them to my cattle. Will you do it?'

'I would much rather cook them and make them into mescal to drink,' replied Teofilo, 'but if you wish, I will roast them for your cattle to eat.'

As there was a supply of mescal heads already cut, Manuel and Pancho helped Teofilo dig a great pit. It was nine feet deep and five feet in diameter, dug in hard and gravelly ground, under a pitiless sun which blazed down to heat it like an oven.

'This pit is hot enough to cook mescal without a fire,' asserted Teofilo, as he crawled out, wringing wet, to cool off and roll a cigarette.

Charlie and Lorenzo loaded the truck with cord after

cord of well-seasoned oak wood and piled it near the pit. Two days later the digging was completed and Teofilo prepared to build a fire in the pit. On the ground in the center of the pit, he cunningly arranged a crisscrossed mound of powder-dry, finely split, juniper kindling. There must be no doubt of its igniting when the whole edifice had been laboriously erected. Four-foot lengths of cord-wood were handed down to Teofilo by a man who remained on the surface of the ground. In the form of a hollow square, in the middle of which was the mound of kindling, Teofilo built up the pile of wood, log-cabin-wise, gradually placing the sticks crisscross and nearer the center, always leaving a hole through which the kindling might be reached. When a cord and a half of wood had been thus disposed, large rocks were handed to Teofilo and these he fitted like a pavement over the wood, several layers deep, until only the hole in the center remained uncovered. A long sliver of pitch-pine, fat with resin, was set ablaze and dropped through the central hole to the dry juniper kindling below. Rocks were quickly massed upon the hole and up came Teofilo from the pit, to dash the beads of sweat from his face and bare his chest to the hot wind.

Through small crevices between the rocks, white smoke arose as the kindling caught fire and ignited the dry oak. By the edge of the pit, half-blinded by smoke, Teofilo stood with a long piece of pipe in his hand. When a tongue of flame gleamed redly amid the white smoke, he prodded with his iron pole until the rocks closed up the orifice through which the flame had escaped. As the wood was gradually made into live coals beneath the rocks, the prodding of the pole kept the banked fires level. The rocks which smothered the flames, weighted the burning wood until it gradually crumpled into the bottom of the pit, a mass of red-hot coals. The time had at last arrived when smoke no longer

curled among the rocks and only an intense, quivering heat rose from the charred wood below.

Hurriedly, mescal heads were thrown into the pit; it took two hundred of them to fill the hole and round its contents into a cone-shaped peak that extended two feet above the surface of the ground. Over this were arched old pieces of corrugated iron; masses of coarse, green bear-grass were piled on the iron and earth was shoveled over all. Thus the heat was penned in to do its work with the mescal. Twenty-four hours elapsed before the pit was reopened.

When the earth, bear-grass, and iron were all removed, there lay the mescal heads, brown, steaming, tender. After they had cooled off a little, they were carried to the barn to be chopped, mixed with cake, and fed to the cattle. The cows seemed to like the cooked food as well as the raw and after a few days the calves grew brisk and frisky. Charlie soon ran out of cottonseed cake again and went in to town for more. There was none to be had. All through the Southwest, men were feeding cattle, and the supply had been exhausted. At sixty dollars a ton, Charlie was obliged to buy a substitute for the cake and he continued to buy it, although this patent feed had not nearly the nourishing value of the cottonseed cake.

Now our days have settled to a routine, broken at times by the incidents and accidents which are inseparable from the handling of cattle. Charlie superintends everything, goes to town for feed when he must, and rides the range as much as he can. José Nuñez feeds the cattle and looks after the near-by watering-places. Lorenzo, Pancho, and Manuel cut and pack mescal and one or another of them helps to refire the pit or assists us in any emergency that arises. Teofilo cooks a batch of mescal, cools the pit and cleans it out, then refires it and cooks another batch. While his

pit is covered, he has time to help with the chopping when Charlie cranks up the engine and the knives begin to whirl.

I ride a little in the mornings when I can take time from my work at home. Cooking, washing, and a little cleaning have to be done, whether or no. Lorenzo's wife cooks for all the men with the exception of José. He has a little table in the corner of my kitchen and his choice of anything in the pots and pans on the stove. When he does not come in by the time we are through eating, and that occurs often because he will not come in until every animal has been fed, I fill a plate with food and put it in the warming-oven for him. When he has a spare moment from his numerous jobs in the corrals, he sometimes washes the kitchen floor or a dingy window, quite of his own accord. I do not know whether that is simply giving me a helping hand, or is a hint that my housewifery is not up to his high standard. So long as he does the work, I do not care why.

No matter what I do in the mornings, my afternoons are all alike. By two o'clock I am mounted on Blue Bell and she and I are off on our chief job for the day. We must go out to the home pasture, find every animal in it, and bring them all in to be watered and fed. First we go straight up the mesa to the very top of the glade, noting the cattle as we go, so that we can find them on our way back. To miss one that is lying down under a tree will mean another trip. We count the cattle each day and, if one is missing, she may be unable to get up on her legs or she may be calving and in difficulties. Many of the cattle rise, stretch themselves, and start on their plodding way to the water-lot as soon as they see Blue Bell and me, not waiting to be driven. Others see us and try to hide among the trees or behind the most inaccessible thickets. All are routed out finally and we punch them along ahead of us, down the

glade, through the parade ground and into the water-lot.

I shout for someone to crank the engine at the well; the water begins to flow into the troughs and I go back to the pasture to make my second round, this time in the ravine. I ride clear to its head, where the fence encloses a little of the river — if one may call that dry, baked expanse of rocks a river. Then I ride back toward home, driving all the cattle that I find ahead of me. Blue Bell well knows that if we miss a cow on the mesa or in the ravine, we shall have to come back to look for it. If I seem likely to overlook a cow that is hidden in the brush, Blue Bell turns from the trail and routs out the beast herself, with a bite on the tail of the cow for the trouble she has given a poor, hard-working mare.

When the cattle are all present and accounted for, I unsaddle Blue Bell and feed her, then take a quirt in my hand and go out to the watering-place. Long ago the pool by the spring dried up and the trickle from the spring itself is not enough to be depended upon. We have a pump and an engine on the strong well that provides water only for our house in normal times, but must now take care of the cattle's needs also. We have still another well, down near the creek, with walls of solid rock. It has never been known to go dry since it was dug, many years ago, and water stands in it within four feet of the surface, even in this dry year. That well we shall make use of if necessary, moving to it the pump and faithful engine.

Some of our cows are ladies. They take modest little sips, about seven gallons apiece, then amble off and out of the way, to let others have their turn. Some of our cows are not ladies. They drink until their sides bulge out, then turn around in front of the troughs and fight off any thirsty animal that approaches. It is for these ill-mannered beasts

that I carry the quirt with which to force them away so that even the weakest and most timid cow may have her chance at the water-trough.

About forty cows at a time are fed in the round corral at the tablelike feeding-troughs. As the cattle are watered, José comes and opens the gate to admit enough of them to take the places at the troughs. The greedy and belligerent cattle try to rush in ahead of the others, but he opens a gate and lets them run into a little side corral, where they cool their heels until the gentle cows are fed. One would think that they would learn to avoid being sidetracked in that manner; instead of which they are betrayed each day by their own haste and greed. In this simple manner, the mean, cantankerous, fighting cattle segregate themselves and are fed last of all. Crowding, pushing, hooking, stopping to fight in the midst of a meal, they will not even let one another eat in peace. We do not concern ourselves with their troubles, since there are no gentle cattle with them to be frightened and molested.

After one bunch of cattle has been fed, we drive them out through a side gate into a corral where they remain while the next lot are being served. The cows do not want to leave the troughs. They are always hopeful that if they refuse to budge, they may be given a second helping. Charlie, José, and I had all worn ourselves out one blistering hot afternoon, running and shouting, in the effort to put a lot of gentle cattle out of the corral. They were determined to stay where they were and ran around in a circle, time after time, ignoring the open gate. We stopped to rest a moment, and I saw Robles and Foxy lying comfortably in the shade of a tree in front of the house.

'Come here, Robles!' I called.

When he trotted over, Foxy coming with him, I pointed to the cows and commanded, 'Put them out!'

He wagged his tail, ran this way and that, with a worried look on his face. He wanted to help, but he did not know what to do. Never in his life had he been told to chase a cow, unless she was in his own dooryard, and as a puppy he was punished for barking at them.

'Bow-wow! Bow-wow!' I barked, to set him an example, and ran toward the cattle.

'Bow-wow! Bow-wow!' barked Charlie, and charged them from the other corner. Robles caught the idea.

'Bow-wow!' he roared, and ran at the astonished cows.

'Yip! Yip!' exploded little Foxy, the firecracker, and in two minutes the cattle were out and the gates were closed. Now the dogs have a regular job too.

Not all of our cattle rush up to the troughs, gobble their rations, and beg for more. We wish they would. For several years we have made a practice of feeding our heifer calves when we wean them in order that they may know how to eat from a trough and manger in just such an emergency as this. Our troubles are now with the older cows that were not given the benefit of a sound education in their earlier years. The wild-natured ones — 'Snakes! Snakes!' — huddle in the farthest limits of the great, round, feeding-corral; they tremble and shake their heads menacingly when we enter the corral on foot. Famished, they still will not approach the feeding-troughs. Such cows as these we leave in the corral at night, together with a gentle cow or two, knowing that they will venture up to the feed when they feel sure that there is no human eye upon them. We sprinkle a few handfuls of our treasured hay over the troughs to lure these cattle near enough to smell the other feed and learn to eat it.

Timid or weak cows, in danger of being knocked down or of being crowded and shoved away from their places at the troughs by the onslaughts of greedier neighbors, must

be fed in small, separate corrals, where each may be alone with her own calf and may take her time to eat. Charlie and José fill tempting tubs of feed for these frightened, feeble animals that show no inclination to learn to eat. Mescal, mixed with the patent feed, is put in the bottom of an old washtub; over this is sprinkled a very little cotton-seed meal; and scattered over all is a little alfalfa hay, to attract her attention by its tempting green color. No cow has ever yet spent the day alone in a corral with this fare without eating it. For this purpose Charlie is using the few bales of alfalfa that he brought from town. He is afraid of it now and uses it cautiously, after bloating a thin, hungry cow by giving her too much of it. The first day that he fed it to her, she puffed and groaned and moaned. After she had recovered from that bloating, he tempted Providence by giving her some more of that hay. This time she died.

'That teaches me a lesson,' said he. 'No more flakes of alfalfa hay for weak cows.'

At all times, cows display an ingenuity in getting into trouble. In this dry year they seem determined to bog down or drown. We have an abundance of water, and the more we hear of the troubles of some of the other ranchers, the more we appreciate that blessing. The river no longer runs on the surface of its rocky bed, but there are pools in its upper reaches. The semi-permanent waters have dried up without worrying us, since the permanent springs afford their usual flow. The cattle that are still rustling for themselves on the range should have water in as many places as possible so that none may have to travel over-far to get a drink. Cattle foul their watering-places, trample mud into them, roll rocks in to spoil the natural storage places. That obliges someone to go about with a shovel on his shoulder to clean up first this watering-place and then

that. Usually Charlie does the far-off ones and José the ones near-by. One day, when Charlie was riding home with a shovel on his shoulder, weary and muddy from cleaning up the pool in the beef pasture, he passed the Hermitage orchard and rode in to look at the spring there. Since the cattle are more valuable in our eyes than are the apple trees, we have now thrown open the fence and let the cows water there. An unusual movement at the spring caught his eye as he rode up. Could it be a pair of horns, protruding from the ground? It could be. Up to her neck in mud, occupying every inch of space in the spring, was a bogged, incarcerated cow. Near-by was her bewildered calf, hungry, bawling. Charlie could do nothing for her by himself. He came home in a fine rage, bundled all the men on the place into the truck; took along shovels, ropes, pulleys, planks, and returned to the rescue. Luckily he was able to back the truck up close to the cow. When he got her home she was too stiff and chilled from her long immersion in the mud to be able to stand up. However, she liked to eat, and in a day or so 'Boggy' was up and quite herself again.

Before our pool by Rucker Spring dried up, we were in the habit of watering there the cattle that were so thin and so scary that we did not like to turn them out into the pasture. Lorenzo was supposed to go down to the pool with these cows each morning and stay with them until all had watered. Then José would come and help drive them back to the corral. One morning, while the cows were drinking, Lorenzo felt thirsty himself and went over to his house for a cup of coffee. On his return he found that a poor, weak cow, heavy with calf, had fallen in the same place where Old Flaca took her tumble and lay with her head in the pool, drowned.

On another day I turned my back upon the cattle that

were watering at the troughs and presently there arose a great commotion among the cattle. As a supplementary trough, we had filled the large porcelain bathtub which had been defaced in the fire when our old house burned. On her back in the tub, nose and kicking legs in the air, was a cow that had been toppled in by some fighting, hooking neighbor. Men were at hand that time, and 'Tubby' was hauled out before she had more than a refreshing bath.

We have been told that during a severe drought some years ago, Mr. Lutley went out early one morning to one of his watering-troughs on the Bar Boot Ranch and found there an unfortunate cow that had managed to hook her horn under a cross-bar of the trough and thus had held her own nose under water until she drowned. Mr. Lutley gave the cow one long look, then said to his foreman, 'When this drought is all over, if there is a cow left alive on this ranch, write to me and I will come back.' Whereupon he got on his horse and rode away. We should like to do the same ourselves.

Almost the only cheerful place on the ranch these days is my own yard, in one corner of which José now runs a 'calfyteria.' The baby calves have the freedom of the yard and the pickings of dry grass which is still here because we have never allowed cattle to graze within this small enclosure. The dogs now accept the presence of the calves with some degree of toleration, chasing them only when they come too near my honeysuckle vine or my little bear-grass house of which I am so fond. It is just like the *jacals* that the Indians build for themselves, and Charlie built it for me with the help of Teofilo, as my birthday present last summer.

In addition to the grass, the baby calves have a low manger full of patent feed, barley, and corn meal, mixed together. New boarders stick their noses in, experimentally,

lick them off, find it 'larripin' good truck,' and come back for more. Foremost among the calves that José is feeding, are the 'dogies,' the motherless ones. There is small, red Lucky, whom we found by the pool in Red Rock Canyon, beside her dead mother. There is little black Chance, a calf that was so nearly dead when Charlie chanced to find him that he rode home across Charlie's lap in the saddle, without a kick or wriggle to show that he was still alive.

Salomón, Mrs. Trouble's foster son, suddenly appeared in our corral one afternoon, hungry, his little nose caked from fever and lack of milk. We could not locate his mother among the cattle that we were feeding; a count of noses showed that each cow among them already had her own calf. We fed the stray baby, and the next morning Charlie rode out to the nearest watering-place to see if he could find there a cow that was bawling or one that looked as though she had lost her calf. He found a heifer at the water that had a small bag of milk and no calf with her. He drove her home and Salomón rejoiced to see her. After the calf had sucked, Charlie turned the two out together; for this happened early in the spring, before we were bringing in all the mother cows and calves. Twenty-four hours later, slim little Salomón squeezed into the corral again between two posts that barely admitted his lank form. He was famished; his nose was dry again, and he bawled his complaint quite plainly, 'My mother ran off and left me!' Once in a long while a flighty heifer will do that very thing. The wise Salomón, knowing where milk was to be found, came to us, and we gave him permanently to Mrs. Trouble.

Both Lucky and Chance share the milk of generous mother cows who have enough for another calf besides their own. In addition to these 'dogies,' there are a number

of thin, stunted calves belonging to our two-year-old heifers and these need more to eat than the scant ration of milk that is given by their young mothers. Nobly to the front steps Mrs. Trouble. One teat she gives to her own calf and one to Salomón; this is enough for them, as her milk is very rich and yellow with cream. The other two teats are milked and my own job is to pour the warm milk into long-necked bottles, grab a baby calf between my knees, tip up its head and pour the contents of a bottle down the small throat.

After a few times the calves thoroughly understand what I am about and swallow every drop that gurgles from the bottle. One little calf we have named *Leche*, Milk, because of his great appetite for it. He absorbs his own bottle, and if there is any left after I have made my rounds, he swallows that also, opening his mouth as I approach, whether he is standing up or lying down.

As a reward for the help that Mrs. Trouble is giving us in our hour of need, we have forgiven her all her past misdemeanors. I shall try to forget the barn doors that she knocked down, the mistletoe that she ate, the time that she side-swiped me with her great head and mashed me against a tree. I think we shall have to change her name to Benevolence.

When the last rampaging, fighting, hooking cows have eaten their supper and gone back to the pasture, we eat our own, and then sit for a little while on the terrace in front of the house to enjoy the one moment of peace and leisure the day affords. No cattle stir the powdery dust of trodden corrals. Darkness hides the arid earth, or the moon lends beauty to a brown and seared world, and for an hour we may forget its barrenness. Music comes from the house of Lorenzo where Manuel is playing a mouth-organ or José has put a record on his phonograph. For all

of us it is a respite from the wearying heat and the fierce domination of the sun.

My dear Aunt Mary Abby, of New England, for a long time has been closing her weekly letters to us with the words, 'May the Sunshine of Prosperity shine upon you and Charles.'

Recently I have asked her to choose some other phrase, telling her that our present lack of prosperity is due to altogether too much undiluted sunshine. Today came her answer with its new termination, 'For you and Charles, I wish a Shower of Blessings.'

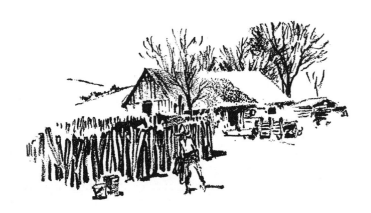

CHAPTER XL

THE COTTONWOOD COW

YESTERDAY was June twenty-fourth, San Juan's Day. While we did not, as do the Indians of San Juan Pueblo, deck ourselves with beads and feathers, dance, shake gourds or beat upon drums to propitiate the rain gods, we have a superstitious feeling about that day which is a part of the tradition of the Southwest. Every evening during the latter part of June, we, to whom rain is life and livelihood, anxiously watch the sky for propitious signs.

'Did you see the lightning flashes in the south?' asks one.

'I saw them. Now, if it will only rain on San Juan's Day.' And yesterday we rejoiced when a few big drops fell from a passing cloud which momentarily obscured the sun. One great drop splashed upon my forehead and I accepted it reverently as a pledge of torrential rains to come.

This cheering portent of help from the skies did not in the least interfere with our efforts to help ourselves. Feed was running low, and Charlie was obliged to go to town for another ton of it. He has been asking a great deal of our ancient truck of late and spent the day before the trip in greasing it, tightening up nuts, and replacing worn parts. He carries enough new parts along on every trip to make a nearly new truck. Just at dusk, as he was reassembling some vital thing-a-ma-jig, Charlie dropped a tiny screw on the ground beneath the machine. All hands and the cook groveled for an hour, continuing by lantern light, before we found it. It appears that there is not another

screw like that all-important one on the whole ranch. It enraged me to think that a truck so large could be put entirely out of business for lack of a screw so small. In the morning, in spite of all the tinkering and greasing, the truck was behaving in a very temperamental fashion, and Charlie thought it better to take Lorenzo along with him to town. If the man could not help in case the truck balked on the road, at least he could walk somewhere to get help.

After the men had taken their early departure, I happened to go over to see Barbarita, Lorenzo's wife, and I found her much disgruntled. Almost invariably she wears a towel or cloth of some description on her head; this time I found her without this conventional covering. Her long, straight, black hair was braided and hanging nearly to her knees. She told me that she had washed and braided it because, if a woman wants her hair to grow thick and long, it is necessary to cut a piece off the end of the braid on San Juan's Day. Lorenzo had rushed off to town with Charlie in a great hurry and told her he had no time to bother with her hair. I offered to cut it for her with my shears, but she said that would do no good. Properly to ensure the growth of her hair in the year to come, she must kneel down on the ground, place the end of her braid on a chopping-block, and her husband must chop off an inch or so with an axe.

I tried to pacify her by saying that there would still be plenty of time for Lorenzo to do that when he came home that evening, but I left her still grumbling.

Although these are the longest days in the year, darkness had been upon us for an hour before I heard the truck laboring up the hill. When it finally drove into the corral and I ran out with a lantern, Charlie alone got down from the seat.

'Where is Lorenzo?' I inquired.

For answer Charlie jumped into the back of the truck and called Lorenzo's name loudly, meanwhile pulling, jerking, and prodding the man, who was finally roused enough to sit up on the sacks of grain, swaying groggily.

'Get out, Lorenzo! You're home! Get out!' shouted Charlie, and I waved the lantern to show the man where he was.

Still in a daze, the usually brisk Lorenzo crept over the grain sacks to the tail of the truck, eased himself to the ground, and staggered down the familiar path to his own house. His feet had traveled it hundred of times and needed no command from his muddled head.

'You can bet I am glad to be home!' declared Charlie. 'Lorenzo went across the line to Agua Prieta and his friends there treated him to mescal and *tequilla*. Then they brought him back to where I was waiting for him, threw him in the truck and he has slept there, dead to the world, all the way home.

This morning I asked Barbarita if she had her hair cut last night. '*Seguro que no!*' she raged. 'Do you think I would kneel down for him to chop when he was that drunk? He would have been more apt to chop off my head than my hair!'

I rode awhile this morning, after the dishes were washed and the house was in some semblance of order. A big pot of *frijoles* was already cooked and I had pounded the jerky on a flat rock to have it ready to cook when I came back. Early in the spring we killed a steer, cut the meat in narrow strips, dipped them in brine, and threw them over the clothesline to dry in the sun. That is our standby in hot weather when we have no way of keeping fresh meat, nor of getting any except when we buy a steak or small roast in town. I cook jerky this way; then I cook

it that way; employing every method that I can learn. When we go on long rides, we carry strips of jerky in our pockets to gnaw upon when we feel the pangs of hunger.

Saving Blue Bell for the afternoon's work, I mounted the little Eohippus and left home at nine o'clock. Charlie and I no longer ride together. We need to see as much of our range as we can manage to cover, so we ride in opposite directions. Any cow that now needs to be fetched home is too thin and dispirited to give any trouble. My trail crossed the dry, rocky bed of Rucker at the start of my ride. It seemed unbelievable that Lieutenant Anthony Rucker was drowned by roaring flood-waters while trying to save the life of a fellow-officer, in this very spot where heat now radiated from sun-baked boulders. I was on my way to visit Clay Seeps, a watering-place hidden in a fold of the hills. Strong cattle drink there constantly without mishap; it is a boggy, treacherous trap for the feet of a poor, weak cow. For that reason it is necessary that someone should see the place at least every other day. One very encouraging thing I saw on my way up the canyon, across the mesa and over the hills to the Seep. Foraging for themselves on the range the young cattle had at last learned to eat the great, green clumps of rankly growing bear-grass; something our cattle have always refused to do before, though cattle on other ranges are in the habit of eating it.

As I neared Clay Seeps and looked down from a height upon its deposit of opaque, yellow, uninviting water, I saw an emaciated, black, muley cow looking down into the pool. From her lank sides I judged that she had not been drinking. By her side was a thin, red calf. I knew the cow well; Old Cottonwood we called her, a true 'snake' if there was one on the ranch. When we were gathering up the mother cows to bring them home to be fed, we saw her in

her usual haunts in the vicinity of Cottonwood Canyon and we purposely left her there.

'That fighting Old Cottonwood cow will have to be taught to eat from a trough and she is so ornery and mean that she may starve rather than learn,' decided Charlie. 'She and her calf are looking pretty well and she climbs the mountains like a goat. I am going to leave her here to rustle for herself.' Apparently she had been unable to do so.

Rocks rolled under the feet of Eohippus as we came down the hill and Old Cottonwood turned apathetic eyes upward to watch our descent. In her palmy days, given that warning of our approach, she would have disappeared over the hill in a streak of dust. We rode clear up to her, and still she did not budge, beyond a feebly menacing shake of her head. She looked as though she might collapse at any moment. I started her on the nearest trail that leads toward home, her calf following. I hoped that she might be able to continue putting one foot before the other until we reached our destination. I dared not hurry her for fear she would stumble and fall; I dared not stay too far behind her for fear she would lie down and not be able to get up again without help. Like every poor cow from the beginning of time, she chose the roughest footing and lengthened her journey by sliding into every possible by-way. Down the steep and rock-strewn trail that passes Blue Spring, she swayed and slipped, while I momentarily expected her to land in the ravine below. It was a great relief to me when I came to the spring and found José Nuñez there, plastered with blue mud, plying his shovel diligently.

'I am almost through cleaning up this spring,' said José. 'If you will let the cow rest and stay here for a few minutes, I can help you take her home.'

'Good! I'll wait for you, José,' I said. As we were

speaking, Old Cottonwood's wabbly legs took her to the shade of the nearest juniper tree and there she sank down exhausted, her calf beside her. I did not mind now if the cow took a rest, since I had José to 'tail her up' for me. I dismounted to sit in the shade also.

One thing that has caused us anxiety this spring is the fear that a cow may lie down and lack strength to get up of her own accord. Especially this troubles us if she proves too weak to walk after being 'tailed up' and has the misfortune to be lying in a spot where the truck cannot travel. By riding diligently, early and late, before the cattle became dangerously thin and weak, we forestalled most of this trouble by feeding the cattle. Among the cows that we are feeding are a few that had not yet borne their calves when we brought them home, and occasionally one of these heavy cows cannot get up without help. One afternoon when I made my round-up of the pasture on Blue Bell, she espied a cow in a clump of junipers in the ravine. We rode so near that Blue Bell's nose touched the animal and still she did not get up. I dismounted, thinking that the cow would fear a human being on foot more than she would a horse. The cow wagged her horned head at me, but she made no attempt to rise. I was satisfied then that she could not do so.

On my return to the water-lot, I told Charlie about the cow, and he called Manuel to go with him to the rescue. Manuel is a short, chubby, good-natured boy, a good match for Teofilo, and the two have kept our forces in excellent spirits by their jokes and pranks. In his pocket Manuel keeps a little wisp of black horsehair. Plastering that on his upper lip, pulling down his hat, twirling a stick, and shuffling his feet, he gives an imitation of the world's great pantomimist which has earned him the nickname, 'Charlie Chap.'

I rode slowly back to where I had found the cow, Charlie Rak and Manuel following me on foot. Charlie grasped the cow by the horns; Manuel lifted her by the tail, and up she came. Charlie released the horns and leaped nimbly to one side as the cow regained her feet. Sometimes cows come up in a fighting mood. The cow lurched toward Charlie. Manuel held on to her tail and was jerked along behind her.

'Let go of her tail! Let go of her tail! *Suelta la cola!*' shrieked Charlie and I, in two languages, quite in vain. The frightened cow and the panic-stricken 'Charlie Chap,' linked together by his frantic grip on her tail, careened away among the trees.

I drowsed under the shade until presently José threw down his shovel. 'That's done!' he said with satisfaction.

'Take a little rest yourself, José, before we start for home,' I advised. 'The cow and I are in no hurry.'

He rinsed the blue muck from his calloused hands and came over to the shade to smoke a cigarette.

'There is no use in hurrying, *Señora*,' he said. 'We can do so little and those clouds up there could do so much — if they would.' We looked up toward the white masses that were majestically sailing over our heads, as they have been doing every morning lately. 'It is hard to see dry years like this when the grass cannot grow and the cows are thin and lie down to die. It is sad to see too much rain, also, though that does not happen very often in this country, or in Mexico.

'One time in Mexico it rained and rained without stopping for one minute for seven days and seven nights. Nothing like that had ever happened before in anyone's memory. Adobe houses that were old, old, stood in water until they melted and fell down in a heap of mud. People left their homes and went to the hills. Many cattle were

swept away by the flood. No one could understand such a rain in Mexico where the sun is so warm and bright.

'I was a boy then, a wood-cutter, and when the rain drove us out of our camp, we wood-cutters moved up to a hill, built some new huts of bear-grass and poles, and waited for the sunshine to return. Our new camp was close to the river which grew wider, deeper, and stronger every day, and trees and all sorts of things floated down past us. Across the river from us was a town, and at night the lights looked so bright as we sat in those wet grass huts, trying to cook beans with wet wood. How we desired to go over to the saloons where men were drinking and playing cards! We wanted to go badly enough to swim across the river, but what was the use? We had no money. There is no place sadder than a town when one has no money. Even a wet wood-camp is better.

'We were all young and we were soon tired of sitting about the camp. So one day we walked down the bank of the river to see what damage the water had done. As we came around a bend in the stream, a man who was up in a tree saw us and shouted for help. All around the tree the river was running very swiftly so it could not stand much longer against that flood. We ran down to the edge of the water and saw that it was a Chinaman in the tree. Naturally we did not feel like going into that strong water to get him. He soon saw that we did not mean to enter the water. This time he called out "Gold! Gold!" That was different.

'"How much will you pay?" I shouted.

'"Ten dollars!" he answered.

'"Not enough."

'"Twenty-five dollars! Gold!"

'"I shook my head and we pretended to walk away.

'"Fifty dollars! Gold! Gold!" And that was as high as he

would go, though we waited and shook our heads again. We finally decided that fifty dollars was all he had.

'One boy ran back to camp for two of the rawhide ropes which we used to lash the wood on our burros. We tied these ropes together well. Then one end was tied around my waist while the boys held the other end, and I entered the river quite a little way above the tree. There sat the Chinaman in a fork of the limb and by him sat a rooster. That was all he had saved when the river came down on his vegetable garden. After I got there, the man was afraid to come down from his limb and enter the water. I had to tell him that I would shake the tree if he did not hurry. When at last he came down, I grabbed him by the long hair which Chinamen still wore in those days. He had the rooster under his arm. The boys pulled on the rope and hauled us to land, rooster and all. We treated that man well, too, first taking the fifty dollars and making sure that he had no more. We took him to our camp, built a fire, and gave him beans and hot coffee.

'Then we made small bundles of our clothes, tied them to our heads, and swam across the river. The water was so strong that we were a mile below the town when we reached the other bank. After that we did not care for the rain. There were cards, mescal, and dancing — and that fifty dollars. "Gold! Gold!" '

José and I must work again. We tailed up Old Cottonwood and started her on the last mile of her journey, first offering her a chance to drink from the spring, which she refused. She traveled better after her rest and José walked closely behind her to force her into the smoothest paths.

'Mount me on a horse,' said José, 'put a riata in my hand, and you will find that I am a very poor cowboy. Let me be on my own feet with a shovel on my shoulder and I can keep this old cow and her calf going all day.'

On arriving at home, we put Old Cottonwood and her
calf into a small corral and arranged a tub of feed in the
most enticing manner. Listlessly she sniffed at it, rolled
her lack-luster eyes mournfully toward us, and turned
away from the tub. The calf plunged a willing muzzle in
the feed and munched away. We had no idea what to do
next. Charlie came along while José and I were hopelessly
regarding that starved cow.

'Put that cow in the chute,' ordered Charlie, and we
obeyed, without expressing our great curiosity.

When the cow was penned between the walls of the chute,
bars before and bars behind so that she could not move,
Charlie pried her mouth open with a stick, thrust his hand
deeply between her jaws and removed a big, knobby bone
that had been lodged in the roof of her mouth for days.
I had heard before that cattle sometimes gnaw on bleached
bones that they find upon the range and die when the bones
become so wedged into their mouths that they can neither
eat nor drink. I had never seen an instance of it before.

Gladly the cow slaked the thirst of days. Willingly she
plunged her nose into the tub of feed.

'You and José are wise cowpunchers!' laughed Charlie.

CHAPTER XLI

A DANCE AT THE SCHOOLHOUSE

'IF IT rains. When it rains.' One phrase or the other preface all our conversation in this hot, dry month of June. All the signs are favorable for a normal rainy season which should start the last of this month or early in July. Yet we cannot help remembering the old saw, 'All signs fail in dry weather.' Water running in the river and an inch or so standing in the rain gauge are the signs in which we believe. We watch the sky and say little, mindful of the Arizona saying, 'Fools and tenderfeet predict the weather.' We have been in Arizona a long time.

Feeding cattle and riding in search of others that need to be fed have left us in no proper mood for festivities, and it was with a sinking heart that I had to break the news to Charlie that I had accepted an invitation to a dance for the following Saturday night. The wife of one of the neighboring ranchers was giving a party for some of her friends who were moving away; all the people in the countryside were to be there, and since all are working hard and waiting for rain too, we could hardly make that an excuse for declining the invitation.

'All right. We'll go,' conceded Charlie. 'But none of that all-night dancing for me. I have to ride in the morning, Sunday or no Sunday, and I want some sleep.'

We thought, of course, that the party would be at the ranch-house, and it was not until the very morning before the dance that I was told that so many people were coming, it would have to be held in the schoolhouse. Then, for the first time, I had a real enthusiasm for going. From Charlie

and from all the friends who have lived long in the South-
west, I have heard many stories of high-old times at dances
in schoolhouses. In the old horse-and-buggy days, people
came from far and near; no distance seemed too great for
the cowboys to ride to a dance. People rode or drove all
of one day, danced all night, and went home in the morning,
weary and happy. In these easier days of automobiles,
the dancers still keep it up all night and there are country
dances hereabout all of the time. My trouble has been
that I could never get my husband up to the point of
taking me to one of them.

'I've been to hundreds of them, all alike. What's the
use of going to another?' he invariably said. So I, who
had never seen such a dance at all, had been vainly pining
to go.

As I baked my cake (all the women take cakes to the
party), I thought of stories I had read about country
dances. I hoped some larky cowboys would swap the
clothes on all the babies as they did in Owen Wister's
novel, 'The Virginian.'

Dozens of automobiles of many vintages were already
parked in front of the schoolhouse when we arrived and a
goodly number of saddle horses stood patiently in the
schoolhouse yard. Although there is but one room and one
teacher, the building which houses the Rucker school is
neither little nor red. It is a long, gray-plastered adobe,
with tall windows on the sides and a door at either end.
The front door boasts an entry-way where the children
hang their hats and lunch-baskets.

Seated on a platform by the teacher's desk a fiddler and
a guitar-player were doing their level best to make them-
selves heard above the scraping of many dancing feet on
the rough, unwaxed floor. Bright tin reflectors threw the
light of hanging, kerosene lamps upon the best bib-and-

tuckers of the dancers, and myriad moths fluttered against the lighted windows, dancing to the music. Because the desks are so frequently removed to make room for dancing, they have been screwed down to wide boards instead of to the floor itself and now some of the desks and seats were ranged about the room and the remainder had been carried outside. One corner of the long room had been fenced off by desks to form a small corral in which babies were penned while their parents disported themselves. Most of the little ones were soon asleep on blankets spread for them. As the evening progressed, sleepy, older children gradually gave up the brave attempt to keep awake and tumbled into their corner. All the cakes had been unwrapped for admiration and were ranged about a table near the door. As I put my own cake with the rest, I saw a roly-poly little girl walking around and around the table, eyeing the cakes greedily.

'I'm going to have a piece of each!' she gloated. 'I'm going to have a piece of each!'

Then we danced and danced some more. Charlie, who was so tired that he would have been in bed for hours had we stayed at home, hopped about over the splintery floor like a two-year-old, even though the fiddler was scraping away at the tune most inappropriate for that gathering of ranchers — 'It ain't goin' to rain no mo'.'

Outside, on a campfire, men were boiling water for coffee in five-gallon oil-cans, and during a dance when I was a wallflower, I asked the Forest Ranger to go out with me and see if we could get a cup of coffee to help me stay awake. We went outside and were standing by the campfire, when the schoolmaster, a new one this year, came up and was introduced to me. Through the windows we could see Charlie gaily prancing through the figures of a square dance, 'Pop goes the weasel!' Seeing Charlie, then ob-

serving my white hair in the gleam of the firelight, the teacher asked, 'Are you that young Mr. Rak's mother?'

'No,' I replied. 'I am that young Mr. Rak's wife.'

Flustered, he blundered on, 'Well, you look old enough to be his mother.'

The Ranger choked. I maintained a stony silence — and the unfortunate pedagogue wandered off into the night.

Going inside once more, I met Charlie, who had been looking for me. 'They are going to fix supper now, and if we stop to eat, we won't get away for an hour,' he urged. 'Come on, let's go!'

On the table was a big chocolate cake. It had just been cut open, and I could see what a noble confection it was; the rich white layers with gooey chocolate filling oozing between them; walnuts sprinkled on top of the thick icing by a liberal hand. Cakes had been all too scarce of late in our busy bread-and-onion lives. I hated to leave without sampling the one of my choice. Yet we had a long, rough ride before us, it was very late, and we needed an hour's sleep much more than a midnight feast. We said goodnight to our host and hostess, and I waited near the door while Charlie had a parting word with some friend. Over in the nursery corner I could see the roly-poly little girl, soundly sleeping, dreaming doubtless of cakes, which was far more wholesome than eating her coveted 'piece of each.' Near me stood a newly married couple and the girl was doing her best to persuade her husband, a young cowman, to take her to some projected picnic, but he told her that he could not leave his cattle for all day. Their friends were listening as she still teased him to take her, and he evidently hated to refuse his bride the pleasure of the outing, especially before folks.

'Forget the old cattle, just this once!' she begged.

At that he stiffened and said with finality, 'I've got to stay with the cows.'

The rest of us, cattlemen's wives all, looked at her pityingly. Poor girl, she had still to learn that all her life she must play second fiddle to a cow.

CHAPTER XLII

'WHEN IT RAINS'

THE morning after the dance began like all others during these dry, heat-harassed months, except that we were even more weary than usual when we arose. A pitiless sun beat down upon us as we went about the day's routine. As though the sun were not enough, I had a big fire in the stove to bake my bread; smoke and quivering heat rose from the mescal pit where Teofilo was preparing the bed of coals to roast the next batch of feed. Out on the sweltering hillsides, Lorenzo and Pancho were prying mescal heads from their roots and chopping off the thorny leaves. In a row stood the three hard-working burros, while Manuel loaded them and roped the mescal heads securely so that they would not be jolted off. Four of the smaller heads are a burro-load; one large one on either side of the pack-saddle is all that a burro can carry and one of the monster heads must be split in two before being roped to the saddle. We were grateful that the mescal grows rankly and in abundance. There was no way of knowing how much we might need before the rains gave us grass once more.

The crisp, sun-scorched leaves of the oaks had at last loosened their hold and had been blown away. Every tuft of old grass growing among the rocks of our home pasture, every shrub that showed an edible leaf, had been searched out and eaten by the cows weeks before. Under the grateful shade of the spreading, evergreen, juniper trees, the cattle were now lying, patiently waiting until it was time to be brought in for the food and water provided by man.

By ten o'clock clouds began to form, materializing out of nothingness to hang about Turtle Peak. They had been doing so for a week or more and thunder frequently called us from our tasks to watch a darkening sky. Invariably, after an hour or so of hopefulness, the west wind arose to whisk the clouds away.

Thunder was growling and rumbling when two young friends came over to see us. They were spending their vacation in a camp by a spring up in the canyon. Norman Caldwell has been a cowboy; Lois is the daughter of Jim Hunsaker, a cattleman; so they are both well used to life ordered by 'If it rains' and 'When it rains.' Hot rolls and loaves of yeast bread were out of the oven by the time they arrived; *frijoles* were cooked and seasoned; it only remained to pound the inevitable jerky. I had no hesitancy about asking our visitors to have dinner with us.

We were at the table when a sound arrested our conversation and halted forks on their way to hungry mouths. A tap — tap! A soft patter; a drumming; at last a steady roar. Rain! Rain! Falling on our iron roof! We were afraid to speak of it, superstitiously fearing that a word might staunch the flow from the sky. Abandoning the table, we rushed out into the rain. Drenched, we rejoiced. Rivulets formed everywhere and joined their paths to unite in rocky washes where they swept away the dry-leaf dams and tore downward to the river. A curtain of heavy rain hid even the nearest mountain peaks from our view.

'Rucker is coming! Rucker is coming ' shouted Charlie.

Engulfing the dusty stones of its long-dry bed and grinding them together; snatching at broken limbs and uncovered roots, Rucker swept down its winding channel. Warned by the roar of advancing flood-water, we reached the high bank in time to see the first yellow crest take possession of the river-bed. Then the swollen, irresistible

flood, fed by a cloudburst and bearing a tree for battering-ram, burst through our puny fences and swept on down the canyon.

The sun presently broke through the clouds to find us still running about, trying to comprehend all of our good fortune. The height of the flood-waters had already passed down the canyon, but all the little creeks were trickling still. Tanks were full and the air had a washed feeling, new and exquisite to our eager nostrils. A well-curb had been swept away and sand filled the well. The mescal pit hissed and smoked like a geyser where the rain had poured down on red-hot coals. Nothing mattered. We had felt the rain.

After our young friends were able to ford the river and return to their camp, I still walked about to marvel at our re-created world, Scooter and Negrito frolicking before me. Down at the edge of the river, where the fence had been swept away by the flood, I saw myriad tracks. Cloven hoofs of cattle, all pointed toward the mountains, had left their imprint there since the rain. Obeying the instinct of their kind, they had forsaken the pasture, the corrals, the feed provided by the foresight of man, and at the falling of the rain they were returning to their hills.

I ran to the house to tell Charlie about the cattle. On the leather couch I found him. With Foxy beside him, Robles at his feet, he had fallen asleep.

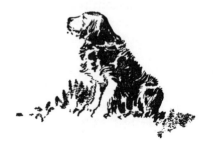

INDEX

paint: household recipe for, 104–105
Pancho (laborer): 258, 262, 264, 290
Pearce, Arizona: 7
Pedregosa Mountains: 108
Peter Cat: 54, 63, 172, 174, 180
Phoenix, Arizona: cotton fields near, ment., 56
pink-eye: 21–22
Pirtleville, Arizona: 6, 238
Poe, John Williams: xii
Poe, Sophie: xii, xiii
prairie dogs: 230
Prescott, Arizona: xi

R

rabbits: 175
railroad: at Apache, ment., 7
rain. *See* weather
raindance: 275
Rak, Charles Lukeman (Charlie):
background of, xv; shoes horses, 1;
describes his small house, 2; pictures
of, f. 4, f. 196; his attitude toward
cattle work, 18–19; cow charges,
34–35; traps wolves, 48–55, 71–74,
81, 194–197; frees fox from wolf
trap, 71; frees dog from wolf trap,
74–75; new hat of, 77; and
breaking horses, 86; his comment
on the guest-room, 104; drinks
mescal, 127; his comment on a
"cutting" horse, 128; Mexicans
afraid of, 131; struck by lightning,
247; attacked by bull, 250–251. *See
also* horses, Charlie's
Rak, Mary: background of, xiv–xv; her
brand, xviii; her ranch, xviii;
literary career of, xviii–xix; C. L.
Sonnichsen describes, xix, xx;
picture of, f. 4; learns to make

tortillas, 26–27; learns Spanish,
28; educated on cows, 31; invents
method of toting hay, 64; and
fallen barn doors, 65–66; traps
wolves, 71–74; catches difficult
steer, 72–73; her idea for finding
cattle, 101; creates guest-room,
104–106; lays pipe, 117; doctors
ranch laborers, 117–118, 158;
fights fire, 118–120, 231–234;
teaches Juana to read, 156, 166,
170; her reaction to game warden,
175–176; falls from horse, 210,
222; her comment on anger, 233;
her attitude toward clothes, 235–
237; travels to town alone, 237–
240. *See also* horses, Mary's
Rak Ranch. *See* Old Camp Rucker
Ranch
Ramirez, Jesus: 125
Ramirez, Lupe: 108
Ranchers: A Book of Generations, The:
ix
Ray, Mr. _____: 249–251
Ray (visitor): 75
Rita (cowboy's child): 191–192
Rivera, Carlos: 28–29
Rivera family: works for Raks, 28–29
Roach, Joyce Gibson: ix
Robles (dog): frolicks off with riding
boot, 1–2; snuggles to backyard
campfire, 3; refuses tortilla, 27;
with Charlie, 49, 292; and wolves,
50–51, 54, 193–195; keeps Mary
company, 63, 66, 67, 118–119;
greets new dog, 75–76; ruins dirt
map with wagging tail, 81;
puppies of, 98–99, 159; with
cattle, 103, 104, 226, 267–268,
271; afraid of dynamite, 116;
hunts skunks, 136–137; Indian